VISUAL STUDIES

VISUAL STUDIES

A Foundation for Artists and Designers

Frank M. Young

Associate Professor, Minneapolis College of Art and Design
Manager, Product Design, Tonka Corporation

Prentice-Hall, Inc., Englewood Cliffs, N.J. 07632

Library of Congress Cataloging in Publication Data

Young, Frank M.
 Visual studies.

 Bibliography; p.
 Includes index.
 1. Art—Study and teaching. 2. Visual perception.
3. Visual communication. I. Title.
N85.Y68 1985 707 84-4920
ISBN 0-13-942508-X

Editorial/production supervision: Marina Harrison
Interior and cover design: Jayne Conte
Cover photo: Larry Kirkland. Tsunami. Commissioned by Arthur Anderson and Co.
 Portland, Oregon. 1980. 30'h × 15' × 9'd. Jerome Hart photo.
Manufacturing buyer: Harry P. Baisley
Page layout: Meg Van Arsdale
Visual reference chart layout: Meryl Poweski

Printed in the United States of America

10 9 8 7 6 5 4 3 2 1

ISBN 0-13-942508-X

Prentice-Hall International, Inc., *London*
Prentice-Hall of Australia Pty. Limited, *Sydney*
Editora Prentice-Hall do Brasil, Ltda., *Rio de Janeiro*
Prentice-Hall Canada Inc., *Toronto*
Prentice-Hall of India Private Limited, *New Delhi*
Prentice-Hall of Japan, Inc., *Tokyo*
Prentice-Hall of Southeast Asia Pte., Ltd., *Singapore*
Whitehall Books Limited, *Wellington, New Zealand*

This book is dedicated to my boys:
Matthew, Chad, and Colin
in hopes that their lives may be enriched
through exposure to the visual arts.

CONTENTS

Preface

Introduction: Foundation and How to Deal with it 1

THE PROBLEM-SOLVING METHODOLOGY, 2
 Boundary Pushing, Setting Standards, Innovation versus Imitation
GOALS OF THE FOUNDATION PROGRAM, 5
SUGGESTED READINGS, 6

1

The Visual Arts: Education and Application: A History of Foundation Studies 7

THE TRAINING OF THE ARTIST, 8
 The Artists' Guilds, The Academies, The Bauhaus Approach, Elements and Principles Approach, Institute of Design Approach, Unstructured Approach, Today's Approach
VISUAL REFERENCE CHART: A COLLECTION OF ARTIFACTS, 1850-1980, 12
 The Rationale Behind the Selections
SUGGESTED READINGS, 23

2

Perception/Manipulation 24

CONCEPTS OF VISUAL PERCEPTION, 24
FIGURE/GROUND, 25
 PROBLEM 2-1: FIGURE/GROUND STUDIES
 Figure/Ground Factors
 PROBLEM 2-2: POSITIVE-NEGATIVE EXPANSION
EVALUATING THE COMPOSITION, 29
 Compositional Components, Consistency, Attraction/Communication, Methodology
 PROBLEM 2-3: POSITIVE/NEGATIVE CHARACTER
PROXIMITY, 35
 Proximity Factors
SIMILARITY, 38
 Similarity Factors
 PROBLEM 2-4: VISUAL DISTRIBUTION
 PROBLEM 2-5: COMPLEXITY
CLOSURE, 40
 Closure Factors, Conceptualizing Closure with Symbols
 PROBLEM 2-6: SYMBOL
 PROBLEM 2-7: SUM OF THE PARTS
VISUAL DECEPTION, 44
 PROBLEM 2-8: VISUAL DECEPTION
 PROBLEM 2-9: APPLICATION
SUGGESTED READINGS, 48

3

Basic Color Theory 49

QUALITIES OF COLOR, 50
> Problem 3-1: Simultaneous Contrast

COLOR THEORIES, 50

SUBTRACTIVE MIXTURE: PIGMENT, 51
> Prang System, Munsell System, Ostwald System, Four-color Process
> Problem 3-2: Hue Mixture

ADDITIVE MIXTURE: LIGHT, 53
> Problem 3-3: Additive Mixture

VALUE AND INTENSITY, 54
> Problem 3-4: Value Mixture
> Problem 3-5: Intensity Mixture
> Problem 3-6: Color Equalization
> Problem 3-7: Color/Mix and Match
> Problem 3-8: Application

SUGGESTED READINGS, 58

4

Visual Components: Structure/ Manipulation 59

COMPONENT ANALYSIS, 62
> Problem 4-1, Part 1: Surface Pattern

GRID STRUCTURE AND SURFACE PATTERN, 67
> Problem 4-1, Part 2: Surface Pattern

CONNOTATIVE STRUCTURE, 67
> Problem 4-2: Word Visualization

INDIVIDUAL COMPONENTS, 67
> The Dot
> > Problem 4-3: Dot as Center of Interest
> > Problem 4-4: Dot Fusion
> > Problem 4-5: Visual Order
> > Problem 4-6: Optical Mixture Grid
> Line
> > Problem 4-7: Linear Displacements
> > Problem 4-8: Linear Progression
> Planar Shape
> > Problem 4-9: Transformation Study
> > Problem 4-10: Modular Structure/Implied Motion
> Relief Form
> > Problem 4-11: 40-11 Modular Relief
> > Problem 4-12: Modular Construction
> > Problem 4-13: Application

SUGGESTED READINGS, 78

5

Spatial Representation and Drawing Methods 79

SPATIAL ANALYSIS, 80

SPATIAL ORGANIZATION: DEPTH ILLUSION, 81
> Object Location, Contrast of Size, Overlapping Forms, Transparency, Color Quality, Aerial Perspective, Line Weight Quality and Direction, Value Contrast, Gradation, Convergence, Linear Perspective

TECHNICAL DRAWING SYSTEMS, 87
> Orthographic Projection, Isometric Drawing

COMPUTER-AIDED DRAWING, 88

DISCURSIVE DRAWING, 88
> > Problem 5-1: Parallel Perspective
> > Problem 5-2: Parallel Perspective Development
> > Problem 5-3: Angular Perspective Development

PROBLEM SOLVING/DRAWING METHODOLOGY, 92
> > Problem 5-4: Object Investigation
> > Problem 5-5: Figure Translation

CLASSIFICATION OF IMAGERY, 95
> Abstraction, Representation Imagery, Nonobjective Imagery
> > Problem 5-6: Disaster
> > Problem 5-7: Quadruped Mammal
> > Problem 5-8: Object: Self-Integration
> > Problem 5-9: Self Image: Past/Present/Future

SUGGESTED READINGS, 102

6

Three-Dimensional Form: Analysis/ Manipulation 103

COMMON PROBLEMS WITH THREE-DIMENSIONAL STUDY, 104

WHAT IS FORM? 104

VISUAL ANALYSIS OF THREE-DIMENSIONAL FORM, 104
> Linear Form, Planar Form, Solid Form, Linear-Planar Form, Linear-Solid Form, Planar-Solid Form, Linear-Planar-Solid Form

MATERIAL CHARACTERISTICS, 114

BASIC THREE-DIMENSIONAL PROCESSES, 114
> Hands as Tools
> > Problem 6-1: Hands as Form
> > Problem 6-2: Hands as Form Maker within Constraints

COLOR–FORM RELATIONSHIPS, 118
> PROBLEM 6–3: HANDS AS FORM MAKER
> WITHOUT CONSTRAINTS

TOOLS AS EXTENSIONS OF HANDS, 121
> PROBLEM 6–4: THREE-DIMENSIONAL CONCEPT
> FORMATION

TWO–DIMENSIONAL/THREE–DIMENSIONAL
INTERFACE, 123
> PROBLEM 6–5: PLANAR DEVELOPMENT
> PROBLEM 6–6: TRANSLATION
> PROBLEM 6–7: APPLICATION

SUGGESTED READINGS, 128

7

Physical Structure/ Manipulation 129

PERFORMANCE–ORIENTED FORMS, 130
MATERIAL DETERMINATION, 130
> PROBLEM 7–1: ALTERED PLANAR FORM

STRUCTURAL PRINCIPLES, 132
> Compression, Stress, Tension, Flexure, Moment
> PROBLEM 7–2: SELF-SUPPORTING FORM

> Post and Beam, Triangulation, Slab, Suspension
> PROBLEM 7–3: VERTICAL PLANAR SUPPORT FORM
> PROBLEM 7–4: VERTICAL LINEAR SUPPORT FORM
> PROBLEM 7–5: HORIZONTAL PLANAR
> SPAN/SUPPORT FORM
> PROBLEM 7–6: HORIZONTAL LINEAR
> SPAN/SUPPORT FORM
> PROBLEM 7–7: TALLEST FORM/LONGEST FORM

> Arch, Dome, Shell, Membranes, Pneumatic Structures, Cantilever
> PROBLEM 7–8: CONTAINER
> PROBLEM 7–9: MAILER CONTAINER
> PROBLEM 7–10: SPACE-ENCLOSING FORM
> PROBLEM 7–11: APPLICATION PROBLEM

SUGGESTED READINGS, 148

8

Materials and Processes 149

THE WORKSHOP EXPERIENCE, 149
> PROBLEM 8–1: ULTIMATE FORM

HANDTOOLS, 151
> PROBLEM 8–2: HAND TOOL, SUBTRACTIVE METHOD
> PROBLEM 8–3: POSITIVE/NEGATIVE CUBIC FORM

MACHINE TOOLS, 154
> PROBLEM 8–4: CUBIC FORM CONSTRUCTION

KINETIC ANALYSIS, 154
> PROBLEM 8–5: KINETIC RESECTION

COMPONENT CONSTRUCTION, 156
> PROBLEM 8–6: COMPONENT FORM
> PROBLEM 8–7: RELATED FORMS

PROPORTION SYSTEM, 160
> PROBLEM 8–8: FORM/SPACE RELATIONSHIPS

FORM FOR FORM'S SAKE, 161
> PROBLEM 8–9: PURE FORM

SUGGESTED READINGS, 162

9

Functional Aesthetics 163

THE CONSUMER, 163
> Factors in Aesthetic/Purchase
> Decisions, 163

PRODUCT EVALUATION CRITERIA, 167
KITSCH, 168
ETHICAL AWARENESS, 175
> Environmental and Safety Concerns, Cost, Craftmanship

HUMAN FACTORS, 177
AESTHETIC CONCERNS/DECORATION, 178
> PROBLEM 9–1: CRITERIA DEVELOPMENT
> PROBLEM 9–2: PURCHASE DECISIONS

SUGGESTED READINGS, 181

Conclusion: Attributes and Attitudes of the Visual Artist 182

AESTHETICS, 182
TECHNICAL SKILLS, 183
COMMUNICATION, 183
RESEARCH, 183
PROBLEM SOLVING, 183
CRITICISM, 183
COMPROMISE, 183
FUTURE ORIENTATION, 183
EXPERIENCES, 184
STANDARDS, 184
WORK, 184
SELF–IMAGE, 184

Index 187

PREFACE

VISUAL STUDIES is based on the premise that there are few, if any, differences between art and design when experienced at an introductory level. Regardless of your professional goals, fundamental information—i.e., basic visual concepts—forms a basis for approaching solutions to and understanding future visual problems.

You will be exposed to concepts, materials, and processes through a series of structured problems developed in such a manner as to give you the latitude to experiment analytically and intuitively. These problems will challenge you to think, to ask questions, to set standards, and to aspire to innovation. The text includes over 60 challenging problems that are clearly stated in terms of the *task, materials,* and *considerations.* These problems are presented in a simple though complex arrangement to allow for gradual conceptual growth, as well as the development of an expanded technical expertise. Illustrations accompany each problem indicating an appropriate solution to that problem; however, these are only points of reference—you are encouraged to develop solutions that surpass the examples.

The problems cover a diverse range of topics which are integral to the visual arts. Concept areas included are: *visual perception; color theory; two and three-dimensional composition; drawing systems; analysis and manipulation of three-dimensional forms; physical structure* and *materials and processes.*

VISUAL STUDIES includes subject areas that are seldom addressed, yet are essential to visual arts foundation study. You are introduced to foundation study by a discussion of methodology; a suggested approach of how to deal successfully with foundation problems.

A VISUAL REFERENCE CHART exposes you to a catalog of visual imagery composed primarily of objects in everyday use from 1850 to the present in the areas of environmental design, visual communication, and product design. In addition, the chart highlights significant events in social history and trivia. You will be able to identify relationships between the images, thereby increasing your sensitivity to past forms, processes, and stylistic trends that have led to the development of contemporary forms, as well as forms you will be creating in the future.

Finally, an extensive discussion of *functional aesthetics*—i.e., the physical and psychological relationship between utility and visual form is included. It encourages you to develop a personal philosophy as a basis for the development of a criterion for making aesthetic decisions in relationship to your studio work, your personal environment, your future as a visual artist.

ACKNOWLEDGMENTS

As with any project of this magnitude it is impossible to complete the task alone. I thank the following individ-

uals for their support and assistance. Without their efforts I could not have completed this text.

Nancy Buck, historical research; Kevin Byrne, lending collection and constructive criticism; Guy Cassaday, illustrations; Jamie Engel, clerical and correspondence; Sam Hammack, photography; Paul and Arlene Johnson, lending collection and moral support; Dave Karekin, photography and illustration; Cork Marcheski, lending collection; Jan Mercer, editorial and constructive criticism; Paula Midthun, bibliography and table of contents organization; Lisa Moran, illustrations; Russ Mroczek, lending collection and constructive criticism; Leslee Owens, clerical and photostat touch-up; Rik Sferra, lending collection; Gail Samsa, photostats and illustration; Denis Langlais, model making; Phil Van der Weg, constructive criticism; Mary Wahlquist, photography; Karen Williams, typing manuscript; and finally, a special thank you to my wife, Linda, and my boys for their patience and understanding during this period.

In addition, I would like to thank Jay Doblin and Eleanor DuQuoin who, by example, taught me to question and to believe, respectfully.

I would also like to thank the Minneapolis College of Art and Design for the use of their archives and the 1981 Summer Stipend. A special thanks goes to Gerry Allan for allowing me to teach the special visual studies class I needed to test the contents of this text.

Acknowledgment for illustrative material is appreciatively extended to the following individuals, institutions, and corporations:

Corporations, Institutions, and Individuals

American Heritage Publishing Co.; American Telephone and Telegraph Co.; Animal Fair; Arista Records, Inc.; Atari, Inc.; Bell Helmets, Inc.; Binney & Smith, Inc.; Borden, Inc.; Braun Ag.; Burger Chef Systems, Inc.; Byte Publications, Inc.; CBS, Inc.; Chermayeff & Geismar Associates; Chevrolet Division, General Motors Corp.; Colorado Historical Society; Container Corporation of America; Crown Publishers; Deere & Company; Eastman Kodak; Edison Institute; Electrolux Corporation; Ford Motor Company; Frigidaire; General Electric Company; George Nelson and Associates; Gold Medal Company; H-M Vehicles; Harris Gobaty Associates, Inc.; Herman Miller, Inc.; IBM; Instrumentation Laboratory, Inc.; James River-Dixie Northern, Inc.; Kenworth Truck, Co.; Knoll International, Inc.; Lancaster-Miller Publications; Levi, Strauss & Co.; Libby, Glass Division, Owens-Illinois, Inc.; Liberty United Records (U.K.) Limited; Library of Congress; Litton Industries; Donald W. McCaffrey; McDonald's Corp.; McGraw Hill Book Co.; Maxell Corporation of America; Mazda Motors of America (central); Minneapolis Society of Fine Arts; Montgomery Ward & Co., Inc.; Moss Tent Works, Inc.; N.A.P. Consumer Electronics Corp.; National Housewares Manufacturers Assoc.; Nebraska State Historical Society; Northern States Power; Oster Co.; Paragon Advertising Company; Parker Pen Company; Pentel of America; Pioneer Electronics Corporation; Pro-Color; Public Information Office, Wichita, Kansas; Rich Products Corporation; Salem Carpet Company; Seali, McCabe, Sloves, Inc.; Singer Company; Smithsonian Institution; Sony Corporation; Steak & Shake, Inc.; Stendig, Inc.; Squirt & Company; Texas Instruments; The Cleveland Institute of Art; The Coca-Cola Company; The University of Illinois Press; The Munsell Company; The Old House Journal, Inc.; Thonet Industries, Inc.; Tonka Corporation; Union Tank Car Company; Upjohn Company; Van Nostrand Reinhold Publishers; Gene Winfield Special Products; Worrell Design; Zippo Mfg.

Museums/Galleries

Art Gallery of Ontario; Le Musée du Louvre, Paris; Minneapolis Institute of Art; Museum of Art, University of Kansas; Museum of Modern Art, Civica Galleria d'Arte Moderna, Milano, Italy; The Art Institute of Chicago; The Metropolitan Museum of Art; The Museum of Modern Art; Vorpal Gallery; Walker Art Center.

Visual Artists

Henry Aguet	Mark J. Harris
Gerry Allan	James D. Howze
Rebecca Alston	Lawrence P. Kirkland
Getullio Alviani	Marlene Knutson
Kenneth Batista	Leonard Koenig
Joy Broom	Jerry Leisure
Joseph A. Burlini	Cork Marcheschi
James Burpee	George Mellor
Kevin Byrne	Judy Miller
Wendell Castle	Aribert Munzner
Ivan Chermayeff	Chuck Owen
Bob Clore	Elizabeth J. Peak
Robert Coppola	Bonnie Printz
Bob DeBrey	Steve Rettew
Hiroshi Fukushima	Judith Roode
Johannes Gaston	Kenneth G. Ryden
Dan Gorski	Robert Tobias
David Graves	Alvis Upitis
Sam Hammack	Phil Van der Weg
Robert Jensen	James Walton
Katherine and Michael McCoy	W. Robert Worrell
Jean Harmon-Miller	Gianfranco Zaccai

Student Credits

Below is a list of former students whose work illustrates the studio problems posed in the text. The illustrations

were selected from hundreds of successful solutions. They tend to exemplify adequate, well-communicated solutions to the problems. However, in most cases they are first attempts at solving the problem. They should be viewed as departure points, not influences.

Dale Allison, Figure 6-58; Alan Atwell, Figure 7-19; Mark Benyo, Figure 8-21; Tom Bethke, Figure 5-52; Elinor Bowen, Figures 2-9, 2-45; D. J. Bravick, Figure 3-3; Mary Brown, Figure 3-20; Doug Butterworth, Figure 4-19; Dan Byers, Figures 2-49, 3-5, 5-36, 5-37, 5-38, 5-39, 5-40; Susan Carlson, Figure 3-22; John Coleman, Figure 4-24; Joyce Courtney, Figure 8-20; John Davis, Figures 2-12, 2-57, 6-57; Doug Dobbe, Figure 2-40; Gretchen Dreisbach, Figure 2-44; Karen Drickey, Figures 8-6, 8-8, 8-9, 8-10, 8-25, 8-26; Janet Dunzer, Figure 3-6; Jamie Engle, Figures 3-4, 3-21, 4-37; Tom Evers, Figure 8-1; Mary Furuseth, Figure 7-37; Susan Gold, Figures 4-39, 4-40, 6-34; Susan Goodrie, Figure 3-23; Jay Henning, Figure 5-49; Carmel Irons, Figure 7-20; Cathy Jacobson, Figures 4-29, 4-30; Dave Kareken, Figures 4-26, 5-26; Rick Lahti, Figure 5-53; Denis Langlais, Figures 7-13, 7-38; Mark Laux, Figure 5-54; Sue Lent, Figures 3-17, 3-18; Dean Lucker, Figures 5-27, 5-28, 5-29, 5-30, 5-31, 5-32, 5-46, 5-47, 5-50; Laurie Maendler, Figures 6-54, 6-55, 6-56; Colin McRae, Figures 2-32, 2-55, 8-19; Sara Mars, Figures 2-47, 6-37, 6-59; David Meuer, Figure 3-2; Marcia Miller, Figure 8-5; Bruce Nelson, Figure 4-18; Leslee Owens, Figures 7-39, 7-40; Michael Pistillo, Figure 7-21; Marsha Ruse, Figure 8-14; Paul Rynkiwicz, Figures 2-27, 2-28; Mary Jane Sahl, Figures 2-10, 3-28; Dean Steffen, Figure 3-28; Linda Tallier, Figure 4-32; Joe Throssel, Figure 8-18; Bill Tresh, Figures 4-21, 4-22; Joan Van der Veen, Figure 8-31; Steve Wagner, Figure 7-22; Jim Walton, Figure 6-43; Margo Ward, Figure 8-19; Rik Wright, Figure 2-56; Gary Yamron, Figures 6-38, 8-11.

I apologize to those students whose names I was unable to associate with their work; the work is consequentially labeled *student unknown.*

Introduction: Foundation and How to Deal With It

The visual arts foundation studio experience is a period of exposure. You will be exposed to the basic vocabulary of visual perception, theoretical concepts, and visual criticism. You will learn about the processes, materials, and tools of the visual arts and the variety of forms and images developed in Western culture since the Industrial Revolution. You are enrolled in a foundation course primarily to gain access to information and to receive feedback on what you have done with that information. The information may be categorized as conceptual, technical, or aesthetic in nature. This information is available to you from a variety of sources in and out of the classroom—from instructors, books, technical manuals, television, films, museums, classmates, and your personal experiences.

All problem-solving courses are set up in essentially the same format. You are given a problem to solve, and you draw on your information to produce on investigative result, which you then present to your in-

structor for critique and/or evaluation. It is essential for you to have or develop a positive attitude. You must be interested in your work, eager to learn, and self-motivated. In all likelihood, you will experience some frustration during your foundation year. A positive attitude enables you to continue and succeed. This course of study was developed for the person interested in becoming a visual artist. A visual artist is an individual who solves theoretical or applied problems primarily with the tools of a visual language.

Visual artists are usually known by more specific titles, such as painters, potters, graphic designers, sculptors, or product designers, etc. In this course of study I have used the general term *visual artist,* since I believe the information in this text can be applied to all specific disciplines within the visual arts. The studio section of this course of study relies heavily on concepts drawn from visual perception. Four chapters are devoted to two-dimensional studies—perception, color terminology, visual components, and spatial representation and drawing methods. Three chapters address three-dimensional studies: form analysis, physical structure, and materials and processes. The text is structured so as to introduce a concept, assign problems that give you experience in dealing with the concept, and finally, in most cases, question your results. Visual examples of student solutions to the assigned problems are given. Remember that these illustrations simply show how one or more students solved a problem; they are not the only solutions. There is no such thing as only one "right" solution. Each problem is explained and illustrated not to give a specific answer but to suggest a starting point and a way of study. Examples of work completed by professional visual artists are also included to show how the concepts you are dealing with are being used in the profession.

This text consists of a series of projects designed to accomplish the goals for a successful foundation experience, which are listed at the end of the introduction. In addition, the first and last chapter and the conclusion address themselves to information, though not studio in nature, intrinsic to the studio assignments; they examine education and application of the visual arts, functional aesthetics, and the attributes and attitudes of the successful visual artist.

This text does not adhere to the academic concept of first studying theory and then putting it to practice. It places practice before, or at least concurrent with, theory. It could be described as a *nuts-and-bolts* approach to visual arts education. It is my belief that you learn and understand by doing. Once you have experienced something, you can then analyze and discuss it in an effort to understand more fully what you have

accomplished. The *doing* gives you a common reference and point of departure for the discussion to follow.

I also believe that the success of any approach to foundation studies lies primarily in the kinds of assignments chosen and how those assignments are presented to you. If, in stating the assignment, undue emphasis is placed on your freedom and self-expression—that is, on creating art—the end product is often conceptually shallow or meaningless. It is usually imitation rather than innovation or, at the very best, totally predictable. You are operating under the assumption that you are creating art, when in fact you are often handicapped by the lack of information and experiences given in a structured foundation course of study such as this. An assignment to do a painting tends to lead you toward a preconceived solution; that is, you already know what a painting is supposed to look like, so that is what you produce. Such assignments become a process of repeating what exists; therefore, you are unchallenged intellectually or even technically in some cases. In other words, you are encouraged to emulate rather than to innovate. Structured assignments are an excellent method of developing concepts and experiencing materials and processes as well as learning to work within constraints. However, an undue emphasis on a structured approach to visual education can be as damaging as an undue emphasis on an unstructured or spontaneous approach. It can lead you to rely on formulas for solving problems rather than your own thought processes and innate abilities. I hope this text has struck a balance between the two. It provides a structured course of study that can be approached in a spontaneous manner. If you are to get the most out of this course of study, you must be constantly questioning and be prepared to work in areas previously unknown to you. To achieve growth, you have to risk failure, even fail totally at times. This text will encourage you to think, to grow, to take risks, and ultimately to succeed.

THE PROBLEM-SOLVING METHODOLOGY

In order to solve a problem successfully, it helps to have a plan or method of approach. I propose the following problem-solving methodology.

1. Motivation: Accept the problem. Determine your own reasons for working on it. Be willing to attempt a solution. Something of value can be gained from all experiences.

2. Task identification: Define the problem or, in approaching the problems in this text, analyze the problem statement. What does it mean? How might it be interpreted? Consider each word carefully.

3. Research: What exists? Ask questions. Have other visual artists solved this or similar problems? Learn from their experiences, then go beyond their solutions. Consult the *visual reference chart* at the end of Chapter 1. Go to the library.

4. Ideation: Consider alternative solutions. Don't rule out any possibilities. Trust your intuition. As a rule you should not accept your first solution. Develop a concept or preferably a series of concepts. When you think you have a solution, see if the problem can be solved by other methods. Push yourself.

5. Constraints: In addition to the constraints built into a problem, consider these limitations:

Time—How long will it take you to execute the solution? How much time has your instructor allowed? How long will it take you to accumulate your materials, research information, and so on?

Materials—Which material or materials are appropriate for your solution? Which materials are readily available to you?

Technical skills—Are you able to work with the materials you have chosen, or will you have to learn to manipulate these materials?

Cost—How much are you willing or able to invest in the solution of this problem?

6. Selection: Consider your options. Choose the best, most appropriate solution based on steps 3, 4, and 5.

7. Implementation: Solve the problem. Implement your ideas. Execute, fabricate, or give form to the solution.

8. Evaluation: Reread the problem statement. Did you solve the problem? How effective is your solution? Were you innovative? Evaluate your craftsmanship and method of presentation.

9. Refinement: React to your evaluation. Can you make an adequate solution into an exceptional solution? Return to step 4 and redo if necessary.

10. Presentation: This solution represents you and your problem-solving ability. Be prepared to communicate your visual ideas verbally.

Usually the visual vocabulary of a beginning visual arts student is limited to *I like it* or, less frequently, *I don't like it*. During the foundation year you will be enriching your vocabulary by active participation in critiques and discussions. This discourse frequently opens or exposes you to ideas that are quite different from your own, and many may at first seem strange to you. Try to keep an open mind and be receptive to learning.

Once you have made the above steps a part of your approach to problem solving, you will be able to develop effective, innovative solutions to any future problems that arise.

Boundary Pushing

The problems assigned in this course of study should be considered only as starting points. You are expected to be what is called, in psychological terms, a boundary pusher. The term *boundary* is used to define the physical limits of an enclosure, such as an acre of land. However, boundaries may be intangible. The best examples are boundaries that are thought to exist or that are self-imposed. This is often illustrated by the student who states, *but, I thought we couldn't. . . .* A boundary may be a limit to what is known; for example, we know there is more information to be gained through cancer research, but we do not yet have that information. A boundary is also a limit to what can be done; you may know, for example, that you can jog for three miles.

Generally, boundaries are set up by cultures or segments of cultures to encourage, if not demand, certain modes of acceptable behavior. These boundaries may be by consensus, as in the case of laws. An example from the art world is the accepted modes or styles of painting and sculpture that were set by the French Academy at the end of the nineteenth century. It took visual artists like Cézanne and Picasso to step beyond the accepted norm and break down the boundaries that the Academy set for the visual arts. Boundary pushing was also displayed by Ray and Charles Eames when they recognized that plywood could be molded first into sculptural forms and later into splints and finally chairs. Boundary pushing is extending limits beyond the conventional as does the logo in Figure I–3.

The purpose of boundary pushing as a method is to extend the limits of your work, to avoid imitation, and in the process, to develop original solutions. This may require you to question the structure of an assigned problem in order to arrive at a satisfactory solution.

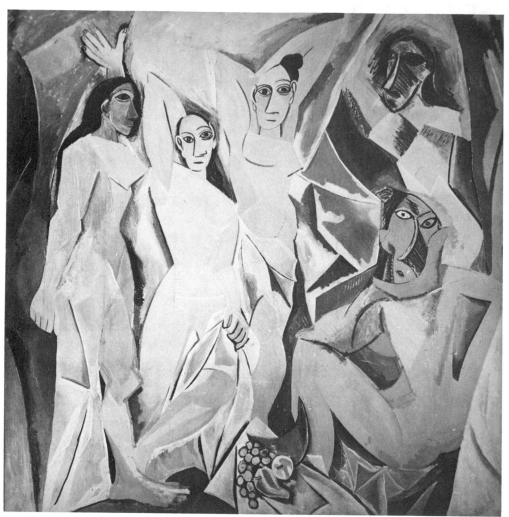

FIGURE I-1
Pablo Picasso. Les Demoiselles d'Avignon. *Collection, Metropolitan Museum of Art, New York.*

FIGURE I-2
Ray and Charles Eames. Moulded plywood forms. Courtesy Herman Miller, Inc.

FIGURE 1-3
Minnesota harvest orchard. F. Young, photographer.

This shouldn't be done, however, without regard for the intended conceptual exploration of the assigned problem. Before you can question a concept, you must understand it. Discuss any proposals with your instructor.

Setting Standards

You should set standards for yourself and try to maintain or surpass them. Students who bring their solutions to an assignment to class and then proceed to make excuses about the content, composition, or craftsmanship have compromised their standards. A good rule to follow is, **if you are going to do it, do it right.** If you truly consider your work a *solution,* then excuses are not necessary. Be proud of your work, your problem-solving ability. This is not meant to imply that compromises or trade-offs are not necessary in the solution to a problem. I have never solved a problem without compromising during the design process. A concept may have to be modified or one material substituted for another. However, once the problem is solved, I can take pride in having done the best that I was able to do at that period of my development as a visual artist. I often tell my students that if they can't live with their work, then it is probably not a good solution and should be reworked.

In the problems to follow, concepts will be dealt with using nonapplied imagery and object-oriented images. In the nonapplied, or theoretical, studies geometric shapes are stressed since they provide the simplest, clearest means to experience visual relationships in a way that minimizes symbolic association. Symbolic association should also be a consideration when you select your object-orientated images. For example, if you like cats and use a cat motif as a solution to an assignment, it will be difficult for you to be objective because of your feelings for cats; in other words, the symbolic association will cloud your objectivity. This is not to mention how viewers might react to the work if they dislike cats.

The visual arts is a profession based on creative excellence. To succeed, you need to be innovative and competent. Often students are concerned about not being talented enough. My response to the issue of ability is that I would prefer a student to be either very good or very bad. If you are very good, generally, you are self-motivated and receptive to learning and the work will be enjoyable for you. On the other hand, if you recognize your limitations and determine that you have much room for improvement, you can improve if you are determined to do so. Nothing succeeds like interest combined with hard work. However, if you are mediocre—just competent enough to get by, easily influenced by the ideas of others, and so on—the chances are that you will become bored or lose interest in the visual arts. The foundation year is a time for testing your abilities. It is a time for you to make a decision about your future career.

Innovation versus Imitation

The assurance of success makes imitation of visual arts products very tempting. Unfortunately, imitation is very prevalent in applied design, so prevalent that imitative products are calmly referred to as "knock-offs" and are often requested in order to get a share of the market. As a visual artist you should strive for originality. Nothing of value is gained by copying another person's solution. Plagiarism is considered undesirable in our culture; originality is admired. This concept has been an essential feature in Western art for the past several hundred years. Although it is impossible not to be influenced by your environment, there is a distinct difference between being influenced and resorting to plagiarism. You must remain perceptive and receptive to the ideas of others. You can't afford the time or effort needed to reinvent the wheel each time you attempt to solve a problem. Be aware of past solutions and stylistic motifs so that you do not unknowingly "copy" previous solutions. The *visual reference chart* at the end of Chapter 1 should be helpful to you in this respect.

GOALS OF THE FOUNDATION PROGRAM

The following goals were developed over a period of years with the assistance of several colleagues. They are not listed in order of importance; however, they will lead to a successful foundation studio experience and, consequentially, help you to become a successful visual arts student.

- To increase your visual perception
- To develop your sensitivities to spatial relationships
- To help you recognize and differentiate psychological, physiological, and emotional responses to a visual arts product

To help you develop an innate understanding of visual arts concepts

To enlarge your visual vocabulary beyond "*I like it*" or "*I don't like it*"

To refine your visual semantics

To broaden your scope in relation to tools, equipment, materials, processes, medium selection, techniques, and the safe and proper use of same

To encourage you to establish appropriate standards of composition, content, and craftsmanship

To prepare you to define and defend your own standards of aesthetic judgment and value

To prepare you to define and state visual concepts meaningfully in verbal and nonverbal presentations

To make you aware of many of the images and forms of art and design since the Industrial Revolution

To encourage you to interact meaningfully—that is, to share ideas—with other students, not merely compete with them

To aid you in developing criteria for making visual aesthetic decisions in relation to your work, the work of your peers, and your choice of personal objects and the purchase of future objects

To develop a positive self-image in relation to the visual arts, in other words, to take pride in your work and your problem-solving ability

To have fun while working and learning

Remember, if you can think and are willing to work hard, you can have a successful foundation experience and be well prepared for the applied work in future classes and job situations.

SUGGESTED READINGS

FABUN, DON. *Three Roads to Awareness.* Beverly Hills, Calif., Glencoe Press, 1970.

GREEN, PETER. *Design Education: problem solving and visual experience.* London: B. T. Batsford Limited, 1978.

HANKS, KURT and JAY A. PARRY. *Wake Up Your Creative Genius.* Los Altos, Calif. William Kaufmann, Inc., 1983.

JONES, J. CHRISTOPHER. *Design Methods.* London: Wiley-Interscience, 1973.

KOBERG, DON, and JIM BAGNALL. *The Universal Traveler.* Los Altos, Calif.: William Kaufmann, Inc., 1976.

McKIM, ROBERT H. *Thinking Visually.*

SAMUELS, MIKE and NANCY SAMUELS. *Seeing With the Mind's Eye.* New York. Random House, Inc., 1975.

VON OECH, ROGER. *A Whack on the Side of the Head.* Menlo Park, Calif. Creative Think, 1983.

The Visual Arts: Education and Application: A History of Foundation Studies

1

As you begin your studies of the visual arts field, I feel it is important for you to realize how courses or texts such as this came into being—how they became essential, throughout the country to first-year studio programs, whether they are called visual studies, basic design, visual fundamentals, studio foundations, or still another name. There is as yet little if any written information available about the history of foundation education in this country. Much has happened in the history of foundation studies, and unfortunately very little recent history has been documented. To make matters worse, confusion exists as to the definition of foundation studies. *The fundamental principle on which something is founded* is the generally accepted meaning of the term *foundation.* However, visual arts educators do not necessarily agree on what are the fundamental (basic) theories that are essential to the education of the visual artist.

No one knows for sure the origin of the term *foundation* in relation to the visual arts. However, it has been attributed to Walter Gropius, the founder of the Bauhaus. Gropius, an architect, was reported to have thought of the Bauhaus curriculum as analogous to a building, with each term being equal to a floor. The first term, the preliminary course, was obviously the foundation of the figurative building. Symbolically, it took on greater importance as the body of information on which all succeeding studies were based.

THE TRAINING OF THE ARTIST

The Artists' Guilds

To better understand the evolution of foundation studies, it would be appropriate to approach the subject from the premise of the training of the artist. It is only logical to start with the program of the artists' guilds of the Middle Ages. A typical program would begin when a boy of twelve years of age would enter an artist's shop as an apprentice. In two to six years he would have learned his craft. After serving his apprenticeship, he would go out as a journeyman, and after several years he could become a master. Eventually, he was able to establish himself as an independent artist. It should be noted that programs of this nature are in existence today, especially in the crafts areas.

The Academies

In addition to the guilds, in the middle of the sixteenth century, a different form of art education, the academy, surfaced. The academy underwent many changes as it developed, until it became firmly established by the end of the eighteenth century. The leader of the academies, the Ecole des Beaux Arts, founded in the seventeenth century, is still operating in France today. Academies of art also exist in this country. However, academic-style instruction reached its peak in the 1930s.

The program of instruction in the academies essentially was lecture, drawing, drawing, and more drawing. This program led to the formation of a definite set of rules for art students. These rules, much too numerous to mention, fell into the following categories: proportion, color, expression, and composition. In academic instruction sources from antiquity were unchallenged, even nature was *corrected* if it did not correspond to idealized Greek and Roman sculpture. Figure 1–1 of an antique class exemplifies the drawings done from plaster casts. Generally, students were kept under the steady supervision and influence of one master instead of studying under many instructors, as you do today. The goal of the student was to imitate the master; those who imitated most accurately were considered the exceptional students.

FIGURE 1–1
1926–27 class in cast drawing. Courtesy Cleveland Institute of Art Archives.

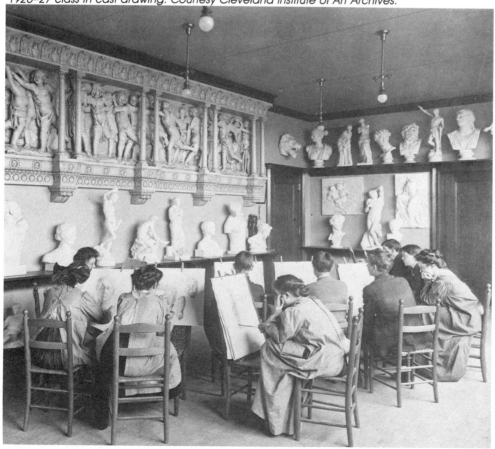

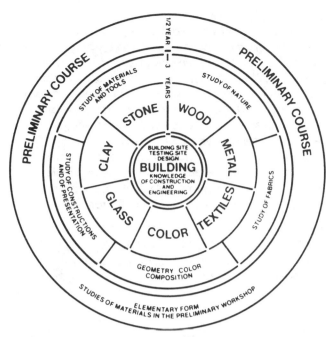

FIGURE 1-2
Bauhaus curriculum. Courtesy of the Busch-Reisinger Museum, Harvard University.

The Bauhaus approach. It would be impossible to address the history of foundation studies without being drawn to the early part of the twentieth century and to the German school, the Bauhaus. Bauhaus education has become synonymous with a series of fundamental exercises introduced as preparation for the applied visual arts courses to follow. Historically, the Basic Workshop approach constituted the first course in which the sole purpose was to develop the creative aspects of the student. It excluded the usual emphasis on teaching retainable knowledge or specific vocational skills. The students were not required or even encouraged to produce (premature) practical results, in-

stead, they were offered the opportunity to experiment freely with various ideas (concepts), materials, and tools within structured problems. In theory, the attitudes, knowledge, and skills acquired in the course would be carried over into an applied visual arts activity. Figure 1-2 outlines the Bauhaus curriculum. Bauhaus is important because of its influence on foundation programs in this country. Due to that influence most American college/university art and design departments as well as private schools of art and design agree that some exposure to the basics is desirable for their students during the first year.

Bauhaus has had much criticism in recent years. Many visual arts educators believe its philosophy and methodology is restrictive, dated, and invalid for students who plan to continue their studies in the area of fine arts. Although the criticism has some merit, I fear that the *baby has been thrown out with the bath water.* Instead of keeping what was valid and discarding the unsatisfactory elements, total programs were scrapped. It is still not generally understood that Bauhaus's major contribution to visual arts education was that it undertook the definitive educational step of forbidding the student to imitate the work of the teacher. The Bauhaus intellectualized visual education and developed a program that permitted the student to combine creative invention with the aesthetics of technology.

Elements and principles approach. Bauhaus methods were known in this country in the 1920s, and some Americans recognized a relationship between Bauhaus thinking and their own. However, much independent work was being done in an effort to upgrade basic art instruction throughout the nation. A prime example is the list compiled by a national committee on the arts in which they attempt to solve the problems of a visual vocabulary (see Figure 1-3). As

ELEMENTS AND PRINCIPLES OF DESIGN

FIGURE 1-3
Elements and Principles Chart. Courtesy McGraw-Hill Book Company.

Elements	Major Principles	Minor Principles	Resulting Attributes	Supreme Attainment
LINE	REPETITION	ALTERNATION	HARMONY	BEAUTY
FORM	RHYTHM	SEQUENCE	FITNESS	
TONE	PROPORTION	RADIATION		
TEXTURES	BALANCE	PARALLELISM		
COLOR	EMPHASIS	TRANSITION		
		SYMMETRY		
		CONTRAST		

early as the latter part of the nineteenth century, visual arts educators such as Arthur Wesley Dow realized that a basic structure was essential for teaching visual arts. In addition, art materials companies such as Milton Bradley and Prang published a series of textbooks for the elementary and secondary schools which firmly entrenched drawing and the elements and principles approach as the American foundation method. Accordingly, the assigned projects in these texts emphasized drawing (see Figure 1–5; it should be noted that *design,* in this case, refers to ornament and repeat pattern).

Many foundation courses today are still being taught by this method. The elements and principles approach is primarily a two-dimensional orientation: Each element and principle are isolated; the student experiences each and in turn theoretically combines them to create beauty or, to put it into the jargon of today, an aesthetically pleasing object. Several best-selling textbooks in today's market are based on this approach.

Closely related to the elements and principles approach is the nature approach. In this approach to foundation studies the instructor makes reference to the elements and principles as they are found in nature. Each assignment is solved with nature as the source. *Nature as the ultimate designer* is the creed. If the use of color is being studied, the student is told to refer to an insect wing, a stone, or a flower. Granted, nature is a valid source, especially in applied areas such as transportation, package design, etc., where the knowledge of bionics is essential. *Bionics* applies the understanding of a natural concept to a man-made product. For example, the manner in which a plant seedpod opens to distribute its seeds could possibly be applied to a packaging problem.

In the years following World War II a modified academic (elements and principles) approach or a modified Bauhaus approach was being practiced in essentially every college/university art and design department and private school of art and design in the nation.

Institute of Design approach. The modified Bauhaus approach, however, was thought to have become too modified. In an effort to return to the pure approach, a graduate visual education program was established in the early 1950s at the Institute of Design (ID) Chicago, the recognized successor to the

FIGURE 1–4
Title page for Art Education for High Schools, *c. 1908. Collection of Phil Rueschoff.*

ART EDUCATION
FOR HIGH SCHOOLS

A COMPREHENSIVE TEXT BOOK ON
ART EDUCATION FOR HIGH SCHOOLS
TREATING PICTORIAL, DECORATIVE
AND CONSTRUCTIVE ART, HISTORIC
ORNAMENT AND ART HISTORY.

THE PRANG COMPANY

NEW YORK CHICAGO BOSTON ATLANTA DALLAS

FIGURE 1–5
Table of contents for Art Education for High Schools. *Collection of Phil Rueschoff.*

Contents

		PAGE
ACKNOWLEDGMENT	III
PREFACE	V
CONTENTS	VII
CHAPTER		
I PICTORIAL REPRESENTATION	I
II PERSPECTIVE DRAWING	34
III FIGURE AND ANIMAL DRAWING	71
IV CONSTRUCTIVE DRAWING	103
V ARCHITECTURAL DRAWING	179
VI DESIGN	222
VII HISTORIC ORNAMENT	277
VIII ART HISTORY	303
INDEX	341

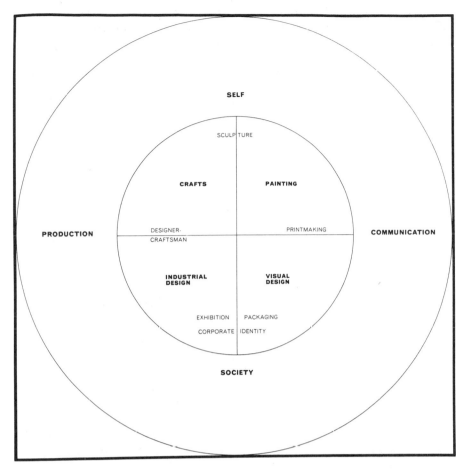

SELF

SCULPTURE

CRAFTS PAINTING

PRODUCTION

DESIGNER-
CRAFTSMAN PRINTMAKING

COMMUNICATION

INDUSTRIAL
DESIGN VISUAL
DESIGN

EXHIBITION PACKAGING
CORPORATE IDENTITY

SOCIETY

FIGURE 1–6
Institute of Design chart, c. 1964. Collection of author.

Bauhaus. Its purpose was to spread the basic educational philosophy of the Institute of Design and to avoid the misuse of ID projects whenever teachers adopted those assignments without apparently understanding the underlying philosophy of the assignments. This chart from an ID catalog of the mid-1960s is illustrative of the school's philosophy. The visual education program at the Institute of Design graduated many students, specialists in theoretical design, many of whom influenced the direction their school's foundation program would take.

Unstructured approach. Programs seemed to stabilize during the 1950s through the mid-1960s. However, by the late 1960s the *anything goes* attitude in the art world had made its way from the coasts to the campus. This unstructured approach became a major method of teaching foundation studies. The experiences ranged from *let's make a piece of art that tastes good* to the encounter group approach to the subject. In general, foundation programs, if they could even be called that, lacked continuity and were as different as the individual instructors. School catalogs often made statements about foundation courses, alluding to the fact that the strength of the "program" came from its diversity. During this period, in my opinion, foundation teaching and course con-

tent was at an all-time low. Very little progress was made toward refining the discipline.

Today's approach. Recently, however, there has been a national trend towards accountability and a return to the basics in general education. This trend seems to have carried over to the visual arts students, who are in large numbers asking for concrete information in foundation classes, or who are simply saying, "I want to get something for my tuition money." If my students are typical, and I believe they are, this demand for structure is increasing each year and will be still greater in the future. I do not mean to imply that visual arts education should return to the educational methods of the guild, the academy, or the Bauhaus or that it should continue with the recently popular unstructured approaches. They worked, some better than others in their time periods, but those methods will not be successful for you—the visual arts student of today. I must admit a bias towards the Bauhaus approach to visual education, since I am a graduate of the Institute of Design. However, this text has made a concerted effort to take what I consider to be the best elements of all of the above approaches and to put them into one course of study relevant to the present.

VISUAL REFERENCE CHART: A COLLECTION OF ARTIFACTS, 1850–1980

One of the major problems with foundation programs is the separation of and lack of association between studio courses and academic courses, specifically visual arts history. Even if these courses are taught simultaneously and a concerted effort is made to relate them, visual arts history tends to be taught in a chronological manner, beginning with prehistory and ending with a discussion of 1945 to the present in the last two class periods of the year. I feel that in order to relate what you are doing in class to the visual arts professions, you need an introduction to contemporary visual arts forms. It is not my purpose to *explain* the following images but only to show you that these images exist or existed so that you can make reference to them during this course of study. Constraints beyond my control made it impossible to include fine arts examples in the visual reference chart. They were excluded on the premise that those images would be more readily available to you than the following examples of design history.

The images have been compiled to give you a general idea of the visual images and forms of design since the Industrial Revolution, the beginning of the modern period. You need a common frame of reference when your instructor makes reference to a prairie style house, a '57 Chevy, or the IBM logo. Obviously, a device of this nature is highly selective, and the information must be supplemented with course work in art and design history. The chart includes a range of classic design objects. It also includes objects taken from popular culture since these are the objects you and I come in contact with in our everyday lives. The major divisions include environmental design, product design, and visual communication design. The stylistic periods are grouped to enable you to look at an object, in the environment, and place it within a decade or a period. Similarities between the different forms and images within a stylistic period—for example, a restaurant logo, a vacuum sweeper, and an architectural detail—should be obvious.

Why were these objects selected? With few exceptions these are industrially produced American products used by typical Americans of one specific time period. This is admittedly a limited point of view in that it tends to focus on the artifacts of the white, Anglo-Saxon, Protestant segment of our society. It excludes the many excellent hand-produced, one-of-a-kind utilitarian objects that have influenced our development as an industrial society. Within the constraints of this project it was impossible to accomplish more than an overview—a superficial view of the past and present.

The Rationale Behind the Selections

The architectural examples in the environmental design section are representative of structures that can be found in almost every town and city in the country. You should be aware that a style of architecture was generally not limited to a specific decade. For example, a Queen Anne style house could have been constructed at any time between 1880 and 1900. You should also recognize the relationship between the westward expansion of our society and architectural styles. While a Greek Revival style house was typical in New York during the 1850s, a sod house was typical in parts of the Great Plains. The interior views are shown to indicate how and where products were used in everyday life. I have emphasized living rooms, bedrooms, dining rooms, and kitchens since their functions have remained somewhat consistent from 1850 to 1980.

The items selected for the visual communication section include packaging, advertising, posters, and corporate identification marks (logos and logotypes). You will notice the close relationship between these areas in terms of stylistic imagery within a specific time period. An image such as the radiating sun of the 1930s was used on a variety of graphic products. The same thing is true today in that the grid is an image used in all forms of visual communication. Examples from the printed medium were selected for this section since these images were more readily available than video images.

In keeping with the theme of this chart, it was felt that any one of these images could be found in any of the houses shown in the environmental design area of the chart. These images were often used to promote products or were added to the labels or packages. Just as these images were found in the home, so were the products shown below.

The product section is divided into four broad categories: transportation, furniture, clothing, and consumer products such as toasters, microwave ovens, and toys. The items selected are self-contained products rather than component products; the product functions individually, not as part of a system.

In addition, I have selected products from the visual communication and product design areas that, with the cooperation of the corporations that produced them, have allowed me to pinpoint significant changes in the development of a product. These changes can be attributed to technological advances in materials and processes, as with the

Chevrolet, or to stylistic trends in terms of imagery, as with the Bell System logo.

Finally, I have included additional verbal information which has been included to enable you to relate social history events and personalities with the visual images of designers.

From the study of this information you should be able to formulate a mental visual image of, for example, an object produced during the 1880s, 1930s, or 1980s. The ready recall process I am asking you to develop is a process most of us use every day. However, you are most familiar with the process in terms of music identification. When you hear a song on the radio, you can probably identify the name and the artist or group within seconds. Let's try it with visual objects. Can you identify the period in which these objects were produced?

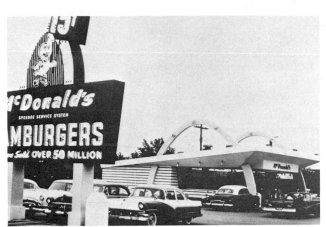

FIGURE 1-7
MacDonald's restaurant. Courtesy MacDonalds Corp.

FIGURE 1-9
Family portrait. By permission of F. Young, Sr.

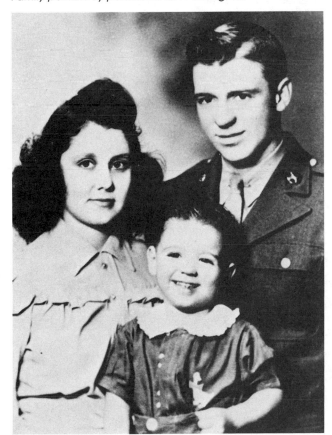

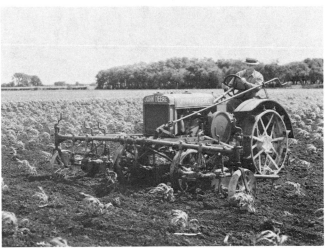

FIGURE 1-8
John Deere model D tractor. Courtesy Deere & Co.

FIGURE 1-10
Vienna cafe chair. Courtesy Thonet.

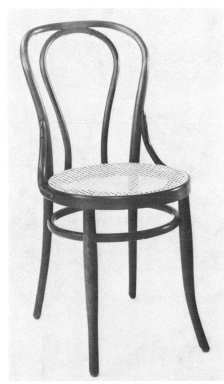

1850–1899

ENVIRONMENTAL DESIGN

1845–75 Italianate

1860 Early Victorian

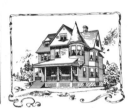

1854 Parlor

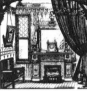

1880 Victorian Baroque

1885 Parlor view

1890 Queen Anne

1851 Crystal Palace
1869–1883 Brooklyn Bridge Constructed
1889 Eiffel Tower
1899 Carson, Pirie, Scott Building—Sullivan

PRODUCT DESIGN

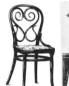 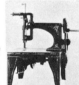

1850 Thonet *1851 Singer sewing machine* *1851* *1850 Henry Balter*

1867 *1869*

 1880

1876 *1887* *1874*

1887 *1884* *1890*

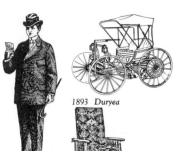

1893 Duryea

1897

1890

1895 Morris

1851 Roll-top desk
1853 Otis safe elevator
1859 Rotary motion washing machine
1860 Typewriter
1868 Tape measure
1869 Suction-type vacuum cleaner
1874 Cowboy boot
1876 Bell patents telephone
 Mimeograph
 Bissell carpet sweeper
1877 Ear muffs
1878 Phonograph
1881 Airbrush
1882 Electric fan
1884 Roller skate
 Adding machine
 Waterman fountain pen
1888 Kodak #1 Roll Film
 Rover Safety Bicycle
1889 Otis electric elevator
 Electric sewing machine
 Power dishwasher
1890 Rand inclined elevator
 Portable typewriter
 Ferris wheel
1894 John Deere tractor
1896 Diamond book matches
 Electric train toy
1897 Vending machine (gum)
1899 Motor-driven vacuum cleaner
 Golf tee

VISUAL COMMUNICATION

1850 *1860* *1870*

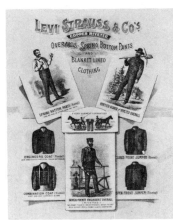

1880

1889

1894 Upjohn logo

1895 W. Bradley

1889 Bell logo

1858 Cigar band
1860 First colored pictorial can label
1865 Trade cards
1891 First fashion photos
1893 White Rock Beverages "Phyche"
1897 First advertising film, Admiral cigarettes
1898 First auto ad

SOCIAL HISTORY/TRIVIA

1850 Safety pin
 Chewing gum
 Magic lantern slides
1851 Borden's condensed milk
 YMCA
 Moby Dick
1853 Potato chips
 N.Y. World's Fair
1854 Ice-making machine
 Perry visits Japan
 First baby show
 Mason jar
1857 Gayetty's medicated toilet paper
1858 Pencil with attached eraser
1863 Butterick, first tissue-paper pattern for clothing
1861–1864 Civil War
1865 Alice in Wonderland
1866 YWCA
1868 Celluloid-first plastic material
 Nickel plating
1869 Transcontinental railroad completed
 A&P, first chain store

1871 The Chicago fire
 Half-tone process
 Oleo margarine
 Corrugated paper
1872 Picture postcard
 Montgomery Ward & Co., first mail-order house
1873 Linoleum
 Barbed wire
1875 Christmas card, L. Prang
1876 Tom Sawyer
1877 Ivory soap
1879 Incandescent light bulb
1880 Four-color printing process
 Canned baked beans in tomato sauce
 Combination Square-Starrett
 Paint from standard formulas, Sherwin Williams Co.
 First rodeo
1881 American Red Cross
1886 Horlick/Malted Milk
 Children's Playgrounds
1887 First appendix operation
1888 Induction electric motor, Tesla
1892 Naismith invents basketball
 World's Colombian Expo., Chicago
 Bottle cap
1893 Chicago World's Fair
 Shredded Wheat, first packaged breakfast cereal
 Wrigley's Juicy Fruit gum
1894 Wrigley's Spearmint gum
1895 Wireless telegraphy
1896 Rural Free Delivery
 Motion picture invented
 First auto accident
1898 Corn flakes
 Book matches
 Rayon
 Munsell color theory
 Spanish-American War
1899 Bayer aspirin
 First submarine

1900–1919

ENVIRONMENTAL DESIGN

1910 Builder's home

1913

1910 Georgian revival

1909 Robie House—Wright
1913 First Automobile service station—Gulf Oil Company

PRODUCT DESIGN

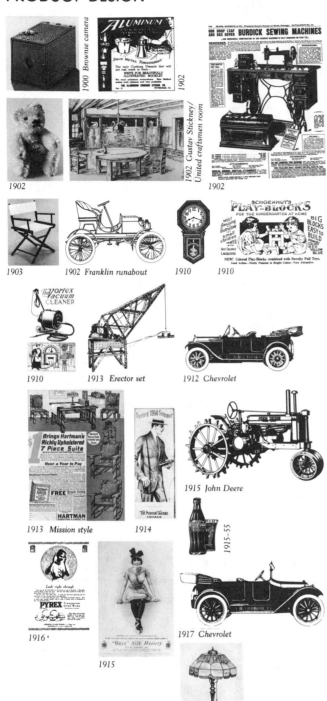

1900 Browne camera

1902

1902

1902 Gustav Stickney/ United craftsmen room

1902

1903

1902 Franklin runabout

1910

1910

1910

1913 Erector set

1912 Chevrolet

1915 John Deere

1913 Mission style

1914

1915-55

1916

1915

1918

1900 Motorcycle, Thomas Motor Co.
1901 Electric Christmas tree lights
 Acusticon, electric hearing aid
 Lionel Trains
1902-04 First gas-powered lawn mower
1903 Ford motor car
 Gillette safety razor
1905 Raleigh bicycle
1907 Thor electric washing machine
 Caterpillar tractor
1908 Model "T" Ford

1909 DeVilbiss spray gun
1910 Photostat
1912 Dixie cup
 Cessna Aircraft Co.
1915 Frigidaire
 "Tommy Gun" submachine gun
1918 Electrolux vacuum sweeper

VISUAL COMMUNICATION

1900 Bell logo 1903 1903

1905 1910 1912

1910-46

1910 M. Parrish

1914-22

1913

1914

1902 Buster Brown
1906 First radio receiver ad
1907 Christmas Seals

SOCIAL HISTORY/TRIVIA

1903 Wright Brothers, first flight
 The Great Train Robbery film
1904 Ice cream cone
1905 Plywood
1906 Radio tube invented
1908 Mutt and Jeff cartoon
1909 Thermosetting synthetic plastic
 Bakelite
1910 Rayon
 Boy Scouts of America

1911 Air Mail service
1912 First supermarket
1913 First assembly line
 New York Armory show
 Crossword puzzle
1914 Electric traffic light
 Prang colorant theory
 Panama Canal
1914–1918 World War I
1915 Panama Pacific Expo
1916 Ostwald Color Theory
1919 Bauhaus

1920

ENVIRONMENTAL DESIGN

1920 Georgian colonial

1920

1928 Bungalow

1928 American 4-square

1925 First motel
1925 Bauhaus Shop Block-Gropius

PRODUCT DESIGN

1920

1920 Chevrolet 1920 1920

1922

1924 Chevrolet

1925 1928
Westinghouse

1925–26 R.M. Schindler

1927 Chevrolet

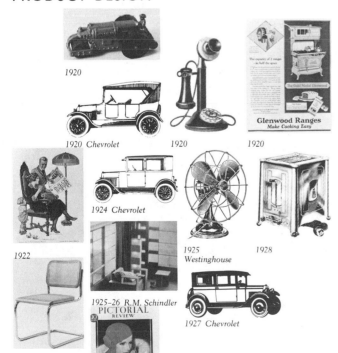

1928 Marcel Breuer

1924 Zeiss contact lens
1926 Toastmaster toaster

VISUAL COMMUNICATION

1920

1921 Bell logo

MORTON'S SALT

1920 1920

1923

1926

1928 Container
Corp. of America
logo

1928

SOCIAL HISTORY/TRIVIA

1920 Radio station begins regular broadcasts
1921 Insulin
 Valentino
1922 Eskimo Pie
 Tut-Ankh-Ament's tomb discovered
1924 Cellophane
 Chrome plating
1925 USS Saratoga, aircraft carrier
1927 Lindbergh's trans-Atlantic flight
 Synthetic vitamin D
 Industrial design as a profession
1928 Regularly scheduled TV broadcasts
 Commercially produced TV sets
 Mickey Mouse "Steamboat Willie" cartoon
1929 Stock Market crash
 Popeye

1930

ENVIRONMENTAL DESIGN

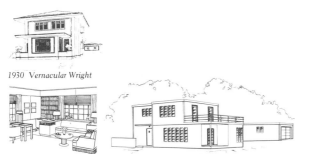

1930 Vernacular Wright

1939 Moderne-style living room

1939 Prefab house

1936 All-Glass windowless structure—Owens Illinois Glass Company

1936 Kaufman House-Wright

PRODUCT DESIGN

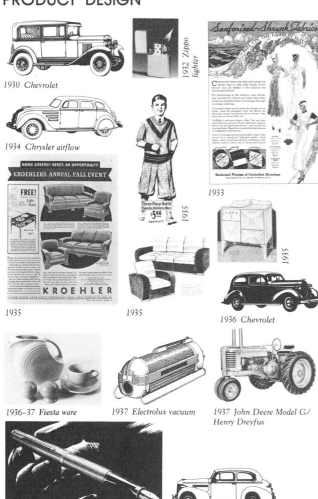

1930 Chevrolet

1934 Chrysler airflow

1932 Zippo lighter

1933

1935

1935

1935

1935

1935

1936 Chevrolet

1936–37 Fiesta ware

1937 Electrolux vacuum

1937 John Deere Model G/ Henry Dreyfus

1939 Parker 51 pen

1936 Chevrolet

1934 Burlington
Zepher streamlined train
1935 Kodachrome film
Parking meter
1937 Coldspot refrigerator
VW auto
1938 Dr. West's toothbrush (synthetic brissles)
1939 Electron microscope
Crosley auto (first mini-car)
Helicopter

VISUAL COMMUNICATION

1930 Cats paw logo

1930

1930

1930

1933

Hurricane Delight Coffee

1935

1939

1934

1934

1938 Henry Dreyfus

1939 Bell logo

1933 Petty illustrations, Esquire

SOCIAL HISTORY/TRIVIA

1930 First Stewardess
Pinball
Frozen food, Bird's Eye Co.
Jet propulsion
1931–1933 Monopoly
1931 Strobe light
1932 Legos
1933 Drive-in movie theatre
The New Deal
Bauhaus closes
WPA
1934 Laundromat
Famous Funnies comic book
1935 Flourescent tube
Kodachrome film
Beer in cans, Krueger Brewing Co.
1936 Lucite
1937 Nylon
Polystyrene
New Bauhaus, Chicago
1938 Minimum wage established, 25 cents
1939 Radar
Gone With The Wind
Colonel Sanders' first restaurant
ISCC-NBS color system

1940

ENVIRONMENTAL DESIGN

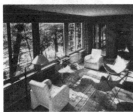

1943 Living room

1946 Cape Cod cottage

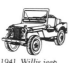

1947 Kitchen

1949 Prefab house

1941 *Quonset hut*
1948 *Solar-heated house*

PRODUCT DESIGN

1940

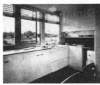

1941 Willis jeep *1942 Chevrolet*

1940

1946

1947 Eames

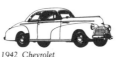

1948

1947 Chevrolet

1949 Model 500 telephone/ Dreyfuss Assoc.

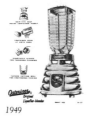

1949

1940 *Hardoy Chair*
1941 *Sikorsky helicopter*
1942 *XP-59 (first American jet aircraft)*
1943 *Ball point pen*
1946 *(Eniac) electronic computer*
1948 *Polaroid Land camera*

VISUAL COMMUNICATION

1940

1942

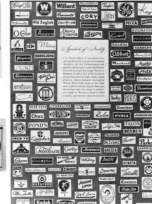

1948

1940s Container Corp. of America logo *1942* *1942*

1944 *1946*

1941 Vargas illustrations

1946 Paul Rand *1948* *1945 Alvin Lustig/Knoll*

SOCIAL HISTORY/TRIVIA

1939–1945 *World War II*
1941 *WNBT-TV station*
1945 *Atomic bomb-Hiroshima*
 Institute of Design, Chicago
 United Nations formed
1946 *Electric blanket*
1947 *Bikini swim suit*
 Tupperware
1948 *ABS Plastic*
 L.P. record
 Transistor
 Radial tires, Michelin
1949 *Gene Autry*
 Rudolph, the Red-Nosed Reindeer sung and recorded by Gene Autry for Montgomery Ward

1950

ENVIRONMENTAL DESIGN

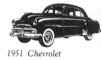

1955 Ranch house

1953 Dining room

1945 Geodesic Dome—Fuller
1956 Seagram Building—Van der Rohe

PRODUCT DESIGN

1951 Chevrolet

1953 1953 1953

1954 Eames

1954 Chevrolet

1955 Chevrolet

1955 Frigidaire refrigerator/ Raymond Lowey

1950 Herbert Matter

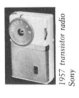

1956 Chevrolet

1955 Portable T.V. 1956 1957 Chevrolet

1957 transistor radio Sony

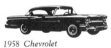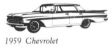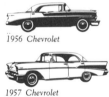

1957 Eames 1957 Saarinen 1958 Edsel

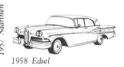

1958 Chevrolet 1959 Chevrolet

1950 Schick electric razor
1951 Univac 1 computer, Remington-Rand
1952 Video tape recorder
1953 Brunswick classroom furniture
 Tri-Taper luggage, American Tourister
1954 Home stereo
1955 Microwave oven
1956 Smith-Corona electric portable typewriter
1957 Electric wrist watch
1957 Boeing 707
1959 Barbie Doll

VISUAL COMMUNICATION

195_ Mc Knight Kauffler

1953 Catalog

1954 Alvin Lustig

1955 CBS logo

SOUNDBLAST

IBM

1957 IBM logo

DRINK SQUIRT THE QUALITY SOFT DRINK

1954 Squirt logo 1957

SOCIAL HISTORY/TRIVIA

1950 International Design Conference, Aspen
 Color Xerox
1950–1953 Korean War
1951 Dacron
1952 Number paintings
 Wash-and-wear clothing
1953 Playboy Magazine
 Saran Wrap
 Holiday Inn
 3-D movies, The House of Wax
1954 Racial Segregation Outlawed
 Hydrogen bomb
1955 Disneyland
1956 WAPQ-TV, all-color station
 Elvis
 Gene Vincent & the Blue Caps First rock group
1957 Sputnik
1958 Laser developed
 Hula Hoop
1959 Buddy Holly dies

1960

ENVIRONMENTAL DESIGN

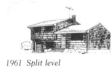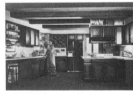

1961 Split level

1965 Kitchen

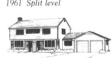

1968 Subdivision house

1967 Habitat—Safdie

PRODUCT DESIGN

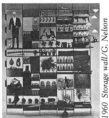

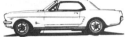
1961 Chevrolet

1962 Pentel sign pen

1960 Storage wall/G. Nelson

1962 007 ball chair

1964 Ford Mustang

1964 Instamatic camera

1964 Mighty dump/Tonka

1964 Chevrolet

1965 Chevrolet

1969 Chevrolet

1969

1960 Accutron electronic wrist watch
Xerox office copier
1961 IBM Selectric typewriter
1964 stacking chair David Rowland
1965 Trimline phone

VISUAL COMMUNICATION

1960 Container Corp. of America logo

1962 Westinghouse logo/Paul Rand

1965

1966

1964 Bell logo

1965 Mobil logo/I. Chermayeff

1966 Victor Moscoso/Junior Wells and His Chicago Blues Band. Collection, The Museum of Modern Art

1969 Bell logo

1968

SOCIAL HISTORY/TRIVIA

1960 Electric carving knife
1961 Manned space flight
1962 Unisex clothing
1963 Kennedy assassination
1967 Measure of Man, Dreyfuss
1968 Yellow Submarine
Martin Luther King assassination
1969 Man on the moon

1970

ENVIRONMENTAL DESIGN

1970 Town house

1975 living room/deck

PRODUCT DESIGN

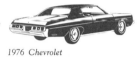

1973 Chevrolet

1976 Chevrolet

1973 Modular storage

1977

1977 Storage system

1978 food processor / Norelco

1979 double oven microwave range / Litton

1979 Sony

1979 Sof-Tech stack chair/ David Rowland

1975 Bricklin Safety Car
1976 Concorde supersonic aircraft
1977 Electronic games
1979 Gossamer albatross

VISUAL COMMUNICATION

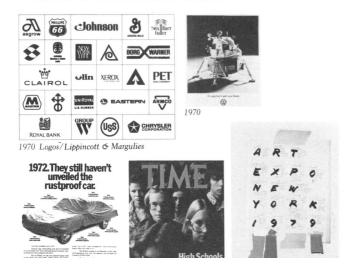

1970

1970 Logos/Lippincott & Margulies

1977

1979 I. Chermayeff

SOCIAL HISTORY/TRIVIA

1972 Cosmopolitan magazine
First Male pin-up, Burt Reynolds
1974 Human Scale 1–9-Different

VISUAL COMMUNICATION

1981

1981 Apple computer catalog

1981

1982

1983 AT&T
logo

1982

SOCIAL HISTORY/TRIVIA

1980 Space shuttle
1981 Pac Man

1980

ENVIRONMENTAL DESIGN

1980 Earth sheltered home

PRODUCT DESIGN

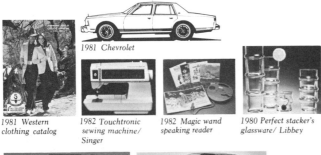

1981 Chevrolet

1981 Western clothing catalog

1982 Touchtronic sewing machine/ Singer

1982 Magic wand speaking reader

1980 Perfect stacker's glassware/ Libbey

1983 T-Bird Turbo Coupe

1982 Disc camera system/ Kodak

SUGGESTED READINGS

BAYLEY, STEPHEN. *In Good Shape—Style in Industrial Products, 1900–1960.* New York: Van Nostrand Reinhold Company, 1979.

BLUMENSEN, JOHN G. *Identifying American Architecture: A Pictorial Guide to Styles and Terms.* Nashville: American Association for State and Local History, 1979.

BROWN, EZRA, ed. *This Fabulous Century.* New York: Time-Life Books, 1969.

DE LA GROIV, HORST, and RICHARD G. TANSEY. *Gardner's Art Through the Ages,* 5th ed. New York: Harcourt Brace Jovanovich, 1970.

DOBLIN, JAY. *One Hundred Great Product Designs.* New York: Van Nostrand Reinhold Company, 1970.

Encyclopedia of Collectibles. Alexandria, Va.: Time-Life Books, 1978.

FEREBEE, ANN. *A History of Design from the Victorian Era to the Present.* New York: Van Nostrand Reinhold Company, 1970.

GIEDION, SIGFRIED. *Space, Time, and Architecture: The Growth of a New Tradition.* Cambridge: Harvard University Press, 1973.

HOLME, BRYAN. *Advertising Reflections of a Century.* New York: Viking Press, 1982.

JANSON, H. W. *History of Art: A Survey of the Major Visual Arts from the Dawn of History to the Present Day.* Englewood Cliffs, N.J.: Prentice-Hall, 1971.

KANE, JOSEPH NATHAN. *Famous First Facts.* New York: H. W. Wilson Co., 1964.

KEPES, GYORGY, ed. *Education of Vision.* New York: George Braziller, 1965.

KRON, JOAN, and SUZANNE SLESIN. *High-Tech.* New York: Clarkson N. Potter, 1980.

MIX-FOLEY, MARY. *The American House.* New York: Harper & Row, Publishers, 1980.

NAEVE, MILO M. *Identifying American Furniture: A Pictorial Guide to Styles and Terms: Colonial to Contemporary.* Nashville: American Association for State and Local History, 1981.

PULOS, ARTHUR J. *American Design Ethic.* Cambridge, The MIT Press, 1982.

RIFKIN, CAROLE. *A Field Guide to American Architecture.* New York: New American Library, 1980.

ROWLAND, KURT. *A History of the Modern Movement Art Architecture Design.* New York: Van Nostrand Reinhold Company, 1973.

SEALE, WILLIAM. *Recreating the Historic House Interior.* Nashville: American Association for State and Local History, 1979.

TAYLOR, JOSHUA C. *The Fine Arts in America.* Chicago: University of Chicago Press, 1979.

WINGLER, HANS M. *The Bauhaus: Weimar, Dessau, Berlin and Chicago.* Cambridge: Massachusetts Institute of Technology, 1969.

2 Perception/ Manipulation

CONCEPTS OF VISUAL PERCEPTION

After being involved with the visual arts for over twenty years, I suddenly realized that the fundamental aspects of the visual arts could be dealt with in the following manner. The visual artist deals with space. Generally speaking, a two-dimensional orientation lies between a flat decorative usage of space and a continuum of spatial devices used to create the illusion of space or the illusion of three-dimensionality. In contrast, a three-dimensional orientation deals with the placement of objects in space or the actual division of space. This may sound somewhat oversimplified. It will be elaborated on in following chapters.

First, one must experience and understand the basic components that comprise the working vocabulary of the visual artist. Once you have been exposed to these components, you can begin to manipulate

them to produce visual arts solutions. You will use these components in combination with concepts, and technical skills. In the following problems you will experience basic visual perception concepts. These concepts come from the research and experimentation of the Gestalt perceptual psychologists. Their research in visual perception gave important evidence about how the eye and brain organize visual information. Undoubtedly, visual artists have long been intuitively aware of these concepts. Visual artists or viewers do not interrupt their work or observation to analyze all of the details of why things are perceived as they are. Perception, as shown in Gestalt experiments, has proven to be relevant to visual arts problems in that it provides psychological support for the components visual artists use in their products. Also, it can be useful in building vocabulary, in evaluating visual arts products, and as a basis for constructive criticism.

FIGURE/GROUND

We begin our studies on the premise that we cannot see objects in a homogeneous field. In order for us to perceive we need a heterogeneous visual field that yields a figure/ground relationship. Figure/ground refers to our ability to distinguish an object from its general surroundings. We see by making comparisons —comparisons between figure and ground. What do you see in Figure 2–1? Once you perceive the figure

you will always see it. Each of us tends to perceive a given situation differently. This is due to the variety of factors that make up our frame of reference. Perception can also depend on what we expect to see or what we want to see. Think of how individual eyewitness accounts of a crime tend to vary. Could that be why our society developed trial by jury? Let's begin our studies with an exercise in creating heterogeneous fields.

FIGURE 2–1

American Journal of Psychology *by Dallenbach. Vol. 64. Copyright 1951. Reprinted by permission of the University of Illinois Press.*

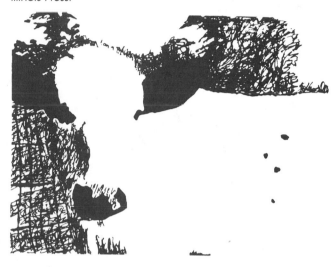

PROBLEM 2–1: Figure/Ground Studies

Materials: Illustration board
Size: 15″ × 15″, 3″ border, all sides
Medium/Tools: Ruling pen, india ink, black paper, rubber cement, T-square, triangle, X-acto knife with #11 blades
Task/Considerations: Divide the work area into a 1½″ simple grid. The object of this problem is to

achieve the strongest figure/ground relationship possible in each section of the grid. This is to be accomplished by placing a shape or grouping of shapes in each section of the grid. Experiment with different shapes, sizes, and positions within each individual square.

Figure/Ground Factors

Here are some factors to consider in working with figure/ground relationships. It should be noted these factors are not hard, fast rules to follow but generalizations based on research and observation.

The ground is usually larger and simpler than the figure. The smaller an area, the greater the probability it will be seen as figure (Figure 2–2).

The figure usually appears to be on top or in front of the ground even though the figure and ground are in the same physical plane (Figure 2–2).

Convex shapes tend to be figure and concave shapes tend to be ground (Figure 2–3).

Unbroken shapes tend to become figures and segmented shapes tend to become ground (Figure 2–4).

What dominates the eye is considered the figure;

FIGURE 2-2
D. Kareken.

FIGURE 2-3
D. Kareken.

FIGURE 2-4
D. Kareken

FIGURE 2-5
D. Kareken.

FIGURE 2-6
D. Kareken.

FIGURE 2-7
D. Kareken.

FIGURE 2-8
Porch railing, Murfreesboro, Tn.
F. Young, photographer.

more passively displayed objects take on the role of the ground (Figure 2–5).

Darker colors tend to form figure (Figure 2–2).

The enclosed surface tends to become figure, whereas the enclosing one tends to become ground (Figure 2–3).

Placement of a shape at the top or bottom of the frontal plane can determine whether the space is perceived as figure or as ground (Figure 2–6).

Figure and ground of the same or nearly the same area tend to become ambiguous (Figure 2–7).

Alternating shapes tend to create figure/ground ambiguity (Figure 2–7).

Do you see arrows or hearts in Figure 2–8?

What can be learned from observation and analysis of Problem 2–1? (See Figures 2–9 and 2–10.) Cut a square mask and view each section individually. Why is a strong figure/ground relationship desirable? After my students discussed the advantages of a strong figure/ground relationship, they generally agreed that a strong figure/ground tends to create

visual excitement and attracts the attention of the viewer. Since figure/ground relationships are basic, they felt that compositions strong in this concept tended to give psychological comfort. As viewers we tend to simplify what we see. As visual artists we are often searching for an economy of means to communicate our message, and strong figure/ground relationships give us simplicity of communication. Weak figure/ground relationships tend toward ambiguity.

Can an ambiguous figure/ground relationship be beneficial? Not generally. However, in the visual identity illustration for Memorial Mall (Figure 2–11), the ambiguity is effective in that the image could conceivably be perceived in as many as three ways. The total image could be read as an **M**; the top and bottom black figures could be read as **M** over **M**; or the positive and negative elements read as **M** over **M** over a wavy line.

Does your image work as a total composition, even though it was not intended to? Could you work in each section and still control the total effect if you had too? Let's try another figure/ground problem, one that emphasizes the importance of the positive/negative aspects of the figure/ground relationship.

FIGURE 2–9
Figure/Ground. E. Bowen.

FIGURE 2–10
M. J. Sahl.

FIGURE 2–11
H. Aguet. Memorial mall visual identity.

PROBLEM 2-2: Positive/Negative Expansion

Materials: Illustration board
Size: 15″ × 20″, 3″ border, all sides, 9″ × 14″ black paper
Medium/Tools: Black paper, rubber cement, x-acto knife, T-square, triangle
Task/Considerations: Draw a 6″ square or a shape of a comparable area within the borders of the black paper. Cut out and discard the shape. You now have formed a positive

negative relationship. Expand on this relationship by sectioning (cutting) shapes from the perimeter of the square and positioning them in the negative shape along the axis of the cut. Be prepared to deal with the mirror images that are produced in some instances. Once a shape has been sectioned you may want to section it further. Repeat the process until you make use of the total work area.

FIGURE 2-12
John Davis.

FIGURE 2-13
H. Aguet. Logo—Country Wood Mall.

Figure 2-12 shows one method of solving the problem. The same concept was used for the shopping mall logo in Figure 2-13.

EVALUATING THE COMPOSITION

You have just completed a composition problem. The key phrase in the expansion problem was *make use of the total work area*. This did not necessarily mean that every square inch of the work area had to be covered. What is a good composition? This is a fundamental issue in this course of study and a question you

will deal with for the remainder of your career as a visual artist. It is a very personal and subjective decision. Contemporary visual arts has no hard, fast rules for evaluating the structure of a composition. The visual artist takes pride in being an individual. Yet, some standards need to be set, especially for beginning students. These are often set by a consensus of opinion; however, you have the option to accept or reject that opinion.

What determines a successful composition? Why were the following compositions shown in Figures 2-14, 2-15, and 2-16 considered successful by the visual artists who produced them?

FIGURE 2-14
Leonard Koenig. Compare and Contrast.

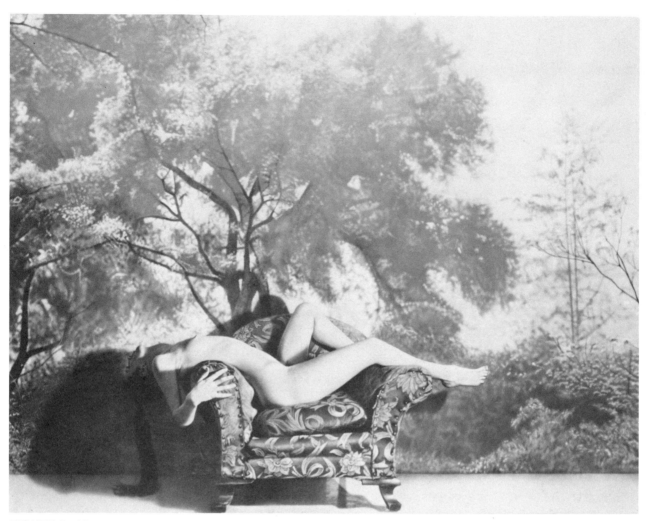

FIGURE 2-15
Jerry Ott. Carol and the Paradise Wall. *1972. Courtesy Walker Art Center.*

FIGURE 2-16
Jean E. Harmon-Miller. Wichita Wall.

Compositional Components

What are the components of a successful positive/negative spatial relationship, or composition? It must make a maximum usage of the positive/negative space or area. A checkerboard makes maximum use of the space, but is it aesthetically successful? Checkerboards do not tend to hold the viewer's interest for any length of time. A successful composition should not only make good use of the space, but it should also be visually interesting. How do you create a visually interesting composition? One method is to have a visual balance between positive and negative areas. *Balance* may be defined as a pleasing, harmonious relationship between positive and negative, that is, a relationship with which you feel comfortable. Balance may be achieved when one area of visual dominance in the composition is combined with other areas taking on a subordinate role. For example, a small positive area may visually balance a negative area of a much larger physical size as in this painting (Figure 2-17).

FIGURE 2-18
D. Graves. Frank's '51 Chevy. 1977. D. Kareken, photographer.

FIGURE 2-17
Clyfford Still. Untitled. 1950. Courtesy Walker Art Center.
Eric Sutherland, photographer.

Since the advent of abstract expressionism there has been a tendency for visual arts educators to prefer and consequentially require informal or asymmetrical balance. Perhaps one reason for this action is that beginning visual arts students tend to produce formally or symmetrically balanced compositions that can be visually boring. This is not to say, however, that formal or near formal balance can't be visually exciting. To be exciting, formal balance must be handled in a sophisticated manner as it is in the professional examples shown in Figures 2-18, 2-19, 2-20, and 2-21.

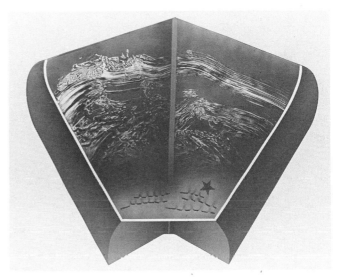

FIGURE 2-19
Leonard Koenig. Dream Space Series. Unit IV.

FIGURE 2-20
Frank Stella. Tahkt-I-Sulayman Variation II. 1969. Courtesy The Minneapolis Institute of Arts.

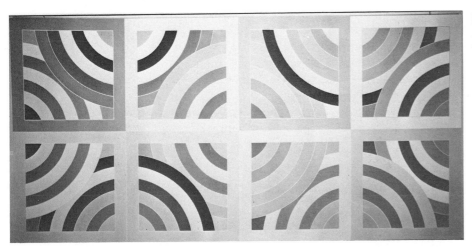

FIGURE 2-21
Robert Tobias. Construction Painting. 1975.

Consistency

Another factor to consider in determining the success of a composition is consistency. Does the composition work as a whole, as a unit? Is it logical? Does one section seem out of character with the rest of the composition? Do the areas of the composition relate to each other in shape, size, and proportion? Is the composition divided by conflict? It should be noted that a small amount of conflict within a composition can make it more interesting. Too much consistency or predictability leads to monotony. Do you find this composition monotonous? (Fig. 2-22)

Attraction/Communication

A successful composition should attract the viewer. What's more, it should communicate its purpose or intent. It is to our advantage to make our purpose clear or evident to the viewer, as was done in Figure 2-23. Remember, the visual artist is rarely present to explain the intent to the viewer. What did this photo postcard (Figure 2-24) communicate to the recipient? Often visual arts products are misunderstood or ignored because the viewer does not clearly see its purpose or intent. For instance, the purpose of an advertisement is to sell a product. If the message to buy is muddled, unclear, or misinterpreted, the product probably will not sell as expected. Can you tell the purpose of the advertisement in Figure 2-25?

Generally, we are more comfortable with an orderly composition rather than a chaotic or visually unappealing one. However, there are exceptions to every rule. Many visual arts products have gained considerable success, despite being considered displeasing.

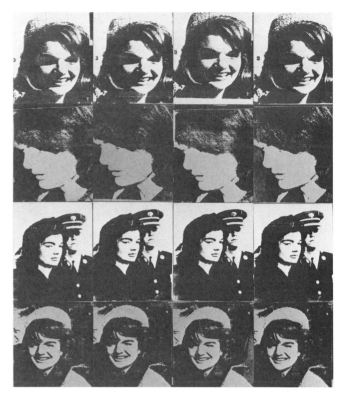

FIGURE 2-22
Andy Warhol. 16 Jackies. 1964. Courtesy Walker Art Center.

This may seem like a contradiction. But visual imagery must be judged by the success of the visual artist in communicating a specific concept. The motivational factor that led the visual artist to produce the work influences its image and form. How do you react to the composition in the painting? (Figure 2-26) However, lack of technical ability may also be responsible for a visually unappealing composition. Visual artists, like all people, have limitations. Often these are limitations of a medium, a technique, or a process. The quality of the work, the craftsmanship, may affect how we evaluate a composition. Be aware that what may appear to be a lack of craftsmanship and technique may be intrinsic limitations of the method by which the visual artist chose to express himself or herself.

Many factors need to be considered before starting to work on a composition, and an important one is the choice of materials, the medium or media in which to execute the composition. What will best communicate the intent of the composition? Are these choices logical? What type of imagery should be used? What process? Do you have the technical ability to make it successful?

All of these factors influence a composition. However, we tend to go one step further and make an aesthetic decision; we decide we like it, or we do not like it. A composition could be considered very successful, yet the viewer might still not like it or want to live with it. The opposite could equally be true.

FIGURE 2–24
Postcard of soldier. Collection of author. Photo D. Kareken

FIGURE 2–25
Roberto Robledo ad. M. Wahlquist, photographer.

FIGURE 2–26
Robert Raushenberg. Trophy II (For Teeny and Marcel Duchamp). *Courtesy Walker Art Center.*

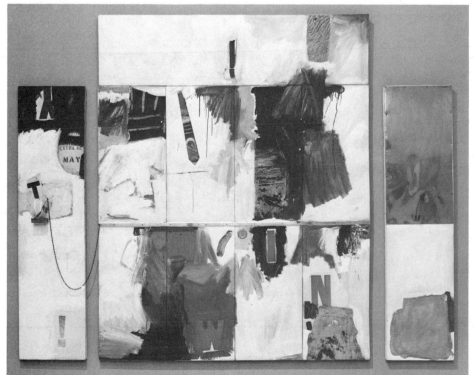

Methodology

Perhaps, then, an objective method for determining whether a visual arts product is successful would be helpful at this time. Theoretically, any visual arts product can be evaluated and decisions made relative to the work in the following manner:

Develop an objective inventory. This is factual information: What shapes, colors, and textures were used by the visual artist? How many elements were used? What was the proportional relationship between elements? In what way were they used? What medium or media were used?

Make a comparative judgment. How does this work compare with other paintings, sculptures, posters, films, or comparable items? Is it original? Is it obvious? Does it challenge you to think, to question?

How was the medium handled? What problems did it attempt to solve? Did it solve the problems or were they left unresolved? What concepts were explored? Is there a concept that explains the work?

Formulate your thoughts in terms of perception. How do you react to the work subjectively? This judgment is primarily based on your frame of reference, your interest in or preference for specific colors, shapes, visual relationships, imagery, and so on. This is your reaction to and interpretation of the visual image, connotation, and intent of the visual artist.

By being objective and visually literate you can determine whether a work is or is not successful. At that time you may add your perception—your interpretation of the work—and determine whether or not you like it.

Let's try a less abstract problem to expand our composition/communication skills.

PROBLEM 2-3: Positive/Negative Character

Materials: Illustration board (two pieces)
Size: 7½″ × 9″, work area 5½″ × 6½″
Medium/Tools: Black pressure-sensitive film, X-acto knife, burnisher
Task/Considerations:

PART 1: Select an individual character from a type sourcebook, newspaper, or magazine. It is suggested this character be of a bold-face, family of type. Enlarge the character to an 8″ height. Transfer the character to black pressure-sensitive film. Cut out the character,

making sure to save the counters and exterior negative areas. Position the character in the work area. You may work in a vertical or horizontal orientation. When the area outside the work area is cut away, the character should be recognizable.

PART 2: Position the counters and exterior negative areas within the work area. This time change the orientation. The character should also be recognizable even in its negative form. (See Figures 2–27 and 2–28.)

FIGURE 2–27
P. Rynkiewicz

FIGURE 2–28
P. Rynkiewicz

Which part is stronger? More easily recognizable? After completion of Problem 2-3, my students generally felt that a strong figure/ground contrast helped to communicate the identity of the character, whereas ambiguity tended to make recognition difficult. In addition, familiarity with a typeface aids in recognition. Our frame of reference also influences recognition; in this case, we are accustomed to seeing black type on white paper. During critiques the positive character placed adjacent to the negative character helped to define the negative character. The students also felt the position of the character, or composition, was important; the essential portions of characters were needed for recognition, and this was achieved by comparing and contrasting characters. Perhaps a more important factor was that we were all expecting to see a type character instead of other images, such as a man's face or a cat. It would be interesting to compare observations between students who had no visual arts experience and your visual arts class. Do you think the results would be different?

PROXIMITY

Return to your solution to Problem 2-1. How does it stand as a total composition? What do you see? Are any groupings formed? These groupings are due largely to a pair of concepts known as proximity and similarity. Proximity, or nearness, is the most basic form of spatial organization. When objects or visual units are close together the viewer tends to group them.

The closer two or more images are, the greater the probability that they will be perceived as a group or pattern. Compare the top and bottom halves of the record cover in Figure 2-29.

Proximity is not limited to the spatial arrangement of images. It also applies to time. Examples of this can be found in slide presentations, motion pictures, and television. Generally, films and videotapes are edited so their projected images will tend to be grouped by the viewer. Events that occur in close proximity in time and space tend to be grouped together. When images are perceived as grouped, we see the whole and not the individual images that form the whole. We associate images in proximity to each other, and we tend to compare and contrast the images in an effort to organize the information.

Proximity Factors

Trace your solution to Problem 2-1, identify the situations where proximity is functioning. Several factors need to be considered when dealing with proximity:

Proximity is the simplest condition of organization.

Proximity strengthens the force of attraction between parts.

When proximity is evoked it results in stable, coherent figures.

Note, proximity may be overpowered by similarity, as in Figure 2-30. Think about situations where you have noticed proximity being used; some examples might be parking lots and furniture arrangements.

FIGURE 2-29
J. Albers. Persuasive Percussion.

FIGURE 2-30
D. Kareken, illustrator.

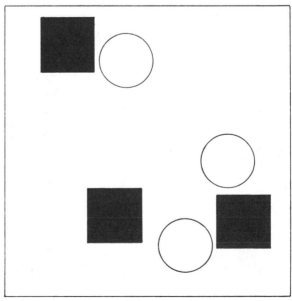

FIGURE 2–31
D. Kareken, illustrator.

The Chinese have a visual puzzle (Figure 2–31) that has been successful primarily due to proximity. The puzzle tends to increase the powers of observation by discovering the similarities between abstract geometric and natural forms such as the illustration of a scorpian in Figure 2–32. The same concept is applied to the poster in Figure 2–33. This process helps you to comprehend abstraction, which is essential in the study of visual symbols such as those used in signage (Figure 2–34).

We have often made use of proximity, possibly without even being aware of it. Throughout time individuals have looked at a star-filled sky on a clear night and have been able to perceive such configurations as Orion's belt and the Big Dipper in the constellations. It is our nature to do so. We have a perceptual need to group and complete units into wholes and a psychological need to make something recognizable and familiar out of the unknown. Other examples of consciously applying subjective values is seeing things in the flames of a fire or the clouds in the sky. This need to make known from unknown occurs with many people when they view an abstract or nonobjective visual arts product. The first reaction is, "What is it?" or "I don't understand it." Later, after scanning for visual organizational clues, they might say, "See the cat?" or "the man's face?" Can you see anything in the image in Figure 2–35?

What meaning does this have for the visual arts students? Viewers need to feel familiar or comfortable with what they are interacting with, be it an advertisement, a painting, or an interior space at home. Familiarity with abstract or nonobjective images comes with continuous exposure to visual arts products or with extended visual education, be it formal or informal. As visual artists we can aid the viewer's comprehension by controlling basic organizational clues through proximity and its companion, similarity. If you know how the viewer most generally will group visual images, you can then arrange the images in a manner that will either enhance or detract from certain groupings or conclusions drawn on the part of the viewer.

FIGURE 2–32
C. McRae. Scorpian.

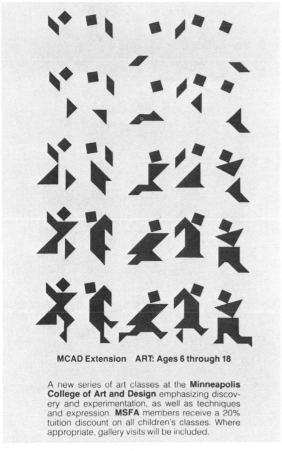

MCAD Extension ART: Ages 6 through 18

A new series of art classes at the **Minneapolis College of Art and Design** emphasizing discovery and experimentation, as well as techniques and expression. **MSFA** members receive a 20% tuition discount on all children's classes. Where appropriate, gallery visits will be included.

FIGURE 2–33
MCAD extension. Courtesy Minneapolis College of Art and Design Archives. Photo: D. Kareken.

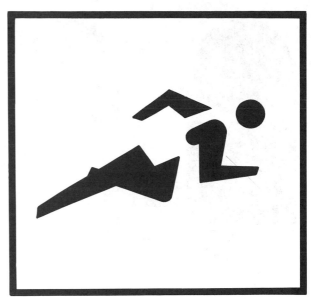

FIGURE 2–34
Tokyo Olympics symbol.

FIGURE 2–35
Newspaper photo of mountain range in Japan.

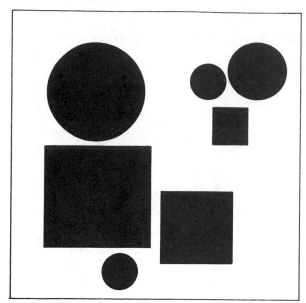

FIGURE 2–36
D. Kareken, illustrator.

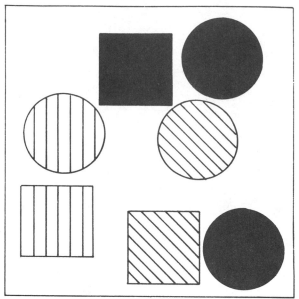

FIGURE 2–37
D. Kareken, illustrator.

SIMILARITY

Similarity is conceptually very simple. It is concerned with the descriptive qualities of an object. Such descriptive qualities as size, shape, color, orientation, texture (surface quality), and value may produce the tendency for images to be grouped together, to be seen as related. What qualities cause the grouping in Figure 2–36? Generally speaking, opposites repel and similars attract and form groupings, which are then completed as wholes. These grouped or related images may be perceived as pattern in nonfigurative images.

Similarity Factors

Here are several additional considerations when exploring similarity:

> Similar qualities of objects tend to form groupings.

Some qualities are stronger than others; for example, similar texture or dissimilar shapes could still unify the composition (See Figure 2–37).

Similar qualities unify whereas dissimilar qualities tend to separate a composition. However, it should be repeated that too much similarity tends to become monotonous, and too little tends to become chaotic. You need to develop a sensitivity to a balance between the two.

Similarity is a stronger force than proximity in perceptual grouping. Visual artists often use symbolic associations to evoke similarity resulting in grouping.

From the information given above it is time to experiment with similarity and proximity.

PROBLEM 2-4: Visual Distribution

Materials: Illustration board (two pieces)
Size: 15″ x 20″, 3″ border, all sides
Medium/Tools: Black paper, bow compass with circle cutting blade and inking attachment, rubber cement, india ink, various materials to provide values, color, textures, etc.
Task/Considerations:

PART 1: Without using a grid structure, arrange nine closed circles, each of a different size,

within the work area. The circles may touch, but may not overlap.

PART 2: Transfer the layout in part one to a second board and draw the circles in an open manner. Using value, texture, color, and such, alter the composition so that different groupings will be perceived. You may want to try several solutions to this part. See how different you can make the two parts appear. (See Figure 2–38 in color insert following page 50.)

During critiques, put up your two solutions in the same orientation but in different parts of the classroom. Try to find the matched pairs. In trying to match the two parts of the problem, it seems to be easier to go from a black image (Part 1) to a colored or textural image (Part 2) than vice versa. I assume this is because the black and white image is stronger and simpler. Many students have found it easier to recognize and match the sets if they mentally "blocked out" such factors as color and texture in part 2 and just concentrated on the shapes. The choice of material, medium, and technique may alter our perceptions. What ways have been used to *alter* our perception of an image other than the obvious methods mentioned in the assignment?

Why is it important to be able to control perceptions as you did in Problem 2–4? The most obvious reason is to sell an idea. This concept is nothing new. During the Middle Ages and the Renaissance the Church commissioned artists to paint the stories of Christ, to sell the idea of Christianity to an illiterate public. There is a positive correlation between the structure of the visual image and how it is perceived by the viewer. The same thing is being done today with toothpaste, automobiles, or insurance, though today a majority of the public is only visually illiterate.

We have discussed methods of controlling the viewer's perception of a composition. Still another aspect of this is being sensitive to the amount of information needed in the composition. One of the most common shortcomings of students is knowing when a composition is completed. This will be addressed in the next problem.

PROBLEM 2-5: Complexity

Materials: Illustration board
Size: 15″ × 20″, 3″ border all sides
Medium/Tools: India ink, ruling pen, X-acto knife, paper, rubber cement, bow compass with circle cutting blade, T-square, triangle
Task/Considerations: Select three achromatic colors (without color, see page 51). Use one for the ground. Draw a 1″ simple grid over the work area. Add shapes to the work area. The shapes are to be squares or rectangles of any size that fit the grid lines or circles (2″, 4″, 6″, or 8″ diameter) that are centered on the grid lines. These shapes are to be cut from the additional achromatic paper stock. As many shapes as desired may be placed within the work areas. They may touch and overlap. You may want to do more than one solution. (See Figure 2–39.)

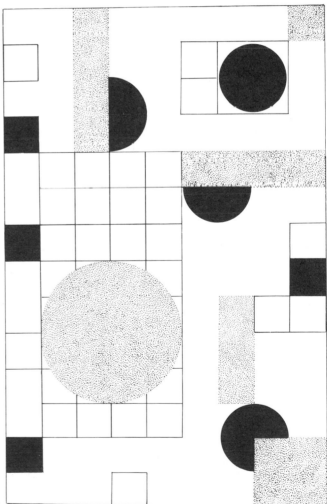

FIGURE 2–39
Student unknown. L. Moran, illustrator.

FIGURE 2-40
Donaldson's billboard. 1982. S. Hammack, photographer.

When you finish, compare and contrast your solution to others in the class. Are any of them busy or overworked? Chaotic? Too simple or sparse? Boring or monotonous? Cold, clean, or sterile? Uninteresting? Perhaps some of these terms need elaboration. *Busy* tends to have a negative connotation. However, it should be noted that many busy works have been considered successful simply because of the organization of the image. *Overworked* is also most commonly accepted as a negative factor. The image has been pushed too far. Too much was done that was not needed. *Chaos* simply means disorder. *Cold* and *sterile* have negative connotations for some individuals. The typical comment is, "This work belongs in a hospital, not a school of visual arts." This may mean the visual image is too organized and leaves nothing to interpretation by the viewer. This is a very subjective area and depends on the individual's preference. In composition we are dealing with a double threshold. There is a stopping point and until it is reached, it's not enough; after that it's too much.

CLOSURE

Becoming sensitive to how much visual information to include in a composition and also how much to leave out is a primary concern of another perceptual concept: *closure.* How much can you omit or subtract from an image and still have the image remain rec-

ognizable? A Minneapolis department store was confident its name would be recognized even though most of it is covered by the illustration (Figure 2-40). Remember how much of the character you cut away in Problem 2-3? Closure is the tendency of the viewer to fill in the spaces in an incomplete visual image in order to make that image visually comprehensible, to mentally complete the image from given clues. Closure is experienced when a group of separate

FIGURE 2-41
H. Aguet. Visual Identity Mark-Golden Triangle Mall.

shapes is recognized as part of a complete visual image. Often the visual artist simplifies an image by omitting areas and letting the viewer complete the image, thereby involving the viewer, as in the visual identity mark in Figure 2–41 and the logo types in Figures 2–42 and 2–43. This involvement tends to challenge the viewer to think. Several years ago I read about the failure of the first cake mixes in Dick Zakia's *Perception and Photography.* It think it bears repetition. Studies were undertaken to determine why the cake mixes were economic failures. It was found that the product failed because it left nothing for the cook to do except bake the cake. Cake mixes became widely accepted when they were changed to require the cook to participate in the process by cracking, adding, and mixing an egg into the mix. In short, if you make the user or viewer a participant, you lessen the odds of failure to communicate.

It should be noted that too much of the image (too much information) can be omitted, in which case the image becomes ambiguous and the message difficult if not impossible to comprehend.

FIGURE 2–42
K. U. Alumni Association logo type. Courtesy Kansas. University Alumni Association.

FIGURE 2–43
Procolor logo type. Courtesy PROCOLOR.

Closure Factors

Some factors to consider when working with closure are:

> Similarity in orientation, color, and shape influence closure.
>
> Proximity is primarily responsible for closure.
>
> The greater the distance between shapes, the more difficult it is to create a closure. This creates more tension.
>
> An enclosed area tends to become figure, and the enclosing shapes tend to become ground. However, there can be closure with an ambiguous figure/ground relationship.
>
> If the configuration formed by closure is complex, it is harder to perceive than a simple configuration.

Conceptualizing Closure With Symbols

Keeping the concepts of closure and complexity in mind, I would like you to develop a symbol. It should be remembered that symbols are exclusively human creations that have in part enabled us to communicate. However, one needs to know the code or language to understand a symbol. A symbol does not have to resemble visually what it is standing for. This is because the meaning is ascribed or assigned to the visual image by common consensus. This results in a consensual symbol. There exist throughout the world consensual symbols that can no longer be interpreted or read because no one who knows the meaning of the symbol is left alive or is in contact with the reader. There are consensual symbols that we can interpret, such as the color pink for baby girls and blue for baby boys. We (the society) agree to the meaning, and we keep it as such. Symbols may be highly ambiguous because each individual has learned to recognize and give his own meaning to each symbol. For example, the yellow light in a traffic signal encourages one driver to slow down and another driver to speed up and get through the intersection. As a visual artist you should be aware of conventional symbols and use them correctly. If you stray too far away from the accepted meaning, if you are too esoteric, you increase the odds of failure to communicate.

PROBLEM 2-6: Symbol

Materials: Illustration board
Size: 15″ × 15″, 3″ border, all sides
Tools/Medium: Open
Task/Considerations: Develop a symbol for the first-year program (if you are not in a program, do it for your class). This is to be executed in one color on a background. If chromatic color is not essential to your symbol, use black and white.

In developing the symbol you need to be detached and objective, yet knowledgeable enough of the subject to develop a meaningful visual image. Information about the subject is acquired through research. The school catalog is a good place to begin since it generally gives the intent of the program. General reference works such as a dictionary or encyclopedia can be useful. An excellent method for gaining information is the interview technique. Interview more advanced students, faculty, administrators, peers, and last but not least, yourself. Document these interviews. What do you think and feel about the first-year program. How can you communicate your information? How can you translate the verbal information into a visual image? Think of the purposes of the symbol:

> To give information about the program
> To project a positive image

To be associated with the first-year program and its students

To be easily recognized

To communicate the concepts of the program

Can you think of other purposes for the symbol? Figures 2–44 and 2–45 show two very different solutions to the problem.

The above items could be the basis of the evaluation and critique discussion. Once you become aware of how a certain result is achieved—through a concept such as closure, for example—then you can deal with a problem in which the solution calls for an understanding of the antithesis of the former concept. Such is the case in the next two problems.

FIGURE 2–44
Doug Dobbe.

FIGURE 2–45
E. Bowen.

PROBLEM 2-7: Sum of the Parts

Materials: Illustration board
Size: 15″ × 20″, 3″ border, all sides
Medium/Tools: Black paper, X-acto knife, rubber cement
Task/Considerations: Develop a shape composed of a minimum of fifteen modules. Each module is to be identical in shape, size, and color. The modules are to fit together without

any cracks or space between them. It is suggested that the module be able to interface from more than one orientation; for example, it could be of an *interlocking* type. Do not share your work with your classmates. View this composition from a distance or view a photostat of the composition and then ask your classmates to identify the original module.

It might be helpful to consider the following factors when attempting to identify the individual module:

- Repetition of contour
- Negative space
- Contrast/variation of contour
- Placement/orientation
- Size
- Reduction to simplest form

Can you identify the modules used in Figures 2–46 and 2–47? They are included in Figure 2–48. Figure 2–49 is an excellent example of the use of positive and negative areas within one module, making it nearly impossible to identify the individual module.

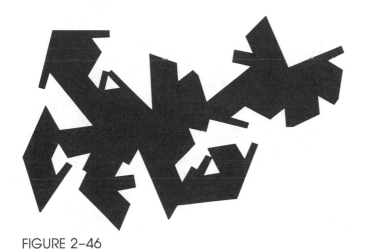

FIGURE 2–46
Student unknown (Mod #4).

FIGURE 2–47
S. Mars (Mod. #5).

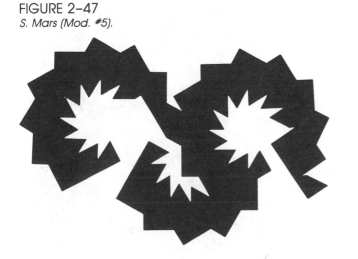

1.
2.
3.
4.
5.
6.
7.
8.
9.
10.
11.

FIGURE 2–48
Visual test to identify modules.

FIGURE 2–49
D. Byers.

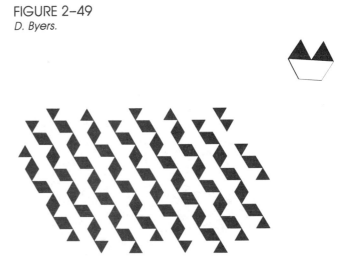

VISUAL DECEPTION

Camouflage could be called the art of visual deception. It consists of images being arranged in such a way that they are grouped together and lose their individuality or they blend into the background and lose their identity. We are all aware of nature's way of protecting some species and aiding others by means of camouflage. Predatory species blend with their natural backgrounds in order to catch their prey, while passive species must blend with their environment to keep from getting caught. Nature relies on visual confusion in form, color, and behavior. The best way for animals to stay alive is to look like what they are not or to convince their enemies they are not there. The military has studied the ways of nature and has applied the concept to disguising military targets and equipment. The illustrator has made use of this concept for many years in drawing puzzles and children's games that *hide* objects. Figure 2–50 is from the late nineteenth century. The purpose of visual deception in this course of study is to create an illusion or to create interest through complexity. The magazine cover shown in Figure 2–51 integrates a computer disc into the image of a viking ship to illustrate software piracy in this example of visual deception. In the photographic relief in Figure 2–52, visual deception is achieved by segmenting approximately six different images, then combining them with drawing. In what manner does this painting make use of visual deception (Fig. 2–53)? How does the artist attempt to trick the viewer?

FIGURE 2–50
Fly puzzle trade card. 1884. Collection of author.

FIGURE 2–51
Byte illustration. Robert Tinney, illustrator. Copyright © 1981 Byte Publications, Inc. Used with the permission of Byte Publications, Inc.

FIGURE 2-52
Judy Miller. Reconstructed Still.

FIGURE 2-53
Rene Magritte. Les Promenades d'Euclide. *1955. Courtesy The Minneapolis Institute of Arts.*

For the next problem, in order for you to work representationally, that is, from an object-orientated viewpoint, you will need two objects, an industrially produced object and an object from nature. You must search for and select objects that are intensely interesting, in fact, fascinating. You will be working with them on and off throughout the course of study. Consider symbolic association reactions during the selection process.

PROBLEM 2-8: Visual Deception

Materials: Optional

Size: Optional (minimum 11" x 14"), appropriate border

Medium/Tools: Optional

Task/Considerations: Develop an image that includes both the natural and manufactured objects you selected. One object is to be obvious to the viewer (strong figure/ground relationship); the other object is to be difficult to see (camouflaged). There are a number of visual methods you might try to achieve visual deception:

Change the scale of the object.

Repeat the object at a size where it becomes a visual texture.

Arrange the objects so one object becomes part of another object.

Try blending or vanishing boundaries.

Position your object with other objects with structural similarities.

Another method that works with two-dimensional objects but not with three-dimensional objects is visual segmentation.

Also, you might consider changing the object's physical state or its time/space relationship.

What methods were used in Figures 2–54, 2–55, and 2–56 to achieve visual deception?

The purpose of Chapter 2 is to introduce you to basic perceptual concepts. Through these concepts and their manipulation it is hoped you will begin to understand how visual arts decisions are made and controlled. In Chapter 4 you will be exposed to an inventory of visual communication devices, that is, the structure that visual artists have at their disposal in the creation of images. However, Chapter 3 will first introduce you to one of the most studied areas in the visual arts, color theory.

Often, theoretical studies are criticized because they do not provide practical experiences. Many times you experience a concept and are then asked to move on without having put that experience to use. In this course, however, you will undertake an application problem at the end of most of the chapters.

FIGURE 2–55
C. McRae.

FIGURE 2-56
R. Wright. S. Hammack, photographer.

PROBLEM 2-9: Application

Concepts, imagery, size, and materials: Optional

Develop a project that makes application of any one or a combination of the concepts explored in Problems 2-1 through 2-8. It is suggested that you select a project that is representative of work done in your area of interest. Figure 2-57 is an application of several of the concepts explored in Chapter 2.

FIGURE 2-57
J. Davis. L. Moran, illustrator.

SUGGESTED READINGS

CARRAHER, RONALD G., and JACQUELINE B. THURSTON. *Optical Illusions and the Visual Arts.* New York: Van Nostrand Reinhold Company, 1966.

DAVIDOFF, JULES B. *Differences in Visual Perception.* New York: Academic Press, 1975.

DONDIS, DONIS A. *A Primer of Visual Literacy.* Cambridge: Massachusetts Institute of Technology, 1973.

GREGORY, R. L., and E. H. GOMBRICH. *Illusion in Nature and Art.* New York: Charles Scribner's Sons, 1973.

JUNG, CARL G. *Man and His Symbols.* New York: Doubleday & Co., 1964.

KEPES, GYORGY. *Language of Vision.* Chicago: Paul Theobald, 1951.

KEPES, GYORGY, ed. *Sign, Image, Symbol.* New York: George Braziller, 1965.

LUCAS, JAMES G. *Processes of Design: A Perceptual Approach.* Dubuque, Iowa: Kendall/Hunt Publishing Company, 1976.

THIEL, PHILIP. *Visual Awareness and Design: An Introductory Program in Conceptual Awareness, Perceptual Sensitivity, and Basic Design Skills.* Seattle: University of Washington Press, 1981.

WADE, DAVID. *Geometric Patterns and Borders.* New York: Van Nostrand Reinhold Co., 1982.

ZAKIA, RICHARD. *Perception and Photography.* Englewood Cliffs, N.J.: Prentice-Hall, 1975.

3 Basic Color Theory

A study of visual perception would be incomplete without an exploration of color. Many excellent texts have been written about color and theories of color. It is not my intention to duplicate those works. However, I believe you need a basic understanding of color perception and a color mixing experience.

As exemplified in this painting by Josef Albers, color is quite deceptive; it is rarely perceived as it physically is. (Figure 3–1 in color insert following page 50 .) Colors are almost always affected by their environment. If I were to say blue, green, red, or orange, each of you would have a different perception of what each specific color is. Each of us has a mental picture of how the specific color appears. Generally there are significant differences in these perceptions. Colors are perceived differently by individuals of different cultures, different geographic regions, diverse ages, and so on. Have you ever noticed that the color your grandparents call red is probably quite different from

the color you consider red to be? If I were to give the class a swatch book of many different yellows and ask each member to select the one that matches the color of McDonald's Golden Arches, I am sure that I would be given several different yellows. The primary reason for the discrepancy is that our visual memory is relatively poor.

Beginning users of color generally have a very limited color menu and tend not to know how to control the color. The following projects will give you control over color at a basic level. When you have completed these projects, you will be prepared to use and appreciate color.

QUALITIES OF COLOR

Each hue in the spectrum has its own characteristics. Some are bright, some are dull; some are dark, some light; some are strong, some weak. In addition, when juxtaposed, hues affect one another's appearance. The problem that follows provides the most basic of all color experiences.

Simultaneous contrast is sometimes referred to as successive contrast or color effect. It occurs naturally when one color is juxtaposed with another. In other words, one color in proximity to another color affects the quality (hue, value, or intensity) of that color. Our goal is to see what happens between colors and to learn how to control simultaneous contrast. There are some general postulates to consider when exploring simultaneous contrast:

If you want a color to appear lighter in value, surround it with a color darker in value and vice versa.

If you want a color to appear to be intense or bright, surround it with a less intense color.

A color will also take on the characteristics of the complement of the surrounding color.

With these postulates in mind, and with a good eye, consistent lighting, and a great deal of patience, you will be able to solve these problems successfully.

PROBLEM 3-1: Simultaneous Contrast

Materials: Illustration board (five pieces)
Size: 10″ × 15″
Medium/Tools: X-acto knife, colored paper, rubber cement
Task/Considerations: Using two 6″ × 6″ ground squares (inducing field) and two 1″ × 1″ effect squares (test field), complete the following:

PART 1: Make the same achromatic color appear to be different (one color appears as two).
PART 2: Make two different achromatic colors appear to be the same color (two colors appear as one color).
PART 3: Make one hue appear to change value or intensity.

PART 4: Make unlike values or intensities of a hue appear to be the same.
PART 5: Reversible ground; same hue. Select a color (I suggest using analogous hues) that when placed on two grounds will appear as the opposite ground, that is, the left test field will appear as the right inducing field and vice versa. (Another way of stating the above is that three colors will appear to be only two colors.)

Analyze each part and determine the reason it was successful. Transfer that information to the back of each board. If you want a real challenge, try Part 5 using complementary hues. (See Figures 3–2, 3–3, 3–4, 3–5, and 3–6 in color insert.)

COLOR THEORIES

There are many color theories available to the visual artist, among the most popular are Munsell, Ostwald, and the Prang system. The Prang system is the one you

were most likely taught in the public schools. The major color theories are predicated on the following information: There are three qualities of color—hue, value, and intensity (Figure 3–7 in color insert). It should be noted that a color exhibits all three charac-

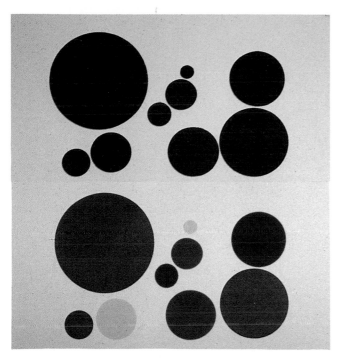

FIGURE 2–38 *Sim/Prox. Student unknown. L. Moran, illustrator.*

FIGURE 2–54 *Visual Deception. M. Laux. F. Young,
photographer.*

FIGURE 3–1 *Josef Albers. Homage to the Square.
Walker Art Center.*

FIGURE 3–2 *Simultaneous contrast. D. Meurer.
S. Hammack, photographer.*

FIGURE 3–3 *D. J. Bravick. S. Hammack, photographer.*

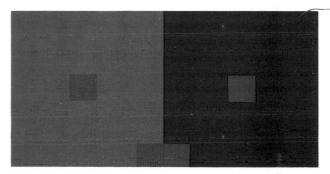

FIGURE 3–4 *J. Engel. S. Hammack, photographer.*

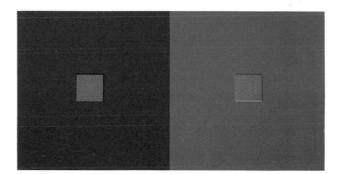

FIGURE 3–5 *D. Byers. S. Hammack, photographer.*

FIGURE 3–6 *J. Dunser. S. Hammack, photographer.*

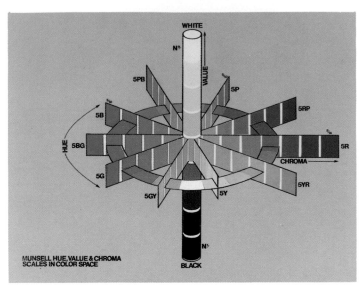

FIGURE 3-7 *Three qualities of color. Courtesy Munsell Color, 2441N. Calvert St., Baltimore, MD 21218.*

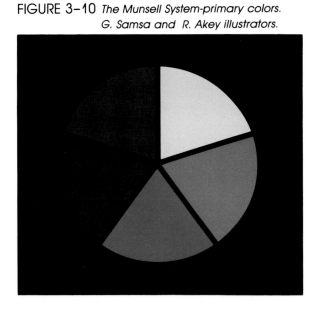

FIGURE 3-8 *Prang colorant system. G. Samsa and R. Akey, illustrators.*

FIGURE 3-13 *The Ostwald system primaries. G. Samsa and R. Akey, illustrators.*

FIGURE 3-10 *The Munsell System-primary colors. G. Samsa and R. Akey illustrators.*

FIGURE 3-15 *The four color process system. G. Samsa and R. Akey, illustrators.*

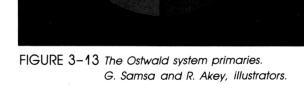

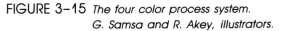

FIGURE 3-17 Hue mixture. S. Lent. S. Hammack, photographer.

FIGURE 3-19 Additive mixture/light theory primaries. G. Samsa and R. Akey, illustrators.

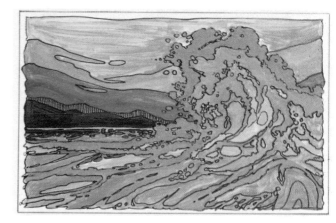

FIGURE 3-20 Additive mixture. M. Brown. F. Young, photographer.

FIGURE 3-18 Hue mixture. S. Lent. S. Hammack, photographer.

FIGURE 3-21 Additive mixture. J. Engel. S. Hammack, photographer.

FIGURE 3-22 *Value mixture. S. Carlson. S. Hammack, photographer.*

FIGURE 3-25 *Intensity mixture. Student unknown. F. Young, photographer.*

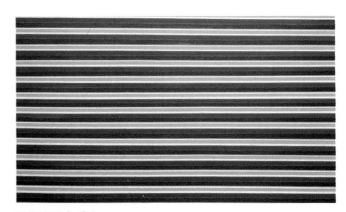

FIGURE 3-26 *Color equalization. Student unknown. F. Young, photographer.*

FIGURE 3-23 *Value mixture. S. Goodry. S. Hammack, photographer.*

FIGURE 3-27 *Mix & Match. C. Konder. F. Young, photographer.*

FIGURE 3-24 *Intensity mixture. M. S. Sahl. F. Young, photographer.*

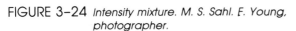

FIGURE 3-28 *Mix & Match. D. Steffen. F. Young, photographer.*

teristics simultaneously. Hue is the color name, red, green, blue, violet, and so forth. It is what distinguishes one color from another. Value is the lightness or darkness of the hue. Intensity, often referred to as saturation or chroma, is the brightness or dullness of the hue; it is determined by the amount of the opposite, or complementary, hue that is mixed with the hue. When complements are mixed together, they produce chromatic grays. Achromatic (without color) grays are mixed from black and white. Achromatic colors can be mixed with chromatic hues resulting in tints, tones, and shades. A tint is the result of adding white to a hue; *pink*, for example, is a tint of red. A shade of color such as *maroon* is made by adding black to the hue, in this case, red. Tones are made by adding grays to the hue, consequentially you are capable of mixing a large selection of tones. The terms *tint*, *tone*, and *shade* are used interchangeably with the term *value* but they are more specific.

SUBTRACTIVE MIXTURE: PIGMENT

There are two basic types of color mixture, additive and subtractive. The next two problems will illustrate their differences in terms of mixture. Theoretically, if you were to mix the subtractive primary colors together, you would get black or the absence (or absorption) of color. In practice, as you know, the mixture will result in a muddy brown color. However, if you were to mix the additive primary colors together, in equal amounts, you would get white. This is the purpose of Problem 3–3.

Prang System

The Prang system has three primary colors: red, yellow, and blue (Figure 3–8 in color insert). These colors are basic; no other colors can be combined to make them. The primary colors are mixed together to form the secondary colors: orange, green, and violet. The primary and secondary colors can be mixed together to form intermediate colors, i.e., red-orange, blue-violet, yellow-green, blue-green, red-violet and yellow-orange (see Figure 3–9).

Three primary colors, in a highly saturated form, mixed in combination with black and white will produce an incredible number of different colors, as you will experience in Problem 3–4. However, it is a misconception to think that all colors can be produced from three primary hues. The three primaries will produce colors in all hues, but the hues tend to be weaker, grayer, or muddier. For this reason and because the Prang system has never been systematized, most major industries in this country make use of the Munsell color system.

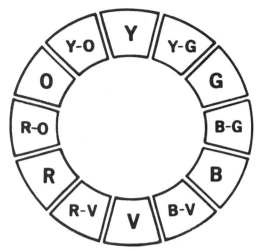

FIGURE 3–9
The Prang colorant system diagram.

Munsell System

The Munsell system is composed of five principal hues: red, yellow, green, blue, and purple (Figure 3–10 in color insert). The three qualities of color—hue, value, and chroma—have been quantified to enable one to identify a specific hue. For example, Figures 3–11 and 3–12 show that a hue is identified by a combination of numerals and hue initials, such as 5GY. The value of a color is identified on a scale of 0/ (absolute black) to 10/ (absolute white) with 9 visually equal steps between. The symbol 5/ is used to indicate middle gray

FIGURE 3–11
Hue symbols and their relation to one another. Munsell color system. Courtesy Munsell Co.

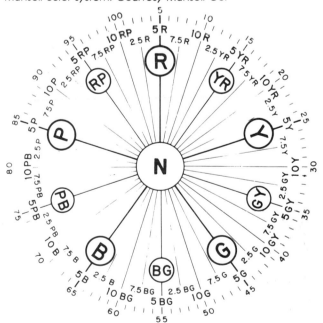

FIGURE 3–12
*Munsell solid color cutaway to show constant hue/54.
Courtesy Munsell Co.*

FIGURE 3–14
Ostwald color system. From The Color Primer
*by Wilhelm Ostwald. Copyright © 1969 by Van Nostrand
Reinhold Company. Reprinted by permission of the publisher.*

and all chromatic colors that appear halfway in value between absolute black and absolute white. The chroma numeral indicates the degree of departure of a specific hue from a neutral gray of the same value. These numerals range from /0 (neutral gray) to /10, /12, /14, or further, depending on the saturation of the color.

The complete Munsell notation for a chromatic color is written: HV/C. A red commonly called *vermilion* would thus be written 5R5/14. The notation for an achromatic color is written NV/; a middle gray would be N5/. However, light yellowish gray would need a more precise classification, N8/ (Y, 0.2). It is essential in industry that a color system be used in order to assure accurate color representation from design to manufacture.

Ostwald System

A color theory that is widely used in England and Europe and has had limited usage by industry in this country is the Ostwald system. This system has four fundamental colors: yellow, red, blue, and sea green (Figure 3–13 in color insert). These are mixed to create orange, purple, turquoise, and leaf green. The color chart is arranged according to the principle that any two colors mixed in equal parts will generate the color located exactly between them. A hue number is given for each principle color step, 1 through 24 (Figure 3–14). Ostwald also quantified value in terms of the

percentage of black and white contained in the color. Any color, with the exception of a fully saturated color, could be described as consisting of a pure hue, white, and black. In practice, most colors do contain a portion of achromatic color in addition to the pure, fully saturated hue.

The essence of the Ostwald system is to be able to create color harmony by arriving at colors that have the same hue, black, and white content.

Four-Color Process. The final major theory is a variation of the Prang colorant system and is mentioned here only because of its importance to future graphic designers and photographers. The four-color process is actually composed of three primary colors: cyan, magenta, and yellow (Figure 3–15 in color insert). The secondary colors are made as follows: magenta plus cyan produces blue; cyan plus yellow produces green; yellow plus magenta produces red. If you mix cyan, magenta, and yellow, you produce process black, which is the fourth color used in the four-color printing process.

I hope this brief explanation of the major color theories has not confused you. It is included here primarily to make you aware of the existence of color systems other than the Prang colorant system. You should now have enough information to begin your study of color theory.

PROBLEM 3-2: Hue Mixture

Materials: Illustration board (two pieces)
Size: 15" x 15", 4½" R circle as work area
Medium/Tools: A water-based opaque paint, appropriate brushes, masking tape
Task/Considerations:

PART 1—Analytical: Position an equilateral triangle within the work area and divide it into 9 equilateral triangles. Next, divide the three inner triangles in half. You should now have 12 divisions in which to place color (see Figure 3–16). Place "pure" red, yellow, and blue in each corner. From these primaries, mix secondary and intermediate hues by adding equal amounts of the parent hues. Note: It is essential that you start with as pure primaries as possible. However, you may want to mix each primary with equal amounts of white to prevent the colors from becoming too dark.

Suggested Colors:

Gouche:	Bengal red #36
	Chrome yellow, pale #60a
	Ultramarine blue, pale #120a
Acrylic Paints:	Cadmium red, medium
	Cadmium yellow, light
	Cobalt blue—brilliant blue purple
Munsell Colors:	Red: 5R5/14
	Yellow: 5Y5/8
	Blue: 5B5/10

The above hues are only suggestions. You may

FIGURE 3–16
Triangle division. S. Hammack, illustrator.

find that the colors are not what you consider to be pure, and you may select others.

PART 2— Intuitive: Lay out a second board in the same manner. Place the *pure* primaries in the corners. From these primaries mix the secondary and intermediate hues visually. Accurately measure and record how each hue was made. (See Figures 3–17 and 3–18 in color insert.)

What was the difference between the analytical and intuitive mixture?

ADDITIVE MIXTURE: LIGHT

The previous problem introduced you to subtractive, or pigment, theory. The following problem deals with the other type of color mixture, additive mixture. Additive mixture, or light theory, is similar to the Prang system only in that it has three primary colors. It is very different in other aspects. Light theory is predicated on the following information: There are three primary hues, red, blue, and green (Figure 3–19 in color insert). These combine to make the secondary hues:

red plus green produces yellow, blue plus red produces magenta, and green plus blue produces cyan. All three of the primaries mixed together equal white. White can also be achieved by mixing any two hues that contain the primaries, such as magenta and green. You are experiencing additive mixture each time you watch a color television or see a theatrical production. Generally, light theory is taught and experienced with three spotlights and theatrical gels. Several years ago I was introduced to a method of achieving the same results with pigment viewed under ultraviolet light.

PROBLEM 3-3: Additive Mixture

Materials: Optional

Size: Optional

Medium/Tools: Fluorescent tempera paints, appropriate brushes

Task/Considerations: Develop a composition of your choice, using fluorescent (Da-Glo) tempera paints. Mix the hues so that when the image is viewed under ultraviolet (black) light, white is created in an area or areas of the image.

Note: The composition should also be visually pleasing under natural light. You may have difficulty achieving white. Be advised that the pigment primaries may not be pure and you will have to adjust. (See Figures 3–20 and 3–21 in color insert.)

VALUE AND INTENSITY

Now that you have experienced additive and subtractive hue mixture, let's continue our studies with the mixture of value. In order to work with value, we need to be able to mix a visually equal gray scale. You could do this by trial and error, constantly making adjustments, or you could make use of the Weber-Fechner law, which states, *The visual perception of an arithmetic progression depends upon a physical geometric progression;* in other words, the amount of paint has to be mixed by multiplying units instead of adding units (see accompanying chart). In the case of our gray scale of 11 visually equal steps between black and white, the formula would be as follows. For purposes of demonstration, I doubled the unit each time. You may use any increment.

Due to impurities in the paint, unequal amounts, or other circumstances beyond your control, be prepared to adjust the scale visually.

B	1W	1W	1W	1W	1W	1W	1B	1B	1B	1B	1B	W
	32B	16B	8B	4B	2B	1B	2W	4W	8W	16W	32W	

PROBLEM 3-4: Value Mixture

Materials: Illustration board

Size: 20″ × 20″, 3½″ border, all sides

Medium/Tools: Water-based paint, appropriate brushes, masking tape, syringe

Task/Considerations: Rule the work area into a simple 1″ grid, (169 units). Place white in the upper left square and black in the lower left square. Mix the two achromatic colors so there appear to be eleven visually equal steps between the extremes. In the second column through the thirteenth column place, in mixture, each of the twelve hues of the color triangle mixed in Problem 2–10, Part 2. Each hue should be mixed with a corresponding step on the value scale. The ratio of mixture should be consistent throughout. I recommend a 1:3 ratio, one part achromatic to three parts chromatic. If the mixture is measured accurately, it is much easier to replicate a color mixture, should you need to do so. I recommend the use of a syringe for measurement. The hues should be placed in spectral order across the top of the board. It is suggested that you mix extra paint for the value scale, as it will be used for making tints, tones, and shades of the twelve chromatic hues. You may vary the format if you so desire. (See Figures 3–22 and 3–23 in color insert.)

PROBLEM 3-5: Intensity Mixture

Materials: Illustration board
Size: 17½" × 30", 3" border, all sides
Medium/Tools: Water-based paint, appropriate brushes, masking tape, syringe
Task/Considerations: Divide the work area into 1½" strips with ½" space between each strip. Divide each strip into 1½" × 2" areas. Using six sets of complementary hues, place the complements at opposite ends of the strips and mix toward the center, arriving at middle gray in ten visually equal steps between the two complementary hues. Again, use the Weber-Fechner law to mix the paints (see chart).

R	1G	1G	1G	1G	1G	1R	1R	1R	1R	1R	G
	16R	8R	4R	2R	1R	1G	2G	4G	8G	16G	

Procedure: On the right side mix green to red and reverse the mix for the left side. You may vary the format of the composition.
Did it make a difference what paint was added first? How do chromatic grays compare with achromatic grays? (See Figures 3-24 and 3-25 in color insert.)

In the following problem we will work with four very different colors and attempt to control, or equalize, their effect. Fabric and wallpaper designers have made considerable use of this concept. Can you think of other examples?

PROBLEM 3-6: Color Equalization

Materials: Illustration board
Size: 15" × 20", 3" border, all sides
Medium/Tools: Colored paper, T-square, X-acto knife, rubber cement
Task/Considerations: Organize a selection of colored strips of varying widths, but of equal length, all vertical or horizontal in orientation and touching at the seams along the full length (no gaps or cracks allowed). Select four colors that are very different in hue, value, and intensity. Begin with equal sizes or areas of the four colors, 3½" × 9" or 2¼" × 14". Segment each color 1½" maximum width) and distribute the pieces so all four colors appear equal or assume the same posture; in other words, they should appear spatially equal, with no one color dominant or subordinate to another color. (See Figure 3-26 in color insert.)

How were you able to achieve the desired effect? How did you deal with bright colors? With dark colors?

I am sure, at this time, you feel as if you have had a thorough color experience. This is not the case. You have only scratched the surface of an extensive area of study. The aim of these problems was for you to develop, through trial and error, a sensitivity to color and color relationships. I strongly recommend further work with color perception, color theory, and its ef-

fects. I hope that this introduction will kindle your interest in a fascinating field of study and that you will pursue further work in the application of color. Color is universal and, to quote Josef Albers, "*the most relative medium in art.*"

Do you ever want to mix paint again? Unfortunately, there is one more mixing project. However, this time it is a test of your mixing skills and your powers of visual discrimination.

PROBLEM 3-7: Color/Mix and Match

Materials: Illustration board

Size: Optional, appropriate border

Medium/Tools: Water-based paint, appropriate brushes, appropriate adhesive.

Task/Considerations: Select an image, such as an advertisement, illustration, or photograph, that has a broad range of color and appeals to your sense of aesthetics. Trace the content of the image. Segment the image in such a manner as to expose as many hues, values, and intensities as possible. Remove the segmented areas. Affix the image to the illustration board. Transfer the tracing to the negative areas. Mix and match the colors in the image. The objective in completing the image is to have it appear as if it were never segmented. (See Figures 3–27 and 3–28 in color insert.)

PROBLEM 3-8: Application

Concepts, imagery, size, and materials: Optional

Develop a project in which you can apply any one or a combination of the previously explored color concepts in Problems 3–3 through 3–7. The following diagrams give you a chronology of the development of major subtractive color theories.

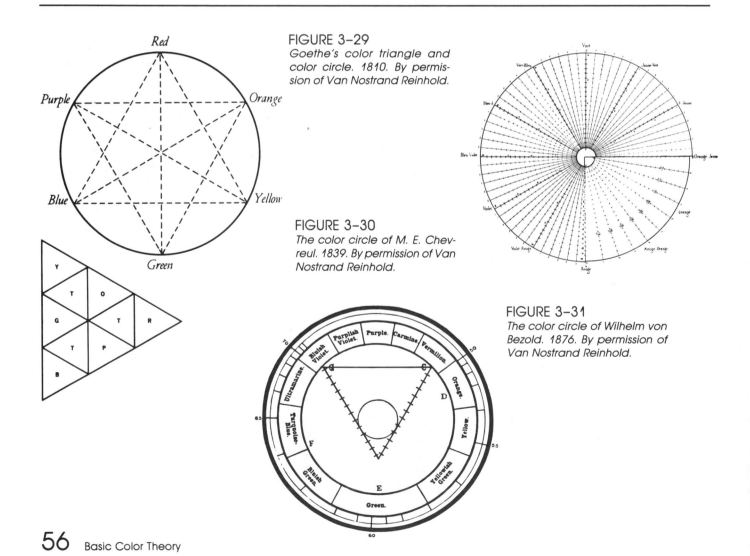

FIGURE 3–29
Goethe's color triangle and color circle. 1810. By permission of Van Nostrand Reinhold.

FIGURE 3–30
The color circle of M. E. Chevreul. 1839. By permission of Van Nostrand Reinhold.

FIGURE 3–31
The color circle of Wilhelm von Bezold. 1876. By permission of Van Nostrand Reinhold.

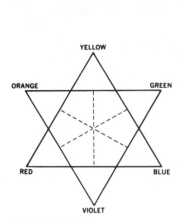

FIGURE 3-32
The color circle of Charles Blanc. 1873. By permission of Van Nostrand Reinhold.

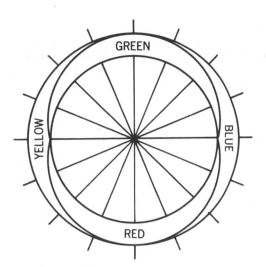

FIGURE 3-33
The color circle of Ewald Hering, c. 1878. By permission of Van Nostrand Reinhold.

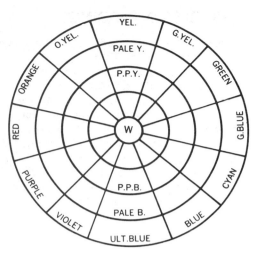

FIGURE 3-34
The color circle of Ogden Rood. 1879. By permission of Van Nostrand Reinhold.

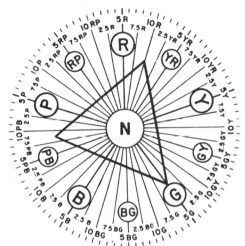

FIGURE 3-35
The color circle of Albert H. Munsell. 1898. By permission of Munsell Co.

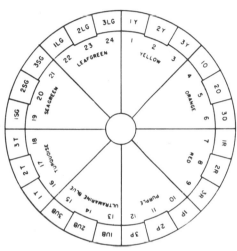

FIGURE 3-36
The color circle of Wilhelm Ostwald. 1916. By permission of Van Nostrand Reinhold.

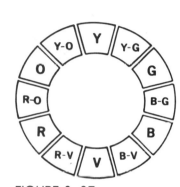

FIGURE 3-37
The red yellow blue color circle, c. 1920. By permission of Van Nostrand Reinhold.

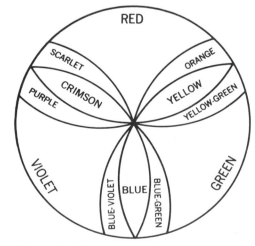

FIGURE 3-38
The color circle of Michel Jacob. 1923. By permission of Van Nostrand Reinhold.

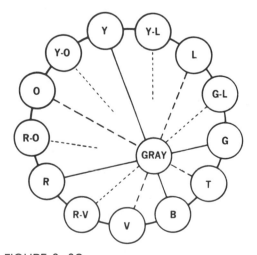

FIGURE 3-39
The rational color circle of Faber Birren. 1934. By permission of Van Nostrand Reinhold.

SUGGESTED READINGS

ALBERS, JOSEF. *Interaction of Color.* New Haven, Conn.: Yale University Press, 1963.

BECK, JACOB. *Surface Color Perception.* Ithica, N.Y.: Cornell University Press, 1972.

BIRREN, FABER. *Color Perception in Art.* New York: Van Nostrand Reinhold Company, 1980.

BIRREN, FABER, ed. *A Munsell Grammar of Color.* New York: Van Nostrand Reinhold Company, 1969.

BIRREN, FABER, ed. *Ostwald—The Color Primer.* New York: Van Nostrand Reinhold Company, 1969.

BIRREN, FABER. *Principles of Color.* New York: Van Nostrand Reinhold Company, 1969.

ITTEN, JOHANNES. *The Art of Color.* New York: Van Nostrand Reinhold Company, 1967.

JONES, TOM DOUGLAS. *The Art of Light and Color.* New York: Van Nostrand Reinhold Company, 1972.

PADGHAM, C. A., and J. E. SAUNDERS. *The Perception of Light and Colour.* New York: Academic Press, 1975.

VASARELY, VIKTOR, *Vasarely II.* Zurich, Switzerland: Editions Du Griffon Neuchatel, 1971.

VERITY, ENID. *Color Observed.* New York: Van Nostrand Reinhold Company, 1980.

Visual
4 Components:
Structure/
Manipulation

We dealt with composition in Chapter 2; however, some basic components used as structural building blocks should be explored in a more analytical manner. Through the completion of problems using these basic visual components, we will explore various methods of achieving compositional stability. After analyzing many compositions, it becomes obvious that visual images may be broken into components. Knowing what the component is—that is, how it may be described and what relationships are formed by its orientation or placement—is of value to the visual arts student when developing successful compositions.

In this chapter you will experiment with forming a composition by a conscious arrangement of components. This system of arrangement may be indirect or visually integrated with the image, as it is in the figure drawing shown in Figure 4-1. Another structural method, the grid, may be purposely visible, as shown in Figure 4-2, a map of the Indiana University campus system.

FIGURE 4-1
Judy Roode. Box drawing.

FIGURE 4-2
Kevin Byrne. Indiana U. Statewide system map.

the new kolya delta typeface

design by johannes gaston

FIGURE 4-3
Johannes Gaston. Kolya delta typeface.

A grid may also be used as a method of obtaining consistent construction, as is shown in the Kolya Delta typeface and its construction diagram, Figures 4-3 and 4-4. In some cases the structure may be in the method as well as the image, as shown in Figure 4-5. Figure 4-6 is a computer-generated image. Can you think of any of the problems from previous chapters where the method resulted in a structure?

FIGURE 4-4
Johannes Gaston. Construction Diagram.

FIGURE 4-5
K. Batista. Untitled.

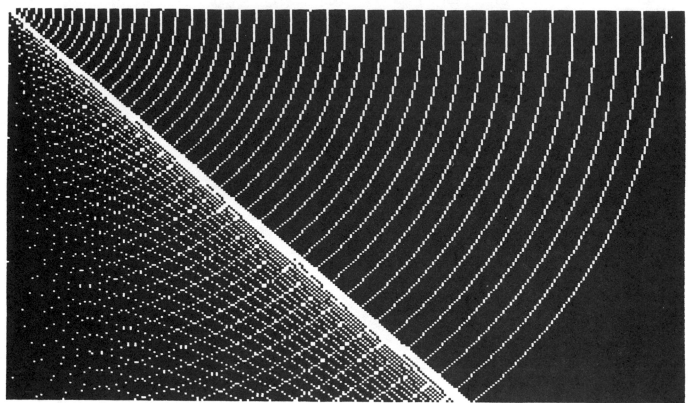

FIGURE 4–6
Sam Hammack. Computer generated image.

COMPONENT ANALYSIS

If you were to analyze the natural and man-made environment you would soon discover the simplest object is the dot or point. The dot is generally small and uncomplicated in shape. If the dot is extended so its primary dimension is length, the object is known as a line. A linear object may be straight or curved, regular or irregular. However, when a line encloses itself it has two primary dimensions, length and width. The resulting object is known as planar shape; included are everything from regular geometric shapes through

organic or biomorphic shapes. Once a planar shape develops a third primary direction, it is known as solid or volumetric form. Solid form will be covered in much greater detail in later chapters that concentrate on the study of three-dimensional form.

There are various methods of manipulating visual structure. For the most part, you have dealt with composition in an intuitive manner—that is, placing components where they look or *feel* right. A grid makes use of intuition but within the confines of a more structured method. The following problem is an introduction to the use of a simple grid plus several variations.

PROBLEM 4-1: Surface Pattern

PART 1: Object Analysis

Materials: Optional
Size: Optional
Medium/Tools: Choice of drawing, photograph, Xerox image, photostat, computer-generated image, etc.

Task/Considerations: Select one of your objects. Determine the simplest form your object can take and still be recognizable as that object. Reduce the object to a black-and-white image (no tonality allowed).

Before attempting Part 2, you must acquire some preliminary information on grid structures and surface pattern.

Before you start, consider the rationale of a surface pattern composition. Surface pattern is different from a single-unit composition, such as a painting or poster. A surface pattern is normally intended to work over a large area. Typical applications are floor coverings, wallpaper, drapery, and clothing fabric. The pattern must visually and physically connect in all directions (see Figure 4-7). Most patterns make multiple use of an image. This is referred to as periodic structure, which is defined as a repetition of the same image at regular intervals. *Repetition* is a very simple visual structural method and generally results in a harmonious visual effect. Images may be repeated in small sizes and infinite numbers, which often gives the appearance of a visual texture rather than a repeat pattern. A pattern, if small enough or viewed from a considerable distance, may fuse to produce a single value or even a recognizable image in black, white, and gray values. An example of this is the way a halftone screen, the kind normally used in newspaper photographs, creates gray from the fusion of black dots and white areas (see Figure 4-8). Repetition may also make use of a few large images. In this case the result is quite different from that created by the smaller units repeated many times to form patterns. The larger units tend to form groupings, to break up and regroup, forming different patterns.

FIGURE 4-8
Enlarged newspaper photo. Rich Foods.

GRID STRUCTURE AND SURFACE PATTERN

Think of the ways to describe an object—size, shape, texture, color, and so on. These are all ways in which images may be repeated. In addition, the spatial orientation (position, direction) of an object may be repeated. This is usually done by using a structural device, usually a grid. Simply stated, a grid determines the orientation of the images in the composition. A grid has several characteristics. It can appear flat or contribute to the illusion of space. Generally a grid is geometric and ordered. It is most often repetitive and gives a regular interval to the organization of the visual image.

A *simple grid* is frequently used with surface pattern compositions. It is composed of equally spaced horizontal and vertical lines that create square areas of equal size (see Figure 4-9). Variations on a simple grid tend to make compositions more dynamic since

FIGURE 4-7
Repeat pattern. Salem Carpet Co.

FIGURE 4-9
D. Kareken, illustrator.

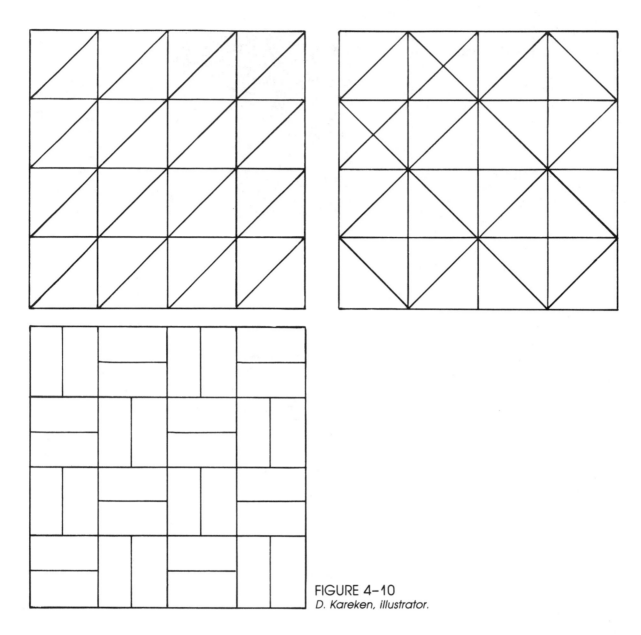

FIGURE 4-10
D. Kareken, illustrator.

FIGURE 4-11
D. Kareken, illustrator.

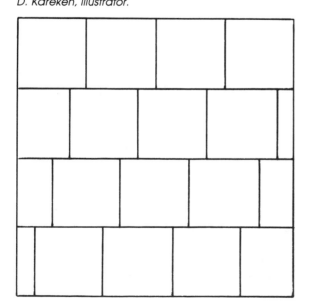

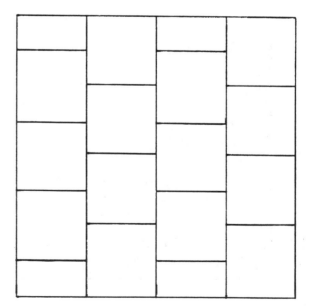

FIGURE 4-12
D. Kareken, illustrator.

FIGURE 4-14
D. Kareken, illustrator.

FIGURE 4-13
D. Kareken, illustrator.

pure repetition tends to become monotonous. Consider, for example, *subdivision:* The squares in a simple grid can be divided into smaller, more complex areas (see Figure 4-10). However, these smaller shapes must be equal in size and shape. A *shift* or *drop grid* is achieved by shifting alternate rows of a simple grid up or down or from side to side, usually by a uniform distance (see Figure 4-11), although the rows may be shifted nonuniformly. A *rectangular grid* is achieved by changing the proportions of the simple grid. This type of grid is used to achieve a vertical or horizontal emphasis in a composition (see Figure 4-12). The vertical and horizontal grid lines can change direction, assuming any angle to create a more dynamic *directional grid.* The directional grid (Figure 4-13) can be subdivided to form the more complex *triangular grid*

(Figure 4-14). The final and perhaps most difficult variation is the *expansion grid,* which starts with the simple grid and combines areas into larger and often more complex shapes. However, all edges should touch—that is, there should be no leftover space between combinations. The map in Figure 4-2 is a good example of an expansion grid.

I have already mentioned spatial orientation within a grid. This is important when working with figure/ground or positive/negative images. Spatial orientation refers to the position of the image within the grid structure. For example, the images may all rest on the bottom and be flush right in a simple grid, or each image may be tilted or rotated 30 degrees, or some other variation may be used throughout.

PROBLEM 4-1: Surface Pattern

PART 2: Ideation/fabrication

Materials: Optional
Size: 36″ × 144″ minimum
Medium/Tools: Optional
Task/Considerations: Using the positive/negative images derived from your object, use a grid to develop a surface pattern that could have a practical or decorative application. You may use the total image, a portion of the image, or a duplicate image. You may also reverse the image.

Before continuing, you should be aware that working with a grid has been criticized by some visual artists as being stifling, rigid, or noncreative. You can challenge this attitude by developing an appropriate grid pattern and then arranging the images within that pattern in a sophisticated manner. However, you should learn to recognize when to use a grid and when another method will produce a more successful visual image as these students did. (See Figures 4–15 and 4–16.)

FIGURE 4-15
E. Bowen. F. Young, photographer.

FIGURE 4–16
Student unknown.

CONNOTATIVE STRUCTURE

Before we begin our study of individual components, let's approach structure from another vantage point, that which could be referred to as connotative structure. Connotative structure is used to reinforce the meaning or communicate aspects of the visual image.

PROBLEM 4-2: Word Visualization

Materials: Illustration board
Size: 15" × 20" or 20" × 20", 3" border, all sides
Medium/Tools: Optional
Task/Considerations: Choose any word. Analyze the letters of the word and transfer them to a shape and color combination that suggests the meaning of the word. In other words, develop a connotative word module (see Figure 4–17). You may vary the size and orientation of the module. You may also work with a full range of values and intensities of hues within individual modules. Develop a structure that is appropriate for and emphasizes the meanings of your word, and repeat the module in accordance with the structure. Think of this image as a section of a visual dictionary, and consider all definitions of the chosen word.

FIGURE 4–17
F. Young. D. Kareken, photographer.

How can you communicate a verbal concept visually? How might this process be applied in the future? In essence, this is a visual illustration of a verbal concept. (See Figures 4–18 at right and 4–19 in color insert following page 98.)

INDIVIDUAL COMPONENTS

The Dot

Let's continue our study by working nonobjectively and concentrating on a basic component, the dot. We are constantly exposed to the dot. A prime example is television. The television picture you view is composed of over 40,000 tiny dots that fuse to stabilize the images we watch each day. The dot has also been used in the fine arts field.

FIGURE 4–18
B. Nelson.

The perceptual concept of retinal fusion was used by the neoimpressionists or pointillist painters, among them Seurat and Signac. The hues and values produced in these paintings are extraordinary, considering the method used to construct the images (Figure 4-20 in color insert).

At this time, let's explore the possibilities of using the dot as a compositional unit in a series of problems.

PROBLEM 4-3: Dot as Center of Interest

Materials: Illustration board

Size: 15" x 20", 3" border, all sides

Medium/Tools: India ink, ruling pen, compass with ruling attachment, T-square, triangle, colored medium.

Task/Considerations:

PART 1: Randomly position an odd number of related open shapes within the work area. This should result in a pleasing division of the space. Feel free to vary the line widths that form the borders of the open shapes. Position a single dot within the borders of each of the open shapes, placing it where it will create the most interest not only in the individual shape but throughout the total composition. You may vary the dot size and the dots can be open or closed shapes.

How does this problem compare to Problem 2-5? How did you make use of your knowledge of similarity and proximity? (See Figure 4-21.)

PART 2: What would happen if you were to make the composition more complex by adding color? Expand on the composition by adding achromatic and/or chromatic colors to the shapes. Consider the relationship between shape and color. (See Figure 4-22.)

Compare the two solutions. Figure 4-23 shows how this concept has been applied to poster design.

FIGURE 4-21
B. Tresh. L. Moran, illustrator.

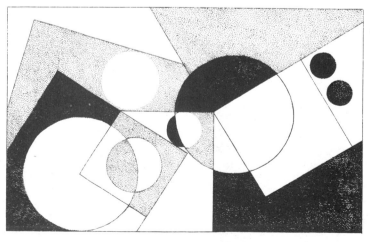

FIGURE 4-22
B. Tresh. L. Moran, illustrator.

FIGURE 4-23
Artist Guild of Detroit poster. Collection of K. Byrne.

PROBLEM 4-4: Dot Fusion

Materials: Illustration board
Size: 30″ × 40″, 2½″ border, all sides
Medium/Tools: India ink, pressure-sensitive film or paper, tracing paper, graph paper
Task/Considerations: Photograph one of the objects that you chose to work with this term. Or, you may opt to use another photograph you have taken. For best results use a medium speed film, such as Plus-X, ASA 125. Print on normal contrast paper, such as F2, in a 5″ × 7″ size. A regular size, (3½″ × 5″) *photo store* photograph can be enlarged to the appropriate size with the aid of an opaque projector or an *Art-O-Graph* machine. Draw a ¼″ simple grid over the work area. (You may opt to use ¼″ graph paper over the work area.) Trace the photograph. Isolate the pure black areas and the pure white areas, then determine separate areas for a minimum of four values that lie between black and white. Enlarge a minimum of five times and transfer the image to the work area. In completing the problem, the values are to be achieved by placing dots (manually, printing, transfer sheets, or cut paper) of various sizes and densities within the designated value areas of the grid (see Figure 4-24).

FIGURE 4-24
J. Coleman. D. Kareken, photographer.

View from a distance for best visual results. Compare your solution to a halftone photograph. Does it work as well? If not, analyze the halftone and determine how to make yours work equally well.

When we view an image composed of identical units we try to make order. Have you ever stared at a floor composed of small ceramic tiles? What happens?

Can you make connections, shapes, or other images from the dots in the enlarged section of a computer image in Figure 4-25? Diagram the groupings and forces with tracing overlays. If needed, complete the following problem to prove a basic visual perception phenomenon to yourself.

FIGURE 4-25
Enlarged section of a computer generated image.

PROBLEM 4-5: Visual Order

Materials: Illustration board
Size: 30″ × 39″, 3″ border, all sides
Medium/Tools: Optional
Task/Considerations: Draw a ⅜″ simple grid over the work area. Select an object that will fit the grid and that can be inked and printed. Transfer the object's image to the illustration board by printing. Adhere to the grid and place all of the units in essentially the same orientation.

When completed, visually analyze the image. What groupings and directional forces take place? Diagram the groupings and directional forces with tracing paper overlays. What would happen if you changed the object's orientation? Its size or color? What would happen if you used a combination of images? Try it!
The object of the last problem was to show how pat-

terns and shapes may develop naturally from the ordered repetition of units. As I indicated earlier in reference to the pointillist painters, fusion is not limited to achromatic colors. Fusion is the concept behind the success of the four-color printing process. *Optical* or *parative mixture* is illustrated in Figure 4-26 (in color-insert). It is relatively easy to control and use, as you will discover in the next project.

PROBLEM 4-6: Optical Mixture Grid

Materials: Illustration board

Size: 15" × 15", 3" border on two adjacent sides, one perpendicular to the other

Medium/Tools: Water-based paint, appropriate brush or paper, paper punch, rubber cement, T-square, triangle

Task/Considerations: Divide into groups of four students. Select a ground color and three other colors to interact with the ground. It is suggested that you use analogous colors. Each student (team member) will develop a composition on a separate board; however, each team member's composition should interface with the other compositions and the piece should function as one composition. Draw a ⅜" simple grid on the ground hue. Place dots of three different hues on the ground hue. Achieve an optical mixture that gives the illusion of more than four hues. The dots do not have to remain constant in size or shape, only in color. For best optical results, the dots should not touch. (See Figure 4–26 in color insert.)

View your solution to Problem 4-6 from a distance of at least six feet. Did the dots change color? Was the color of the ground changed? It should be noted that *retinal,* or *ocular, fusion* will also occur in a linear pattern, provided the lines are thin enough. If time permits, try a format with a linear pattern to achieve optical mixture, or keep the idea on file for future use. Figure 4–27 (in color insert) is a direct application of the concept of retinal fusion. The dot is a very simple form, in fact, the simplest available to the visual artist. Do not underestimate its power. The simplest visual forms can be used with great complexity and sophistication.

Line

Line, if not the simplest form, is certainly the most used form. The primary characteristic of linear form is that it tends to imply activity and is generally a boundary demarcation. The visual artist uses line primarily to communicate ideas in a simple, concise manner. Its uses cover the full range of visual arts products and appear as examples at various places throughout the text.

PROBLEM 4-7: Linear Displacements

Materials: Illustration board

Size: 15" × 20", 3" border, all sides

Medium/Tools: Black paper or pressure-sensitive sheet, rubber cement, X-acto knife, T-square, triangle

Task/Considerations: Lay out an alternating black-and-white striped pattern, using stripes of equal size, in the work area. By segmenting and shifting the positive/negative orientation, change the *run-on* pattern to a unit composition, in other words, overpower the repetitive character. Do not add or delete any material from the stripe pattern. (See Figures 4–28 and 4–29.)

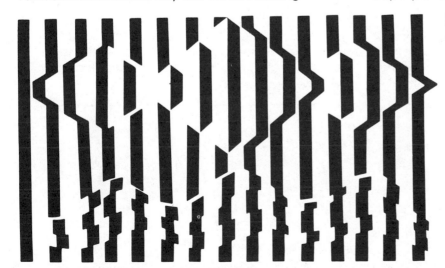

FIGURE 4–28
Student unknown.

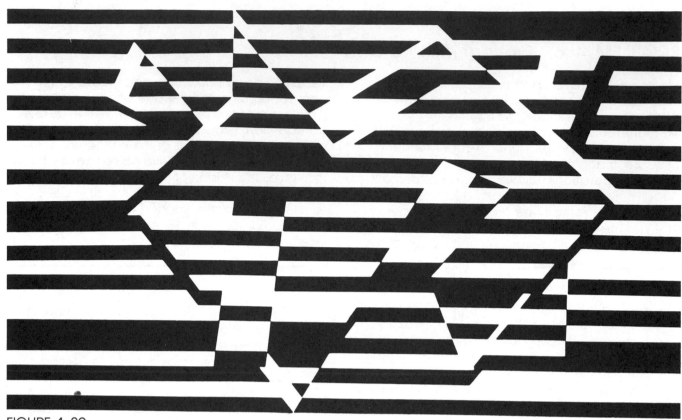

FIGURE 4-29
C. Jacobson.

During the critique, identify the solutions that are considered successful. Why are they successful? What are the necessary components in this type of composition? Was the structure altered? Did you create a new structure? Can you think of an application for this process?

In the next problem we will approach the study of structure in a slightly different manner; we will consider related structural units.

PROBLEM 4-8: Linear Progression

Materials: 100 lb. white cover stock
Size: 6" x 36"
Medium/Tools: India ink or pressure-sensitive film, ruling pen or X-acto knife, T-square, triangle, scoring tool
Task/Considerations: Score and fold the cover stock into six 6" x 6" areas. This is commonly called an accordion fold. Develop a black-and-white linear structure that undergoes a logical change of image from unit one to unit six, in other words, a progression. Each unit must function visually by itself, and all six units must work together, that is, appear unified. Note that visual surface warpage may result; use it to advantage, learn to control the effect produced by warpage. If time permits, try the above assignment using four colors instead of black and white.

How do the compositions compare in difficulty of execution? In visual appeal? In other ways? (See Figures 4-30 and 4-31.)

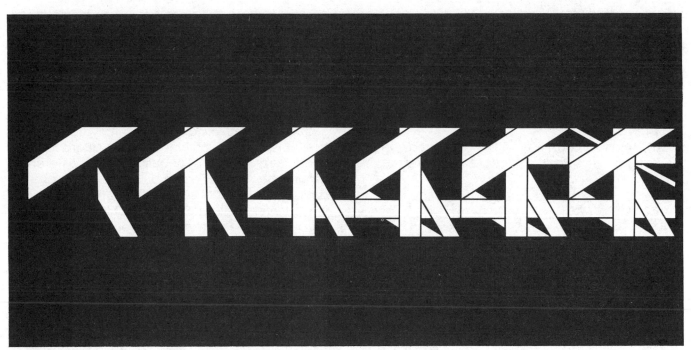

FIGURE 4–30
C. Jacobson.

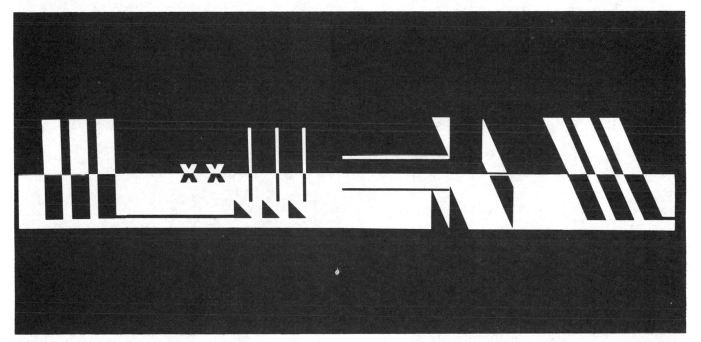

FIGURE 4–31
Student unknown.

Planar Shape

In most solutions the linear images in the previous problem will fuse and be perceived as planes. Planar shape may be defined as an essentially flat area that has two exaggerated dimensions, length and width or breadth, but no thickness. It pertains to area rather than volume or mass. A planar shape may be flat, curved or warped, opaque, translucent, or transparent in appearance. As stated earlier, planar shapes range from regular geometric shapes to biomorphic shapes. Therefore, it would be advantageous for you to discover the range of shapes derived from regular geometric shapes. The following problem should help.

PROBLEM 4-9: Transformation Study

Materials: Illustration board
Size: 15″ x 18″, 3″ border, all sides
Medium/Tools: T-square, triangle, india ink, ruling pen, brush
Task/Considerations: Divide the work area into a 1½″ simple grid. Position a regular geometric shape in the upper left-hand section of the grid. Develop a progression of altered images, working from left to right, top to bottom, where a shape appears to develop naturally from the previous shape. Continue until the alteration is exhausted. When this occurs, select a different regular geometric shape and repeat the process. However, your series of shapes should end in the lower right-hand section of the grid with a regular geometric shape. This enables the image to be read from either the top or bottom without difficulty. (See Figure 4-32.) Note: You may opt to do this problem in a film or video medium or with a computer, as shown in Figure 4-33. A transformation is shown in this example by M. C. Escher, a master of the concept. (Figure 4-34.)

FIGURE 4-32
L. Tallier

FIGURE 4-33
Transformation-Hewlett-Packard. Courtesy Charles Owen, Institute of Design Chicago.

FIGURE 4-34
M. C. Escher. Liberation. *Courtesy of Vorpal Galleries.*

FIGURE 4-35
David Graves. Moto Perpetuoto. *1977. Courtesy D. Graves.*

FIGURE 4-36
Getullio Alviani. Implied motion. *Courtesy Art Research Center.*

The next problem introduces you to a structure that is achieved by changing orientation, not shape. I'm sure you are familiar with methods of creating the illusion of motion in figurative works, such as in Figure 4-35. Can this illusion be achieved in a more structured manner as well? (See Figure 4-36.)

PROBLEM 4-10: Modular Structure/Implied Motion

Materials: Illustration board

Size: Minimum 20″ × 30″, 3″ border, all sides

Medium/Tools: Paper, X-acto knife, rubber cement

Task/Considerations: Develop a module that you consider visually exciting. You may use the same module as in Problem 2–7 or select a shape from Problem 4–9. Construct a grid within the work area appropriate to the shape and size of your module. Develop a sequence for positioning the modules within the grid in order to create a visual flow or the illusion of motion throughout the composition. Note: The module must change its orientation at least once. Repeat the sequence throughout the composition. You must use a minimum of 20 modules. (See Figure 4–37.)

FIGURE 4–37
J. Engel.

Relief Form

I can remember my grandmother referring to something with many items as having "forty-eleven" parts. Such is the next problem. To expand on the concepts generated in Problem 4–10, I feel it necessary to expand into the third dimension. A natural transition between two-dimensional and three-dimensional form is the relief.

A relief comprises both two-dimensional and three-dimensional elements. It has a frontal plane, and dimensional objects are attached to or appear to come from that plane. Reliefs are categorized by how far the dimensional objects project off of the plane—low, middle, and high. These distances are relative, depending on the size and scale of the plane. (Figure 4–38.) Note: This example is not a modular relief as is required in the following problem.

FIGURE 4–38
Charles Biederman. Red Wing No. 6. *1957–63. Courtesy Walker Art Center.*

PROBLEM 4–11: 40-11 Modular Relief

Materials: Poster board, 3-ply bristol
Size: 22″ × 28″
Medium/Tools: 80–100 lb. cover stock, X-acto knife, scoring tool, adhesive
Task/Considerations: Develop the module in Problem 4–10 into a form. The module should be designed to project into space from a flat plane. The module is to be cut from cover stock and constructed by folding. *It is suggested that you score the folds.* Using twenty black modules, twenty white modules, and eleven colored (free choice of color) modules, develop a visually exciting relationship between the individual modules as well as between the modules (figure) and the board (ground). Use only one layer of modules; each module must touch another module. Select and explore relationships in low, middle, or high relief. You may change the orientation of the modules. Select the *correct* module size; fifty-one modules must fit in the work area. Since rubber cement stains poster board, you will want to apply a spray fix to the board before beginning to work with it. Be prepared to discuss the structure used in completing the composition. (See Figure 4–39.)

FIGURE 4–39
S. Petefish Gold. L. Moran, illustrator.

The next logical step in this problem is to develop the module into three-dimensional forms in space. However, you may prefer to approach this problem after experiencing the three-dimensional form and structure units. Refer to Chapter 6, page 103, for a definition of three-dimensional form.

PROBLEM 4–12: Modular Construction

Materials: cover stock, 3-ply bristol board
Size: Optional
Medium/Tools: Scoring tool, X-acto knife, adhesive

Task/Considerations: Develop your module into a free-standing three-dimensional form using a minimum of 10 modules.

Be prepared to discuss the structure used in completing the construction. How does this problem differ from the solution to Problem 4–11? Did the use of space make a difference in how you solved the problem? (See Figure 4–40.)

Analyze the modular construction. Which was the most prevalent aspect, structure or form? Each aspect is essential to the comprehension of three-dimensional form, as you will discover in the following units. I have chosen to present form and structure separately; however, it should be noted that they should not be separated in practice. Many times the sculptor appears to be more concerned with form, and the three-dimensional designer is often primarily concerned with structure, or the functional aspects of the object being designed. With the widespread use of electronic components, form has become a more impor-

FIGURE 4-40
S. Petefish Gold. L. Moran, illustrator.

tant consideration for current designers of three-dimensional products. These components have all but done away with the functional constraints put on the form of products by interior mechanical components. Our goal is to have a structurally functional object in combination with an aesthetically pleasing form.

PROBLEM 4-13: Application

Concepts, imagery, size, and materials: Optional.

Complete an application problem that makes use of the concepts covered in Chapter 4.

SUGGESTED READINGS

GARRETT, LILLIAN. *Visual Design: A Problem-Solving Approach.* New York: Van Nostrand Reinhold Company, 1967.

HARLAN, CALVIN. *Vision and Invention: A Course in Art Fundamentals.* Englewood Cliffs, N.J.: Prentice-Hall, 1970.

HOFMANN, ARMIN. *Grahic Design Manual: Principles and Practice.* New York: Reinhold Publishing Company, 1966.

KEPES, GYORGY, ed. *Module Proportion Symmetry Rhythm.* New York: George Braziller, 1965.

KEPES, GYORGY, ed. *The Nature of Art and Motion.* New York: George Braziller, 1965.

MULLER-BROCKMANN, J. *Grid Systems.* New York: Hastings House Publishers, 1981.

SCHOENFELD, SUSAN. *Pattern Design for Needlepoint and Patchwork.* New York: Van Nostrand Reinhold Company, 1972.

WONG, WUCIUS. *Principles of Two-Dimensional Design.* New York: Van Nostrand Reinhold Company, 1972.

5 Spatial Representation and Drawing Methods

In the previous chapters we have not put an emphasis on creating the illusion of three-dimensional space. It is now appropriate to introduce the subject. Students tend to assume that spatial illusion is concerned with the study and application of perspective. Actually, linear perspective is just one of many methods used by the visual artist to deal with spatial representation. Throughout art history the visual artist has represented space in a variety of ways. Space is, in my opinion, intangible as compared to texture, pigment, shape, and such. However, sensitive use of space is often the most important factor in a composition. As stated previously, the three-dimensional visual artist is primarily concerned with a pleasing displacement of space by form, and the two-dimensional visual artist is primarily concerned with its arrangement on the picture plane or its illusion in the form of depth. In this unit we will concern ourselves only with a two-dimensional representation of space.

SPATIAL ANALYSIS

From my observations and from previous study of the history of the visual arts, I have identified several methods for organizing space. Four basic spatial concepts are available when you are working in a two-dimensional format. In the first concept you work on the surface of the picture plane. This concept is used a great deal in graphic and typographic design (see Figure 5–1). It is called *decorative space* and essentially applies the concepts covered in Chapters 2 and 4. As you will remember from Chapter 2, a perfectly flat two-dimensional surface is extremely difficult, if not impossible, to achieve because of the figure-ground relationships. The slightest manipulation of line, shape, color, texture, or value will generate the depth illusion.

Infinite spatial concepts dominated Western visual art from the beginning of the Renaissance to the time of the Industrial Revolution, the beginning of the modern period. A visual art solution that emphasizes infinite space uses the picture plane as a starting point. It is much like looking through an open window at a landscape that seems to go to infinity (see Figure 5–2).

Contemporary visual artists tend to incorporate many of the elements of both decorative and infinite spatial concepts in their work. This is referred to as *limited space* (see Figure 5–3). Spatial methods are often used arbitrarily, and in combination when necessary, to achieve the results desired by the visual artist. A rule of thumb is: If the combination works, use it. Such is the

FIGURE 5–2
Time Passages. *Performed by Al Stewart, Record No. AB 4190 (p) and (c) 1978, used through the courtesy of Arista Records, Inc.*

FIGURE 5–3
James Burpee. Model, Saw, Matisse. *1978.*

FIGURE 5–1
Herb Greene. The Pointer Sisters Album. Blue Thumb Records.

FIGURE 5–4
Gerry Raferty—City to City. Courtesy Liberty United Records (UK) Limited. D. Kareken, illustrator, photographer.

FIGURE 5–5
Michael and Kathryn McCoy. Architecture Symbol and Interpretation. Courtesy Cranbrook Academy of Art. D. Kareken, photographer.

FIGURE 5–6
James Burpee. Pink Supremes (Tulips). 1975.

case with the fourth spatial organizational concept: *intuitive space.* This type of spatial representation has been in use throughout much of modern visual art history, as the visual artist has taken liberties with the established rules in order to communicate his or her intent to the viewer. The use of intuitive space is often difficult to classify because it uses one or more of the above concepts in combination with various perceptual devices, as Figure 5–4 shows.

SPATIAL ORGANIZATION: DEPTH ILLUSION

If you want to create an illusion of depth, there are several devices that enable you to do so. If they sound slightly familiar, it is because they are derived from the Gestalt postulates studied in Chapter 2.

Object Location

The first device is object location—where the image is placed in reference to the picture plane and the horizon line. The horizon line is used as a reference point. The lower portion of the picture plane is considered the point closest to the viewer. Objects intended to appear closer are placed in a lower position in the picture plane and those intended to appear farther away are placed in a higher position, as in Figure 5–5.

Contrast of Size

A closely related spatial device is contrast of size. We are accustomed to a positive correlation between location and size: Objects appear closer when they are larger in size. If you want an image to be per-

ceived as close, make it larger than other images in the composition. Both of these devices are well illustrated by the images in the poster (Figure 5–5) and the painting (Figure 5–6).

FIGURE 5-7
Dan Gorski. Saltillo Garden. *1979. Courtesy D. Gorski.*

Overlapping Forms

Another device for creating the depth illusion is to place one image so that it partially obstructs the view of another image. This is called overlapping. The image that intercepts the visible surface of another image is perceived as being closer to the viewer. The device of overlapping is very strong and will take precedence over other spatial clues. A small image positioned in front of a large image will appear closer, overriding the contrast of size device mentioned earlier (see Figure 5-7).

Transparency

Transparency is another form of overlapping that, in addition to creating a depth illusion, often creates a spatial contradiction. It can express two or more spatial positions simultaneously, and it tends to create ambiguity, or what might be referred to as *equivocal space* (see Figures 5-8 and 5-9). Transparency can also be used to show simultaneously the exterior and interior views of an object. Orthographic projection (see page_000), another device for viewing multiple aspects of an object simultaneously, is common practice in many areas of the design profession and will be covered later in this chapter.

FIGURE 5-8
Joy Broom. Shower Door for Escrow Closing. *1979. Courtesy J. Broom.*

FIGURE 5-9
Charles Sheeler. Midwest. *1954. Courtesy Walker Art Center.*

Color Quality

Color quality is used by the visual artist to create an illusion of depth. Generally speaking, intense colors tend to appear closer than do dull colors. Also light hues and tints appear closer than do darker hues and shades of a color. Warm and cool colors tend to behave in the same manner. However, this may not always be the case because of the relative characteristics of color. Do you think the color usage is an important factor in creating the depth illusion in the painting shown in Figure 5-10 (in color insert)?

Aerial Perspective

Aerial perspective literally refers to dirt in the atmosphere. Light on distant objects is scattered, absorbed, and reflected before it reaches the observer's eye. As a result distant objects are seen less distinctly. Values are shifted towards middle gray, hues are grayed and weakened, and image contours become vague. Objects closer to the picture plane are stronger in hue, value, and intensity, as you might expect them to be (see Figure 5-11).

Line Weight Quality and Direction

Line weight can be applied to spatial representation. Lines that become light or thin generally appear to recede into the background. Closely related is line quality: Sharp and diminishing detail can have a marked effect on the perception of depth. Due to the physiology of our eyes, we are not able to focus clearly on both close and distant images simultaneously. Close objects appear sharp and detailed to the normal eye, and objects at a distance appear hazy or out of focus (see Figure 5-12). You can also make use of lines that follow a surface direction to emphasize the depth illusion (see Figure 5-13).

FIGURE 5-12
Ottumwa shopping center.

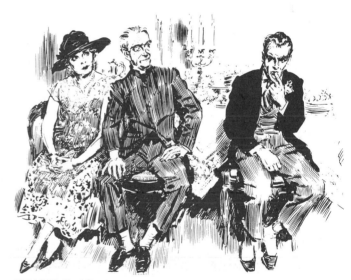

FIGURE 5-13
Surface Direction.

FIGURE 5-11
Untitled. Alvis Upitis, photographer.

Value Contrast

Shading, or value contrast, is often used to enhance the illusion of depth. Assuming the light source is at the picture plane, objects in the foreground are light in value. Other objects become gradually darker as they are placed farther away from the picture plane. The value contrast is directly related to the position of the light source (see Figure 5-14).

FIGURE 5-14
Judith Roode. Pinwheel.

Gradation

A device that was not specifically mentioned but is included in many of the preceding devices is gradation. A gradual increase or decrease of size, color, clarity, texture, or value may be employed to enhance the depth illusion. The regularity of the gradient intensifies the depth effect.

Convergence

At first glance parallel line convergence may be thought to be parallel perspective; however, convergence is often used in an arbitrary manner, without adhering to the rules of linear perspective. Convergence is a natural perceptual phenomenon which occurs when we view parallel lines such as railroad tracks or a highway that disappear at the horizon. It is a very effective method of achieving the depth illusion (see Figure 5-15).

Linear Perspective

Linear perspective is a method of reproducing the appearance or giving the illusion of reality on a flat plane called the picture plane. The following basic concepts are common to all types of linear perspective: You, the draftsman, stand in one position and, in essence, see with one eye. The point where you are standing is referred to as the *station point*. The *picture*

FIGURE 5-15
Circular theatre entrance. Bonnie Printz, photographer. © Bonnie Printz, 1981.

plane is at right angles to the direction in which you are looking. This direction is referred to as the *line of vision*. It is an imaginary line extending from the eye to the object you are drawing. The horizon is assumed to be at infinity. This is called the *horizon line.* At various positions on the horizon line, *vanishing points* are established. The vanishing point will vary depending on the type of perspective you are using. It should be noted that the horizon line always appears at the same height as your eyes. When drawing interiors the horizon line is usually referred to as the *eye-level line.*

The rules of perspective were first established by the

FIGURE 5-16
E. J. Peak. Grain elevator.

ancient Greeks. Later, the Romans executed paintings and mosaics with excellent use of perspective principles. Lost in the Dark Ages, the rules of perspective were rediscovered and perfected during the Renaissance.

The most common types of linear perspective are *parallel,* or *one-point, perspective* and *angular, or two point, perspective.* Perspective drawing, a type of pictorial drawing, cannot be used satisfactorily for showing dimensions or for showing construction, because the sizes of the various parts will not be in proper proportion to each other. Parallel perspective is mainly used for drawing an object that has little depth. There is detail on the front, but the sides are of little interest, such as in Figures 5-16 and 5-17. Or parallel perspective can be used in a interior view where all surfaces are of interest to the viewer, as in Figure 5-18. Angular perspective is used by the visual artist when both the front and side are important to the comprehension of the object. Drawings of this type are especially useful to interior designers, architects, and product designers and to fine artists for making pictorial drawings of proposed projects. This is shown in the cityscape (Figure 5-18) as well as in the drawing of the typewriter (Figures 5-19 and 5-20).

Lesser used types of perspective are *three-point perspective, amplified perspective,* and *simultaneous*

FIGURE 5-17
Hiroshi Fukushima. Easy English teaching machine.
Photo: D. Kareken.

FIGURE 5-18
Gerry Allen. Pin-Ball Room. Courtesy Criterion/Gerry Allen.

FIGURE 5-20
Hiroshi Fukushima. Typewriter. Courtesy H. Fukushima.

FIGURE 5-19
Robert Coppola. Untitled.

FIGURE 5-21
James D. Howze. Transformation and Reincarnation of the "A" Train. Courtesy James D. Howze.

perspective. In three-point perspective a vanishing point is provided for the vertical components in addition to both sides, as in angular perspective. Three-point perspective was chosen for the drawing in Figure 5-21 because vertical convergence is of more importance in objects that are taller than they are wide and because the visual artist wanted to show more of the top than the sides. Notice how the amplified perspective in Figure 5-22 is used to exaggerate the size of the sandwich.

Contemporary visual artists have experimented with modifications of the rules of linear perspective. Many visual artists have changed the static spatial unity of linear perspective by using a number of vanishing points and horizon lines simultaneously within one piece of work. This is often called simultaneous, or multiple, perspective. It tends to give the viewer more

of a feeling of moving through space than does a normal perspective system. It can introduce the concept of time or the representation of the passage of time. Can you think of an example of simultaneous perspective?

In conclusion, linear perspective gives a set of rules for accurately dealing with forms in space. However, it restricts the spatial relationships to one angle of vision

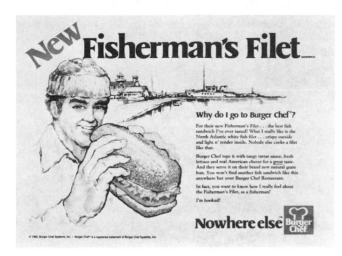

FIGURE 5-22
Fishermans Filet ad. Courtesy Burger Chef Systems, Inc.
Photo: S. Hammack.

and a fixed point of view. If a realistic depth illusion is to be achieved by the use of perspective, it is helpful to be familiar with objects and their actual three-dimensional characteristics. The viewer of today is visually orientated and is used to viewing a wide range of visual media. For example, we are ac-

customed to seeing objects from a perspective that the unaided eye can not achieve in comfort, such as macro views or ant's eye views. As a result, viewers are willing to accept images that differ from their natural perceptions. Consequentially, you, the visual artist, can take certain liberties with perspective without alienating the viewer.

TECHNICAL DRAWING SYSTEMS

Orthographic projection

Another type of drawing system of a more technical nature is orthographic projection. An orthographic projection shows multiple views of the same object simultaneously. *Ortho* means true or correct, and orthographic drawings show the length, width, and depth of an object with separately drawn views representing the shape of each surface as it is viewed from directly in front of your eye. The views of the object are generally arranged on the page with the top view directly above the front view, and the side view located to the right of the front view. In Figure 5-23 a piece of flat-

FIGURE 5-23
Johannes Gaston. Knife orthographic drawing.

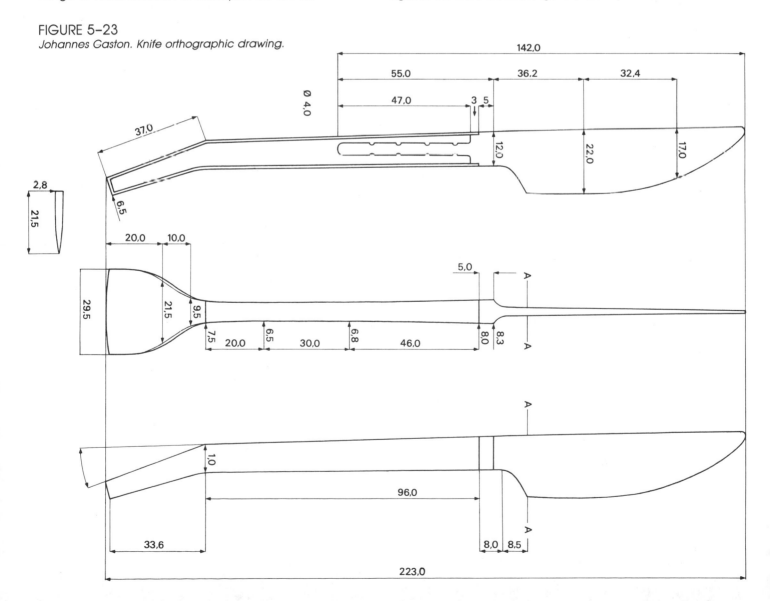

ware is drawn showing a side view, a top view, a cross-section of the blade, and a section view. An orthographic drawing should indicate, as this figure does, the exact dimensions, true shape, construction, and assembly of the object. Written instructions, referred to as specifications, are usually included to indicate the type of material, finish, tolerances, and other pertinent information. This type of drawing is widely used in the product design profession; however, it is also a very useful tool for visualizing any three-dimensional form. You would probably use drawings of this type if you were to commission an individual to construct an object you designed. You will be doing orthographic projections in the problems in the next chapter.

Isometric Drawing

Another technical drawing method that you should be aware of is isometric drawing. The word *isometric* means having equal angles. In this type of drawing, it refers to the equal angles at which the sides are drawn to extend away from the near corner. Isometric

drawings may show limited dimensions and construction methods, or they may be purely pictorial as in Figure 5–24. None of the views shown in an isometric drawing are the true shape. The object is drawn showing three sides, as though it were being viewed from one corner, like angular perspective. Unlike angular perspective, the sides extend away from the near corner at 30 degrees from an imaginary horizontal line. Each of the parallel lines in an isometric drawing represents the true length of the object being drawn. If the drawing is correctly made and the scale of the drawing is known, it can be used to construct the object.

COMPUTER-AIDED DRAWING

A tool that can be used in making isometric and many other types of drawings is a computer linked with a plotter. I would suggest that you become computer literate, that is, familiar with basic languages, programming, and the operation of computers. Computers and CAD (computed-aided design) are already widely used in industry and the visual arts. Imagine how much more prevalent they will be in the years following your entry into the profession. Even the figure drawing in Figure 5–25 was done by a computer.

DISCURSIVE DRAWING

The final method of drawing to be covered is discursive, or freehand, drawing, which hardly needs to be defined. It is mentioned only in the hope that the aforementioned methods of drawing and spatial representation will be analyzed and their principle con-

FIGURE 5–24
X–237. Hiroshi Fukushima , illustrator.

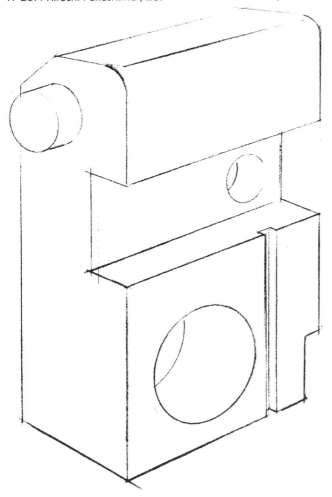

FIGURE 5–25
A computer generated "figure" drawing. Bell Labs.

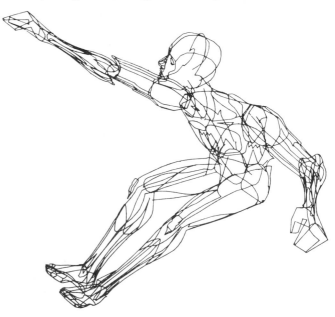

cepts applied as you make observational sketches, drawings from verbal descriptions, and other drawings to aid you in communicating your ideas.

I am assuming you are now having or will be having a more concentrated drawing experience. The projects that follow have been useful and often exciting to former students. Although I do not believe that it is mandatory for you to perfect drawing skills to be a successful visual artist, I do believe it is essential for you to be able to think and to communicate your thoughts visually. Being able to draw reasonably well is a great asset to the visual communicative process. Consequentially, the following problems are both problem solving and technical in nature. Let's begin by drawing a simple form, the common paving brick, in all possible views in parallel perspective.

PROBLEM 5-1: Parallel Perspective

Materials: Drawing paper
Size: 12″ × 18″
Medium/Tools: 2H and 4H drawing pencils, T-square, triangle, architect's scale
Task/Considerations: Draw the contours of a common paving brick (appoximate size: 2½″ × 3½″ × 8″) in nine positions. These positions are: centered on, above, and below the horizon line, to the right and to the left of center on the horizon line, and so on (see figure 5–26).

Note: Draw the views with your 4H pencil. Draw over the object lines with your 2H pencil, leaving the guidelines very light. Be prepared to draw the brick to scale, as nine full-size bricks will not fit on the paper. For additional work, divide the surface of the bricks into equal parts *according to the rules of perspective*. Draw bricks divided into thirds, fourths, or even smaller divisions. This is the same principle that is used to evenly space fence posts, telephone poles, and so on.

FIGURE 5–26
D. Kareken, illustrator.

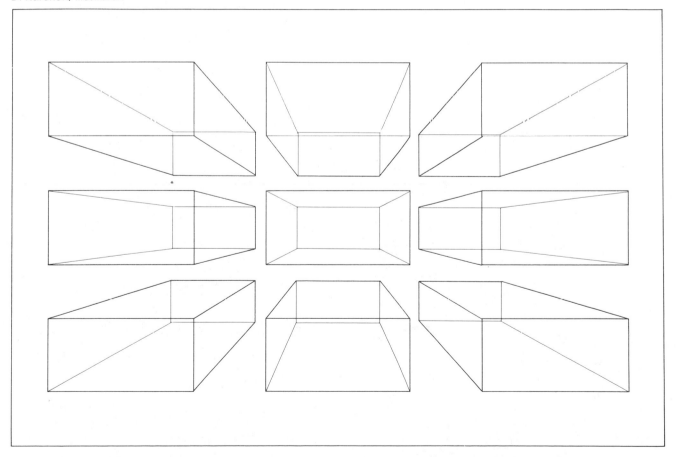

A cube is considered the basic form in perspective. It can be multiplied or divided so as to give you any combination of height, width, or depth. Any three-dimensional object can be drawn by starting with the cube. Experiment with derivations of the cubic form in the following problem.

PROBLEM 5-2: Parallel Perspective Development

Materials: Illustration board and other materials to be specified

Size: 20″ x 30″, 3″ border, all sides

Medium/Tools: Ruling pen and others to be specified

Task/Considerations: Create the illusion of the third dimension by positioning a number of shapes within the work area. Use any device that you deem necessary to create the depth illusion. You may move the position of the vanishing point or have multiple vanishing points if you so desire. The entire drawing is to be achieved by the use of parallel, or one-point, perspective. Note: The composition will be repeated in Parts 1, 2, 3, and 5. Part 4 requires a different composition.

PART 1: A linear rendition with open shapes (Figure 5–27).

Medium/Tools: India ink, ruling pen, T-square, triangle, etc.

FIGURE 5–27
D. Lucker.

PART 2: A textural rendition using implied texture to create the depth illusion (Figure 5–28).

Medium/Tools: Photographs, magazine cutouts, halftone transfer sheets, cross-hatching, stipple tone, etc.

FIGURE 5–28
D. Lucker. S. Hammack, photographer.

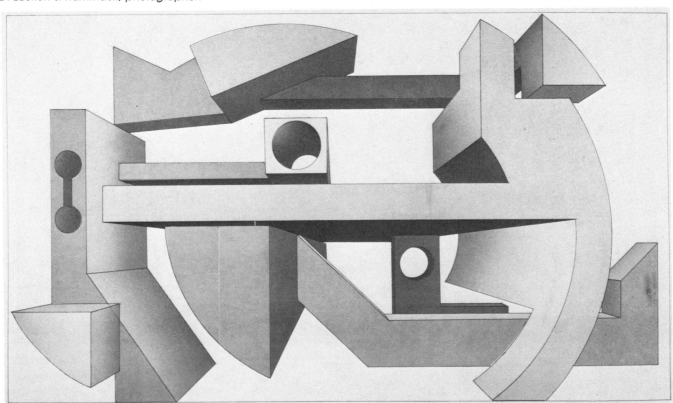

PART 3: A colored rendition exploring the ranges of value, intensity, and hue to achieve the depth illusion (Figure 5-29 in color insert).

Medium/Tools: Paint, paper, ink, etc.

PART 4: A change of station point.

Move the observer to the right or to the left 90 degrees and draw the composition from that position. Note: only you know how these shapes appear. Are there any *surprises* (cut aways, negative areas, etc.) that are hidden from the front view? You may wish to draw Part 5 before attempting this part. (See Figure 5-30.)

Medium/Tools: optional

PART 5 (optional): Give the *illusion* of transparency to Part 3.

Medium/Tools: Opaque colored paper

FIGURE 5-30
D. Lucker. S. Hammack, photographer.

The basic forms from which all others are derived are the cube, sphere, cone, and cylinder. If you can draw these forms correctly, theoretically, you can draw anything.

PROBLEM 5-3: Angular Perspective Development

Materials: Illustration board
Size: 15" × 20", no border
Medium/Tools: India ink, ruling pen, and a range of drawing pencils
Task/Considerations: Compose and draw seven objects, using angular, or two-point, perspective. The following objects are to be included in the composition: a cube, a triangular pyramid or a tetrahedron, a cone, a horizontal rectangle, a vertical rectangle, a cylinder, and an object of your choice leaning against one of the above objects. Some of the objects must be shown above and below the horizon line. Do not show guidelines or construction lines on the final presentation.

PART 1: A linear rendition with the objects shown as transparent
PART 2: A shaded rendition of opaque objects.

Select a light source and show the effect of light and shadow on the objects. A postulate to use in shading a surface is to use a minimum of three values per side per object. Pay particular attention to the reflection of light from the surface of one object to another. It is suggested that you use a range of drawing pencils to develop the dimensional characteristics of the objects. (See Figures 5-31 and 5-32.)

FIGURE 5-31
D. Lucker. S. Hammack, photographer.

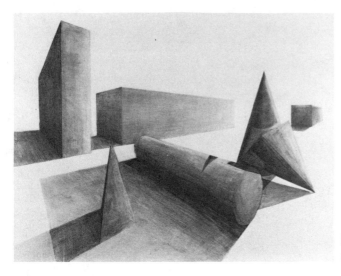

FIGURE 5-32
D. Lucker. S. Hammack, photographer.

PROBLEM SOLVING/ DRAWING METHODOLOGY

The next four problems are not the type of drawing problems that you might be assigned in a typical drawing class. They could be categorized as process or method types of problems in that they ask you to do one of the following: (1) to thoroughly analyze an object and then apply the information gained from that analysis to another project; (2) to use one drawing or part of a drawing to generate another drawing or series of drawings or objects; (3) to predict the effect on the environment or to develop an object for a specific environment. These problems deal with giving form to a concept that is described verbally. This is a method that is widely used in industry to develop new products.

I believe that anyone can learn to draw adequately if he or she is familiar with the object that is to be drawn. This familiarity can only be gained through a great deal of intensive observation. Problem 5-4 will introduce you to one procedure for gaining familiarity.

PROBLEM 5-4: Object Investigation

Materials: A fruit or vegetable, drawing paper
Size: Optional
Medium/Tools: Optional
Task/Considerations: Each member of the class is to acquire the same kind of fruit or vegetable. You are to have it on your person at all times, twenty-four hours a day—when you are sleeping, taking a shower, on a date. Document by any means—visual or verbal—changes in the form, color, texture, size, etc. After one week's time, return the object to your instructor. Can you identify your object when it is put in a pile with the rest of the ones in the class? Could you pick it out blindfolded? Most students are able to do so!

PART 1: Objective drawing

Represent the object in a lifelike or factual manner from all views. Indicate contour, dimensions, hue, value range, texture, details, etc.

PART 2: Hypothesis drawing

By an analysis of the exterior of your object, visualize and record how the interior would appear in cross and longitudinal sections.

PART 3: Dissection drawing

Dissect the object. Visually and verbally record your observations.

PART 4: Structural drawing

Analyze and diagram the interior and exterior structure of your object. How does it maintain its form?

PART 5: Social/Environmental analysis. Visually analyze the function of your object.

What role does your object play in relationship to you and the environment? How is it used? What are its by-products? List verbal and sym-

bolic associations of the object, for example, *"an apple a day...."*

PART 6: Essence analysis ten to fifteen drawings

Simplify the object by going through a distillation process until you arrive at the essence of the object—its basic characteristics; its distinctive qualities; the fundamental nature of the object. Remember Problem 2–3, Positive/Negative Character? This is essentially the same concept. What

is needed to make your object recognizable as that object?

PART 7: Development of an "owner's manual"

Communicate the purpose and function of the object and the directions for its use to someone who is unfamiliar with your object. You might consider developing a manual for an individual who does not speak your native tongue. Figures 5–33, 5–34, and 5–35 show three pages from an owner's manual.

FIGURE 5–33
Student unknown. L. Moran, illustrator.

FIGURE 5–34
Student unknown. L. Moran, illustrator.

FIGURE 5–35
Student unknown. L. Moran, illustrator.

Often, illustrations are done from photographs or composed from components, that is, parts of several photographs can be combined to make one illustra-

tion, as shown in Figure 5–37. The following problem is an introduction to the process of drawing from a photographic source.

PROBLEM 5-5: Figure Translation

Materials: Optional
Size: Optional
Medium/Tools: Pencil, others to be specified
Task/Considerations: Photograph a single human figure. Be highly selective; you will have to work with the image for a long time. Mount the photograph on a board large enough to provide a 3″ border on all sides (Figure 5–36).

PART 1:

Enlarge the image a minimum of two times. Complete a lifelike rendering, striving for a photographic illusion (Figure 5–37).

PART 2:

Select a 3″ × 3″ area that contains a wide range of values. Isolate and trace the range of values. This tracing will be considered as the plan for Part 3 (Figure 5–38).

PART 3:

Medium/Tools: Foam core board, or polystyrene. Translate the values in Part 2 to a 9″ × 9″ relief construction. Equate value with distance from the plane, that is, high relief equals a light value, low relief equals a dark value, (Figure 5–39).

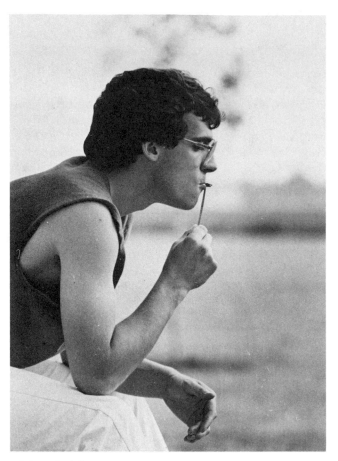

FIGURE 5-36
D. Byers, student artist and photographer.

FIGURE 5-37
D. Byers. S. Hammack, photographer.

FIGURE 5-38
D. Byers. S. Hammack, photographer.

FIGURE 5-39
D. Byers. S. Hammack, photographer.

PART 4:

Medium/Tools: Optional. Pastels, colored pencils, CRA-PAS, crayons, felt pens, are suggested. Enlarge the 3″ × 3″ area from Part 2 at a scale of 1″: 10″. Deal with the color in an arbitrary manner; it does not have to relate to the natural coloration of the figure or to the color usage in the previous assignments (Figure 5–40 in color insert).

CLASSIFICATION OF IMAGERY

Abstraction

The previous problem introduced you to a method of abstracting an image. Often a visual artist is called on to deal with a visual image in an abstract manner. If an abstract image exists, then it is derived from another image. To abstract means to change. There are many ways to change, and many degrees of change. The following is a compilation of some of the ways to change the visual characteristics of an image or object.

Can you visualize visual arts solutions that have made use of one or more of the above? Do you consider this an example of abstraction (Figure 5–41)?

Representation Imagery

Abstraction can best be understood by comparing it to two other classifications of imagery. You are generally able to recognize an image or form as representational, realistic, or lifelike. In its purest form, the image appears recognizable; if you compared it to the real object, you would be able to see little difference between the two. A visual artist may take liberties and

Simplification	Extension of shapes within the picture plane	Motion illusion
Selective focus: select and emphasize significant areas	Change in size relationships, scale	Progression
Arbitrary use of color	Repeat pattern, visual texture	Attitude, connotation
Distortion in perspective or proportion, elongation	Overlapping of objects	Metamorphosis
Rotation	Flattening of areas	Anthropormorphic treatment
Multiple views, simultaneous views	Exaggeration of areas	Function
Angular shapes and forms	Decomposition of surface	Multiple exposure
Transparency	Shifting orientation	Image juxtaposition
		Stylization

FIGURE 5–41

Ivan Albright. Into the World Came a Sould Called Ida. 1929–30. Courtesy of The Art Institute of Chicago.

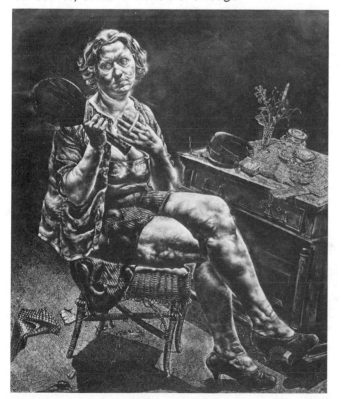

make minor changes when translating from the object to the image; however, the image would still be considered a representational work.

Nonobjective Imagery

Another classification of imagery is nonobjective. A nonobjective work is developed entirely from conscious and subconscious decisions on your part to use a specific line, shape, color, texture, or other components in a specific position in the composition. Many abstractions may appear as nonobjective images, such as the solution to Problem 5–5, Part 4. Technically, this is not a nonobjective image since you began with a photograph of a figure. Figures 5–42, 5–43, and 5–44 illustrate representational, abstract, and nonobjective images.

As stated earlier, abstraction deals with change. The following problem asks you to imagine a change in the environment.

Recorded history has told of disasters since the time of Noah and the building of the ark. Today, the newscasts are filled with stories of disasters throughout the

FIGURE 5-42
David Graves. 41 Lincoln. *D. Kareken, photographer.*

FIGURE 5-43
Joy Broom. Berliner Dog Series. *Courtesy J. Broom.*

FIGURE 5-44
Leonard Koenig. Untitled. 1979.
Courtesy L. Koenig.

world (Figure 5-45). Some are natural disasters, such as the eruption of Mount St. Helens, while others have a human cause, such as buildings collapsing or air raid attacks. Can you imagine what changes would be made in your environment if it were hit by such a disaster?

FIGURE 5-45
Watch our weather. F. Young, photographer.

PROBLEM 5-6: Disaster

Materials: Optional
Size: Optional
Medium/Tools: Optional
Task/Considerations: Select a local franchised restaurant, such as Kentucky Fried Chicken or McDonald's, and do a drawing of it under nor-

mal conditions. Select a natural or deliberate disaster. Develop a drawing that envisions the result of the disaster on the establishment. You may choose to do an interior or exterior view of the selected establishment. (See Figures 5-46 and 5-47).

FIGURE 5-46
D. Lucker. S. Hammack, photographer.

FIGURE 5-47
D. Lucker. S. Hammack, photographer.

The following project was given to me several years ago. Due to my love of nature, I enjoyed the problem's challenge so much that I have included it here.

PROBLEM 5-7: Quadruped Mammal

Materials: Illustration board

Size: 15″ × 20″

Medium/Tools: Optional

Task/Considerations: Develop a four-footed mammal that lives in a hot, arid climate (110° F). The land is rocky and surrounded by cliffs with deposits of broken shale at the base. The shale is so sharp that it would cut an ordinary boot or the feet of most animals. The mammal feeds on small swift snakes it finds under the rocks, (some of the rocks are many times the mammal's size) and on darting lizards that live in the shale. The whole area is infested by biting flies that provide food for the snakes and lizards. Nature has in some way given the mammal natural protection against the large bird that preys upon its species. The mammal is no match for another predator, a catlike animal that appears at nesting season to eat its young. However, the mammal is able to perpetuate himself. Note: The mammal has to function in this environment.

FIGURE 4-19 *City. D. Butterworth. F. Young, photographer.*

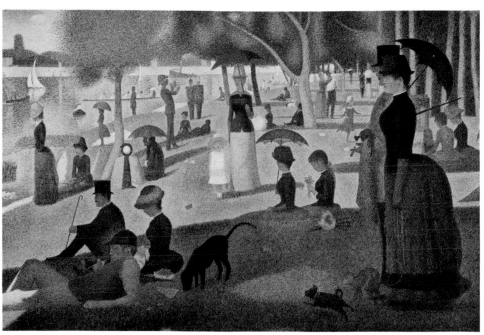

FIGURE 4-20
Georges Seurat. Sunday After-
noon on the Island of La Grande
Jatte. *1884-46. Courtesy of The Art
Institute of Chicago.*

FIGURE 4-26 *Optical mixture. D. Kareken. F. Young,
photographer.*

FIGURE 4-27
Rebecca Alston. Ambient tone created by parative color. *Courtesy R. Alston.*

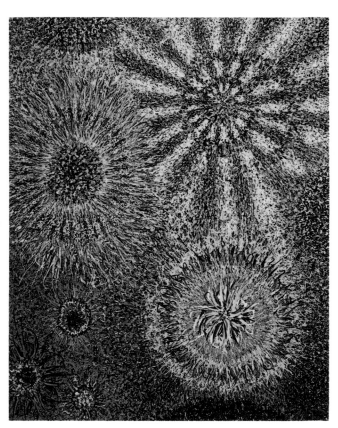

FIGURE 5-10 *Aribert Munzner.* Genesis-80-1. *1980. Courtesy A. Kenneth Olson. Photo: A. K. Olson.*

FIGURE 5-29 *D. Lucker. S. Hammack, photographer.*

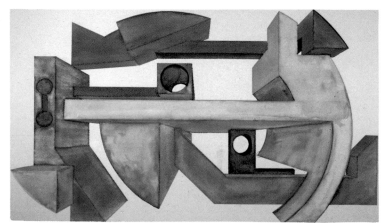

FIGURE 5-40 *D. Byers. S. Hammack, photographer.*

FIGURE 6-17 *Cork Marcheski. Untitled.*

FIGURE 6-38 *Balloon form. G. Dreisbach.*
F. Young, photographer.

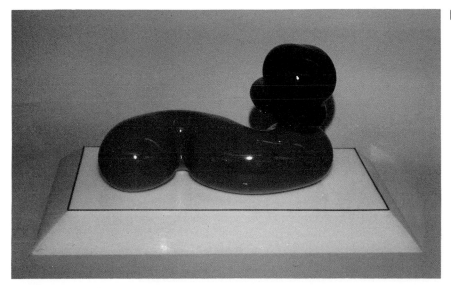

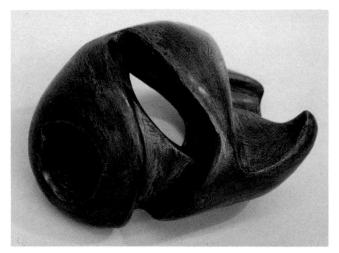

FIGURE 6–39 *G. Dreisbach. F. Young, photographer.*

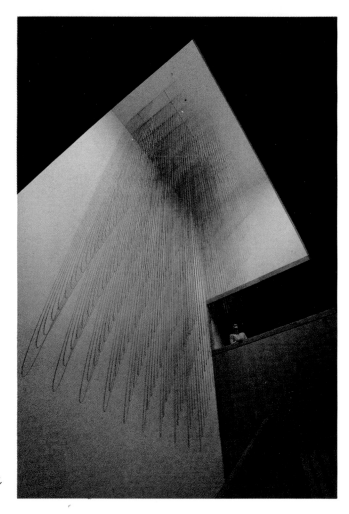

FIGURE 6–40 *L. P. Kirkland. Tsunami. E. Hershberger, photographer.*

FIGURE 6–41 *Mark Harris. Game board. Courtesy M. Harris.*

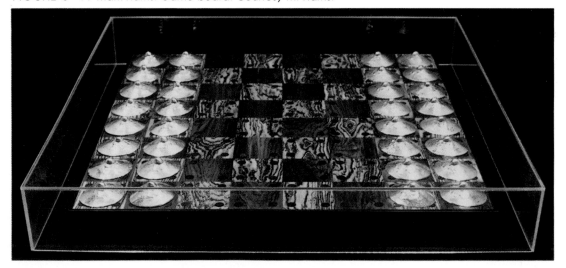

Problem considerations: How does the mammal catch the snake? How does the mammal traverse the shale? How is the mammal protected from the bird? How is the mammal protected from the biting flies? How does the mammal escape extermination from the catlike animal? Illustrate the environment, the mammal, and the nest. A descriptive text should accompany the illustration. (See Figure 5–48.)

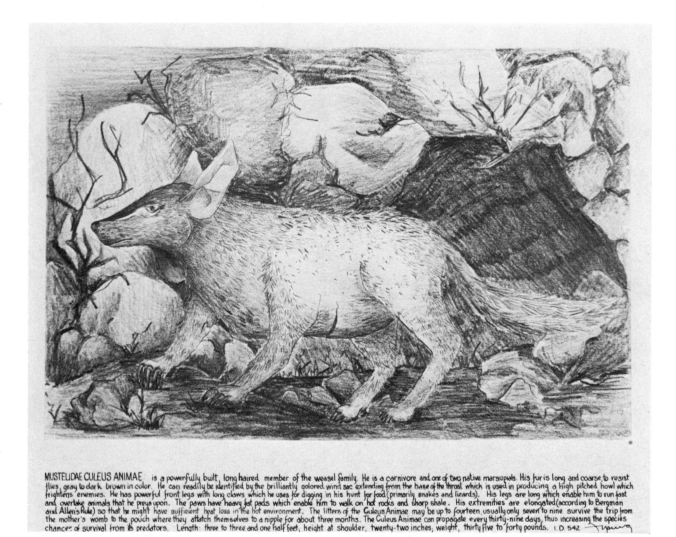

MUSTELIDAE CULEUS ANIMAE is a powerfully built, long haired member of the weasel family. He is a carnivore and one of two native marsupials. His fur is long and coarse to resist flies, gray to dark brown in color. He can readily be identified by the brilliantly colored wind sac extending from the base of the throat which is used in producing a high pitched howl which frightens enemies. He has powerful front legs with long claws which he uses for digging in his hunt for food (primarily snakes and lizards). His legs are long which enable him to run fast and overtake animals that he preys upon. The paws have heavy fat pads which enable him to walk on hot rocks and sharp shale. His extremities are elongated (according to Bergman and Allen's Rule) so that he might have sufficient heat loss in the hot environment. The litters of the Culeus Animae may be up to fourteen, usually only seven to nine survive the trip from the mother's womb to the pouch where they attach themselves to a nipple for about three months. The Culeus Animae can propagate every thirty-nine days, thus increasing the species chances of survival from its predators. Length: three to three and one half feet; height at shoulder, twenty-two inches; weight, thirty five to forty pounds. I.D. 542

FIGURE 5–48
F. Young/J. Janas. Musletidae Culeus Animae.

The next two problems deal with getting to know ourselves. I believe it is essential for you to know yourself in order to function in the visual arts profession.

PROBLEM 5-8: Object: Self-Integration

Materials: Illustration board
Size: 10″ × 15″
Medium/Tools: Optional
Task/Considerations: Analyze your appearance, stature, personality, personal habits or quirks, and so on. Choose an object, manufactured or natural (plant, animal, or mineral) that *is* you or how you perceive yourself. Draw yourself and the object as one being. Note: This is *not* a cartoon. (See Figures 5–49 and 5–50).

FIGURE 5-49
J. Henning. F. Young, photographer.

FIGURE 5-50
D. Lucker, S. Hammack, photographer.

PROBLEM 5-9: Self-Image: Past/Present/Future

Materials: Optional
Size: Optional
Medium/Tools: Optional
Task/Considerations: Develop a list of characteristics that describe you in every conceivable manner. Consider your physical and emotional traits, your name(s), your past, present, and future, your goals, successes, and failures, your relationships. Do not share this list with other students. However, you may want to solicit their opinion. Translate the verbal information into a visual image or images. Capture your essence. Be able to communicate to the viewer what you are all about. What does this example communicate about the couple? (Figure 5–51). (See Figures 5–52 and 5–53.)

FIGURE 5–51
Grant Wood. American Gothic. *1930. Courtesy of The Art Institute of Chicago.*

FIGURE 5–52
T. Betke. L. Moran, illustrator.

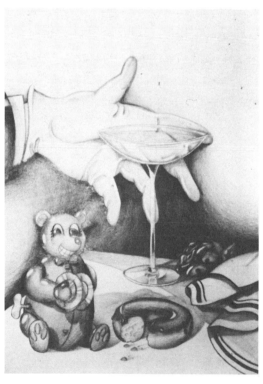

FIGURE 5–53
R. Lahti. F. Young, photographer.

SUGGESTED READINGS

BEAKLEY, GEORGE C. *Freehand Drawing and Visualization.* Indianapolis: Bobbs-Merrill Educational Publishing, 1982.

BRO, LU. *Drawing a Studio Guide.* New York: W. W. Norton & Co., 1978.

DOBLIN, JAY. *Perspective: A New System for Designers.* New York: Whitney Library of Design, 1969.

HANKS, KURT, and LARRY BELLISTON. *Rapid Viz.* Los Altos, Calif.: William Kaufmann, 1980.

HARTMANN, ROBERT R. *Graphics for Designers.* Ames: Iowa State University Press, 1976.

HASTIE, REID, and CHRISTIAN SCHMIDT. *Encounter With Art.* New York: McGraw-Hill Book Company, 1969.

PORTER, TOM, and SUE GOODMAN. *Manual of Graphic Techniques 2.* New York: Charles Scribner's Sons, 1982.

PORTER, TOM, and BOB GREENSTREET. *Manual of Graphic Techniques.* New York: Charles Scribner's Sons, 1980.

SIMMONS, SEYMOUR, and MARC S. A. WINER. *Drawing: the Creative Process.* Englewood Cliffs, N.J.: Prentice-Hall, 1977.

Three-Dimensional Form:

6 Analysis/ Manipulation

Why teach three-dimensional studies? Most foundation texts omit the subject or treat it superficially. Many schools teach only two-dimensional studies, relegating three-dimensional studies to the sculptors. However, this is beginning to change; more schools are offering three-dimensional courses as part of the foundation program. You are, by the very fact of living, experiencing a three-dimensional world, but in most instances you have been given a two-dimensional orientation to your environment. Primary and secondary schools tend to stress two-dimensional mediums and imagery. As a result you are forced to translate three-dimensional forms instead of experiencing them in reality. The visual arts student must be equipped to solve problems in both two- and three-dimensional modes.

COMMON PROBLEMS WITH THREE-DIMENSIONAL STUDY

During my teaching career I have found that students generally experience the following problems when confronted with three-dimensional studies for the first time:

> A failure to visualize and comprehend three-dimensional form
>
> A lack of experience in transferring two-dimensional images to three-dimensional forms
>
> A difficulty in form analysis and classification
>
> Unfamiliarity with the use of three-dimensional materials, tools, machinery, and processes

Three-dimensional studies expose you to the basic aspects of form and instill an awareness of the form-space relationship and an understanding of the manipulation of form. During your exposure to three-dimensional studies, you will begin to think three-dimensionally; that is, you will learn to visualize three-dimensionality. Your tactile sense tends to be revived, cultivated, and coordinated with your visual sense. A three-dimensional work must visually function in all directions and from all vantage points whereas the two-dimensional pieces you completed previously had only to function visually from the frontal plane. You will find that you will generally have to devote more time to the work in this chapter. Working three-dimensionally is more complex than working two-dimensionally and, in my opinion, is more of a challenge. Begin to look at and analyze the three-dimensional forms in your environment. These forms may be described by any one or a combination of the following:

Can you think of other ways to describe a three-dimensional form? Our primary concern in this chapter is with only two of the above characteristics—form and the visual analysis of forms.

WHAT IS FORM?

The commonly accepted definition of *form* refers to the visual and physical structure of an object. Form is three-dimensional. A fundamental fact of human existence is that we live in three-dimensional space surrounded by stationary or kinetic forms. Human beings, like all objects, exist in a form-space relationship. Form cannot exist without space, and space is an aid to the perception and appreciation of form.

VISUAL ANALYSIS OF THREE-DIMENSIONAL FORM

The visual structure of an object may be classified. For the purposes of this course of study there are two major form divisions: *in the round and relief.* All objects, natural, manufactured, fine arts, or design products fall into one of these categories. Figure 6–1 illustrates in the round, Figure 6–2 illustrates relief, and Figure 6–3 exhibits qualities of both. These divisions may be further analyzed and categorized as *linear, planar,* or *solid form* or a combination of categories.

Visual artists tend to rely heavily upon the visual and tactile senses in working with form. The tactile senses are evoked during the conceptualization, material selection, construction, and evaluation of a three-dimensional object. It is through visual observation—that is, form analysis—that you can compare and contrast the visual structure of forms. A capacity for visual observation and analysis is essential if you are to recognize structural similarities and differences between objects in your environment. Once these

Size	Family or class of object (its relation to other objects)	Origin
Color		Sex (masculine, feminine, or neuter)
Visual contour, form	Value (light to dark)	
Texture, tactile quality	Value (monetary)	Environment
Olfactory quality (smell, odor, fragrance	Function	Thermal quality
	Structure	Living or dead
Weight, mass, volume	Component (part-to-whole relationship)	Animate or inanimate
Auditory quality (sound)		Integrated or articulated
Gustatory quality (taste)	Connotation	Mobile or stationary
Material (natural or synthetic)	Emotional or psychological value or effect	Dimensional qualities (first, second, third, fourth)
Natural or manufactured		Solid, liquid, or gas
Animal, plant, or mineral	Durability (life span)	Visual analysis (linear, planar, solid, or combinations)
	Strength	
	Density	

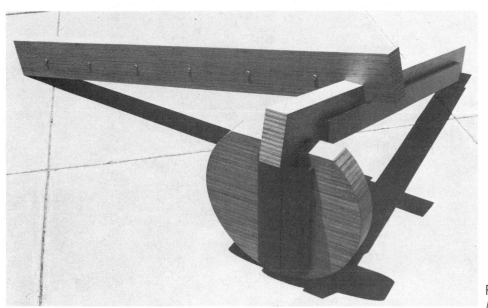

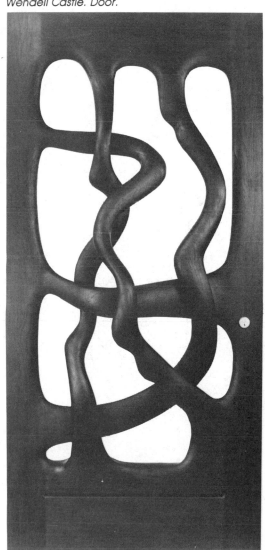

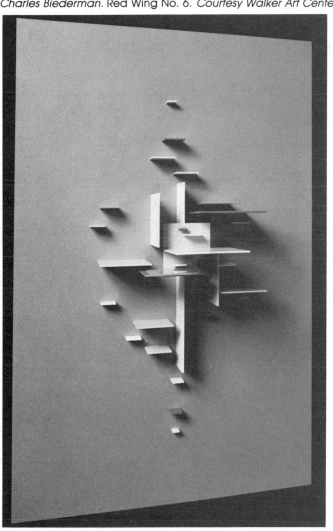

FIGURE 6–1
Robert Tobias. Untitled. 1975.

FIGURE 6–2
Charles Biederman. Red Wing No. 6. Courtesy Walker Art Center.

FIGURE 6–3
Wendell Castle. Door.

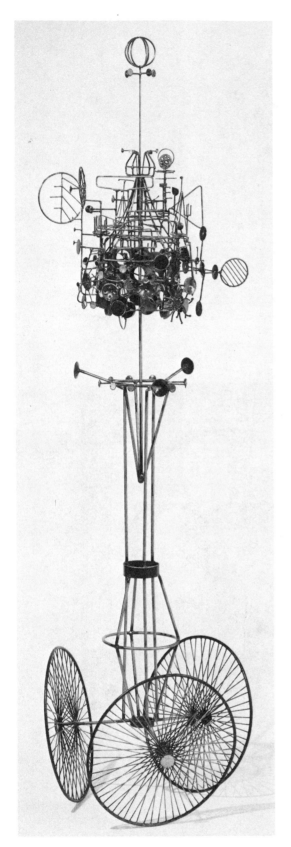

FIGURE 6-4
Joseph A. Burlini. Go Nowhere Machine. *Chicago Archive Photographing Co.*

FIGURE 6-5
Columns as solid form. S. Hammack, photographer.

FIGURE 6-6
Columns as linear form. S. Hammack, photographer.

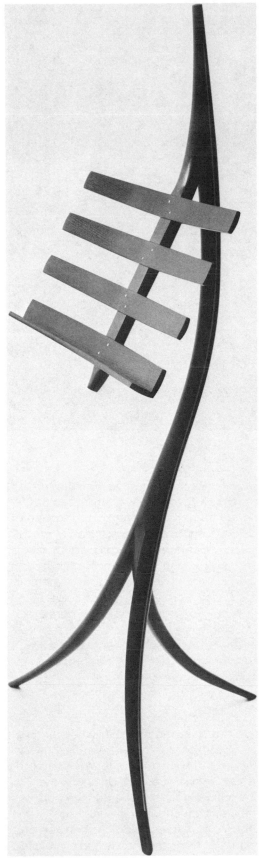

categories of form are obvious to you, your visual vocabulary is enriched. After working three-dimensionally for a period of time, after gaining some hands-on experiences, you will be able to look at a three-dimensional object, analyze the visual structure, be aware of the physical structure, know the construction process, and evaluate the form-space relationship. In other words, you will be equipped to make an aesthetic decision regarding a three-dimensional object.

It should be noted that the visual analysis and placing of objects into categories is based on your perception of the *dominant* visual characteristic of the object. The sculpture in Figure 6–4 would be categorized as linear form, even though it contains some planar elements. The analysis categories are somewhat subjective and open for discussion. I believe such analysis is a good practice and forces you to make well-founded comments. Classification is relative and can also be dependent on size–scale relationships. For example, in the closer view of the building in Figure 6–5, the columns appear as solid forms. However, from a distance, as in Figure 6–6, the columns would be classified as linear forms.

Linear Form

The basic component for visual form analysis as linear form is shown in the music stand in Figure 6–7.

It has been stated that a one-dimensional object is nonexistent in the environment. However true or false this statement may be, let us assume for purposes of visual analysis that a linear form is one possessing an exaggerated dimension, that of length. It is considerably longer than it is high or wide. In linear form, space is articulated with a minimum of mass, by a long thin element, such as the chairs in Figure 6–8.

FIGURE 6–8
Charles Eames. Wire chair. Courtesy Herman Miller, Inc.

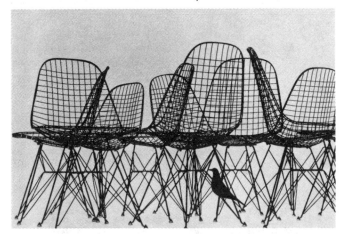

FIGURE 6–7
Wendell Castle. Music stand

FIGURE 6-9
John Mason. Untitled. Courtesy R. Sferra.

FIGURE 6-10
Sol Lewitt. Open Modular Cube, 1966. Art Gallery of Ontario, Toronto.

Since the linear form is much smaller than the surrounding space, its relationship is often in a rather delicate balance. Linear forms often appear skeletal or unfinished—in essence, out of proportion to the space. Since the linear form allows great quantities of space (i.e., the environment) to interact with it, it runs the risk of being overpowered by the environment. Constructing a specific environment that isolates the form is often the solution to this problem. Figure 6-9 illustrates careful placement within an existing environment in order to enhance the form. Another method of solving the problem is to use many lines and imply a greater mass as with Figure 6-10.

Planar Form

When width is added to length and thickness or height is still a minor aspect, planar form results, as shown in the table in Figure 6-11. The planar form is composed of long, wide, and thin shapes that articulate the space. In this book we will not adhere to the pure mathematical definition of a plane—a flat surface—for purposes of visual analysis. Any curved or otherwise irregular surface that has two exaggerated dimensions may be classified as planar form. An example is the piece of furniture in Figure 6-12; the mass is in greater proportion to space than it was in linear form. Would you classify this sculpture as a planar form? (Figure 6-13.)

FIGURE 6-11
Phil Van der Weg. Tension vector table—1979. J. Ross, photographer.

FIGURE 6-13
David Smith. CUBI IX. 1961. Collection Walker Art Center.

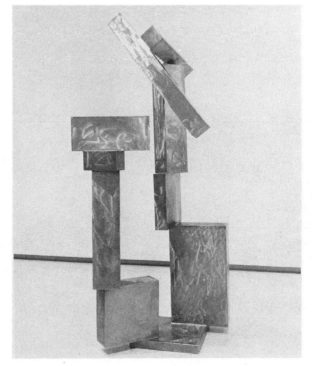

FIGURE 6-12
Wendell Castle, Settee.

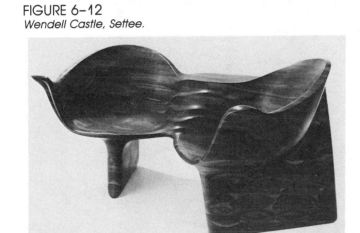

Solid Form

When space appears to be excluded from the form—when length, width, and thickness or height are near equilibrium, as in the laboratory product in Figure 6–14—a solid form exists. A solid form is completely surrounded by space; that is, it is defined by the space. It may exist as a monolithic form, a uniform mass not penetrated by space. In addition to the pure monolith, forms that contain concave and convex and negative areas may be categorized as solid form as long as the proportion of mass is greater than the space penetrating the form. This is exemplified in the automobile in Figure 6–15.

A further refinement of form analysis is the concept of implied form. An implied form has a visual structure that differs from its physical structure. You may find examples in all categories of visual analysis. The construction in Figure 6–16 appears to be solid but is actually hollow. Another method for implying form is shown by the projection of planes of light by the neon structure in Figure 6–17 (see color insert).

In a society composed of complex objects it is very common to observe objects whose visual analysis would be classified as combinations of the three basic categories. These categories may be combined to form the following: linear-planar, linear-solid, planar-solid, and linear-planar-solid form.

FIGURE 6–14
Gianfranco Zaccai. Blood separator. Courtesy Instrumentation Laboratory, Inc.

FIGURE 6–15
Porsche automobile. F. Young, photographer.

FIGURE 6-16
James Rosate. Wichita Tripodal. *Courtesy Public Information Office, Wichita, Kansas.*

FIGURE 6-18
Pablo Picasso. Untitled. K. Byrne, photographer.

FIGURE 6-19
Marcel Breuer. Wassily chair. Mettee Photography. Courtesy Thonet Industries, Inc.

Linear-Planar Form

Linear-planar form is very prevalent in the environment. These objects work well visually because the edge of a planar form is actually a linear form. This is exemplified by the Chicago Picasso sculpture (Figure 6-18) as well as the Wassily chair (Figure 6-19).

Linear-Solid Form

A classification of form that deals with a degree of contrast in form and often in the material used is linear-solid form. The solid form often has the primary visual function with the linear form often relegated to a supportive role. Examples include a telephone (Figure 6–20) and a sculpture (Figure 6–21). Do you think the linear form is subordinate to the solid form in these examples?

Planar-Solid Form

In planar-solid form the planer assumes a greater visual role than line did in the previous category as shown in the examples of sculpture, furniture, and product design in Figures 6–22, 6–23, and 6–24.

FIGURE 6–20
Henry Dreyfuss. Model 500 telephone. D. Kareken, photographer.

FIGURE 6–21
Ernest Trova. Study: Falling Man (Wheelman). Walker Art Center.

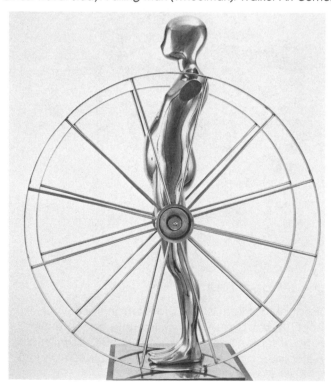

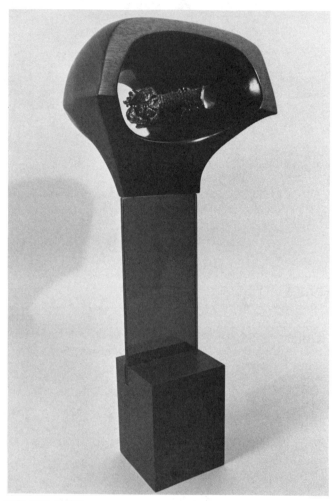

FIGURE 6–22
F. Young. Homage to Hoopeston—Sweet Corn Capital of the World—1972. D. Kareken, photographer.

FIGURE 6–23
Wendell Castle. Winged desk.

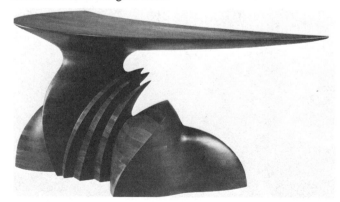

FIGURE 6–24
W. Robert Worrell Design. Kroy Typesetter. Courtesy W. R. Worrell and Knoy, Inc.

Linear-Planar-Solid Form

The most complex and widely used category is that of linear-planar-solid form. Most complex objects, especially mechanical objects such as the chemistry system in Figure 6–25, may be analyzed and categorized as such. A sensitive balance of these elements is shown in the sculptures in Figures 6–26 and 6–27.

These terms describing form provide a basic vocabulary that gives insight about three-dimensional visual structure. This can be a useful tool in solving assigned problems, analyzing your environment, and drawing relationships between the two.

FIGURE 6–26
Robert Clore. Cloud with Leashed Pointed Form. 1976.

FIGURE 6–27
George Mellor. One World #51. 1970.

FIGURE 6–25
Steve Rettew. Chemistry system loader. Courtesy Instrumentation Laboratory, Inc.

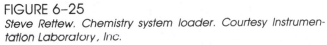

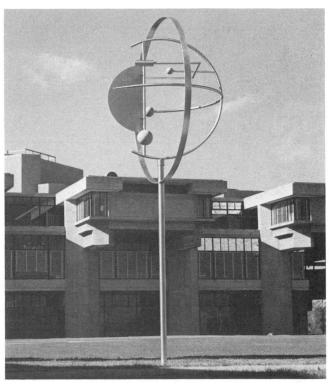

MATERIAL CHARACTERISTICS

In order to work three-dimensionally you need to consider the nature of the material and the process by which it is worked. The characteristics of a material may be classified as *plastic*—easily formed, such as clay, plaster, or polyester resin—or *rigid*, such as steel, marble, or oak. Material may take a linear form, such as steel rods; a planar form, such as plywood; or a solid form, such as a block of limestone.

BASIC THREE-DIMENSIONAL PROCESSES

All material types or forms may be worked by two basic methods: *additive* or *subtractive.* The additive method is a construction method. You put a number of parts together to make a completed object. Houses are built in this manner, as are some furniture, automobiles, and other manufactured products. The sculpture in Figure 6-28 was produced by this method. In the subtractive method parts are taken away from a solid form that is larger than the finished product. This may be achieved through a variety of methods, such as carving. Usually, the form of the object has progressively smaller pieces taken away until it reaches the final form of the object, as shown in

Figure 6-29, a styrofoam model of a proposed dental chair and in Figure 6-30, a wooden sculpture. Stone carvers as well as machinists working with metal use this method.

FIGURE 6-29
Hiroshi Fukushima. Dental patient chair—model. Kinji Yanaba, photographer.

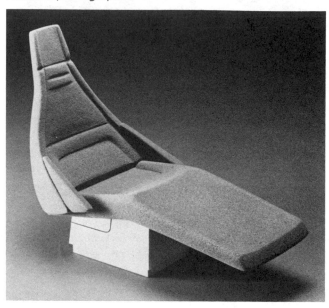

FIGURE 6-28
Robert Tobias. Untitled.

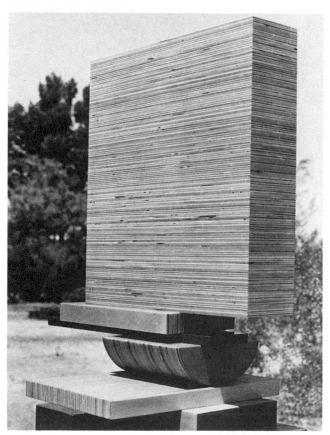

FIGURE 6-30
Barbara Hepworth. Figure: Churinga. 1952. Courtesy Walker Art Center. Eric Sutherland, photographer.

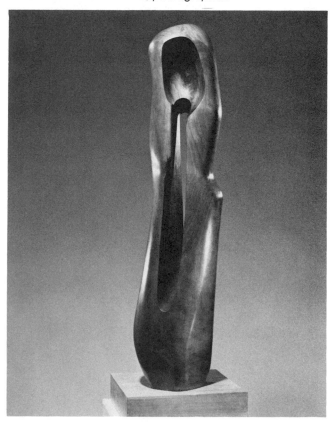

Linear and planar materials may also have their form altered by the bending or folding process. Bending was used to form the linear rings of the sculpture in Figure 6–31 as well as the side casement of the radio receiver in Figure 6–32. Linear, planar, and solid materials can also be altered by segmenting or cutting. However, this segmentation generally leads to re-assembly by the additive method, as exemplified by the extruded components of the radio in Figure 6–33.

It should be noted that the type of tool or machine used to alter the form affects the visual appearance of the form. What type of tools were used to create the form in Figure 6–34?

FIGURE 6–31
Jim Walton. Love seat sculpture. D. Kareken, photographer.

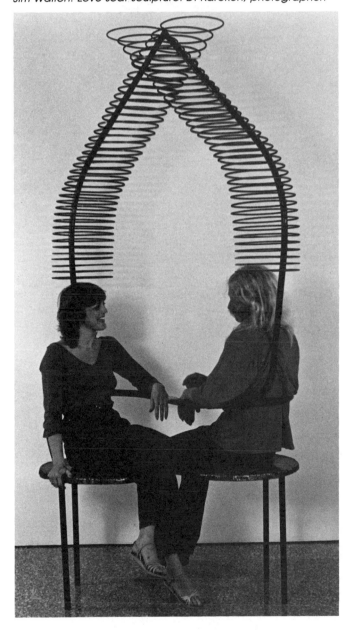

FIGURE 6–32
Robert DeBrey. Radio receiver.

FIGURE 6–33
Robert DeBrey. Radio receiver shell components.

FIGURE 6–34
Handtool form. Susan Petefish Gold. F. Young, photographer.

The process used also affects the visual appearance of the form: a cast bronze sculpture (Figure 6–35), for example, is different in appearance from the constructed sculpture in Figure 6–36. The hand used as a tool can also affect the surface quality and visual appearance of an object. This is evident in a piece of hand-thrown pottery. The metalsmith uses tools as extensions of the hand. However, it is still evident that the work is handcrafted. Power tools and machines are extensions of hand tools and have characteristics of their own. The above has been a general introduction to the nature of materials and the effect of processes and tools upon them. These considerations should not be overlooked as you work with three-dimensional form.

Hands as Tools

Humans are separated from lower primates by having a fifth digit, the thumb. Your thumb makes it possible for you to use your hands in a very sophisticated manner; your hand in effect becomes a tool. How often we take for granted, if not totally overlook, our *natural tools.* The hand or hands together are capable of squeezing, folding, beating, twirling, mixing, stretching, examining, smoothing, rubbing, tearing, breaking, punching, measuring, throwing, dropping, lifting, grabbing, holding, cupping, picking, kneading, pinching, pounding, crushing, and crumpling

FIGURE 6–35
Umberto Boccioni. Unique Forms of Continuity in Space. Civica Galleria d'Arte Moderna, Milano.

materials. What other tool could you find that is so versatile? Even if you could buy a tool to do all of the above, imagine what it would cost. I'm sure very few of us could afford to purchase such a tool if it did exist. Since the hand is your most basic tool, it is only fitting that you begin your studies of three-dimensional form using your hands.

You experienced the positive/negative spatial relationship heavily in the two-dimensional chapters. The same concepts apply to three-dimensional work. Assuming your hands are positive three-dimensional forms, make a void or negative area by cupping your hands together. Is the negative area created very interesting? Most people would rate it low in visual interest. As you will see in the following problem, we tend to underestimate negative space.

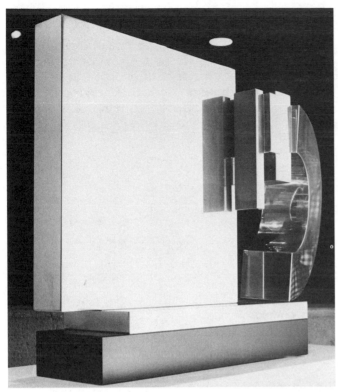

FIGURE 6-36
Robert Tobias. Untitled. 1981. Manley Commercial Photography.

PROBLEM 6-1: Hands as Form

Materials: Plaster
Size: Variable
Medium/Tools: Flexible mixing container
Task/Considerations: Divide into two- or three-person teams. Have one member mix a thick plaster solution. Pour the solution into the negative area formed by your cupped hands. Let the plaster cure.

Observe the concave/convex form created by the negative area of the hands. Compare your form with those created by your classmates. Are any of the forms alike? How does this compare with the positive/negative two-dimensional relationships? Is space real? Can it be ignored?

PROBLEM 6-2: Hands as Form Maker Within Constraints

Materials: Plaster

Size: Optional

Medium/Tools: Balloons, funnel, flexible mixing container

Task/Considerations: Purchase a large children's balloon. Stretch the balloon by pulling and inflating several times. With the help of a partner, insert a funnel into the neck of the balloon, hold the bottom, and pour a plaster solution into the balloon until it is quite full. Tie it off. Develop a concave/convex form by manipulating the balloon until the plaster cures. Note: Be careful not to rupture the balloon. Experiment with several form relationships during the curing period; be sure to have the balloon in its final form when the plaster starts to set. Plaster undergoes a thermal reaction; you will feel it get hot when it starts to set. Consider using multiple forms or *nesting* forms. (See Figure 6-37.)

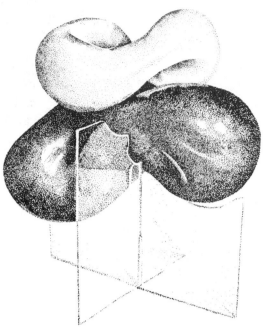

Nesting forms can be made by pressing a wet plaster-filled balloon form into or over another plaster form. Once the plaster has cured the forms will fit together, or *nest.* Also, consider pressing the wet plaster balloon into a base or presentation form. Plan ahead! When the plaster has cooled, cut the balloon from the plaster form so it can begin the drying process.

FIGURE 6–37
Nesting forms. S. Mars. L. Moran, illustrator.

At this time you may want to refine areas of the form. You may want to use a small piece of screen wire as an abrading device to make minor changes in the form before it dries. Be sure to retain visual evidence of the form-making process; your finished product should look like it was made by hand, not tools or machines. Before the plaster is dry you may want to patch some of the pinholes (caused by air bubbles) or cracks. The best time to patch the plaster is while your form is wet or cold to the touch. The form will usually take about a week to dry. If you want to accelerate the drying process, place the form near a radiator or warm air duct. Do not place in an oven or microwave; this will usually cause the form to crack. Once the form is completely dry, you may patch it with lacquer putty or water putty. If you choose to use these materials, be aware that the plaster is softer than the patching material. This may cause problems when you are sanding the patch area flush with the surface of the form. One of the natural qualities of plaster is that it will *dust* when it is dry: It will transfer a coat of white dust to your hands when it is handled or leave white marks on a surface where it is placed. Consider giving the form a finish to prevent dusting. In many cases this finish will also improve the appearance.

Among the appropriate finishes for plaster are paint, varnish, shellac, lacquer, wax, paste shoe polish, paste floor wax, automobile wax, polymer medium, polyester resin, and linseed oil. As you may know, many of these finishes will alter the natural color of the plaster. If you are aware of this, you can control the color-form relationship. If you apply color to your form, be aware of the possible advantages and disadvantages.

COLOR-FORM RELATIONSHIPS

Color can:

Enhance the visual appearance of the form

Destroy the visual continuity of the form

Add to the spatial qualities of the form

Tend to flatten the form, making it seem less three-dimensional

Give illusions of concave, convex, and negative areas

Show your mistakes

Conflict with the form; be wrong for the form

Direct eye movement over the form

Attract attention

Contrast or blend the form with its environment

Soften or harden a form

Give the illusion of transparency and translucency

Evoke emotional responses

Be informative

Change the thermal qualities of the form

Create tension

Be appealing

In order to get the most benefit from the color-form relationship I would suggest the following activities. Be

aware of ready-mix color sources, such as paint stores, auto parts distributors, and hardware stores. Be aware of the color selection available for your use. Learn to use a spray gun if one is available (cans of spray paint are expensive). Experiment with color-form relationships. Have each class member purchase a can of spray paint of a different color. Make twenty-five identical forms and paint them different hues. Determine which ones are successful and which are not. Do not be afraid to use unusual colors or color combinations. Make use of research. Observe current color trends. Develop a working knowledge of several methods of color application. Learn what natural colors are available for your use and how to show their best qualities. Experiment with the juxtaposition of applied color and natural color.

I hope I haven't discouraged you from applying color to your plaster form. Simply think about your form and select a finish that is appropriate for it. Figure 6–38 shows a suitable match between form and color (see color insert). Would you paint an intricate organic form bright orange, or would you finish it with linseed oil or shoe polish (see Figure 6–39 in color insert). Do you have other suggestions for a finish?

Many fine artists tend to use color in an intuitive or subjective manner; they use what feels or looks *right* to them as individuals. However, the choice and juxtaposition of colors may be a conscious decision as Figure 6–40 shows (see color insert). Often visual artists capitalize on the natural color of materials, as shown in the chess set in Figure 6–41 (see color insert). Generally, when we look at a consumer product, we tend to pay little attention to its color. Yet, you may be sure that the product designer gave careful consideration to the color selection. Designers tend to deal with color in an analytical and objective manner.

Color is used in two general ways: as *marketable color* and as *functional color*. Functional color is objective and related to attractability, legibility, and visual acuity. Functional color serves a purpose. What color, for example, is best suited for traffic signs or identification of safety hazards on industrial equipment? Marketable color involves personal factors: color preference, aesthetics, social and emotional attitudes about color choice. Essentially, the designer recognizes that color can help to sell products. The color choices for the toy in Figure 6–42 were made primarily so that the toy would be appealing to children. Can you think of other consumer products that make use of functional or marketable color? It is to your advantage to be aware of trends, attitudes, preferences, and other attributes of color, regardless

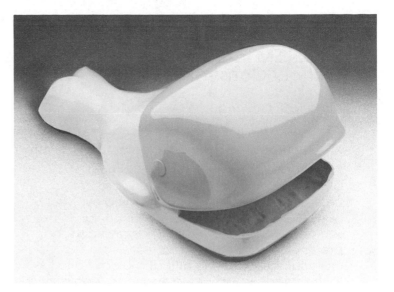

FIGURE 6–42
Marlene Knutson. Whale toy. Courtesy Tonka Corporation/ Marlene Knutson.

of your intended visual arts direction or specialization. Now that you have finished Problem 6–2, did the constraint (balloon) restrict the form in any way? Compare the concave/convex areas in this form with those created in Problem 6–1. How do they differ? Is your form truly three-dimensional? Is it visually interesting from all vantage points? How does it react with the surrounding space? In Problem 6–1 you had very little choice about the outcome of the form. Variations in form were directly related to hand size and position. In Problem 6–2 you had more control; you had the power to make an aesthetic decision about the form. The major constraints were the flexible membrane that held the plaster solution and the time available before the plaster would start to solidify. In other words, the plaster had to be in the *right* place at a prescribed time in order to create a pleasing form. Some similarity of form is bound to exist between your work and that of your classmates because of the limitations of the process. However, the end results are probably quite different.

Let's go a step further. What are you accustomed to in dealing with primarily by the tactile sense? Make a list of things (objects, materials, etc.) you like and dislike touching. Think of visual/tactile contradictions—things that look as if you can touch them but shouldn't or can't without harming yourself. How many of you have visited an art museum and been told by a guard not to touch the artwork? I remember my first experience with a cactus. It looked so soft and harmless! It took me hours to remove the spines from my hands. We have a basic need to touch objects. Touch becomes our connector to reality. If we touch something, then we know it is real.

PROBLEM 6-3: Hands as Form Maker Without Constraints

Materials: Optional

Size: Optional

Medium/Tools: Burnishing tool, plastic dropcloth

Task/Considerations: Select an amount of a plastic material such as earthenware or plasticene clay that feels comfortable in your hands. This amount will vary from person to person depending on size of hands and personal preference for weight, mass, etc. From this material, develop a form that is pleasing to the touch, pleasing to hold, pleasing to fondle, and so on. This should be accomplished with your eyes closed. The form can be refined with open eyes. Consider burnishing the clay with a smooth object, such as a stainless steel spoon, for a textural variation. Strive to develop an interesting form. Explore concave/convex and positive/negative relationships. Consider the *flow* from one area to the surrounding areas of the form. Consider *palm forms* and *finger forms*. Remember your fingers are very sensitive to tactile stimulation. Consider the total form (simplicity vs. complexity); the texture or textural variations, i.e., surface quality; explore human factors, i.e., how does it fit the hand or hands; comfort; material; temperature of the material, etc. (Figure 6–43)

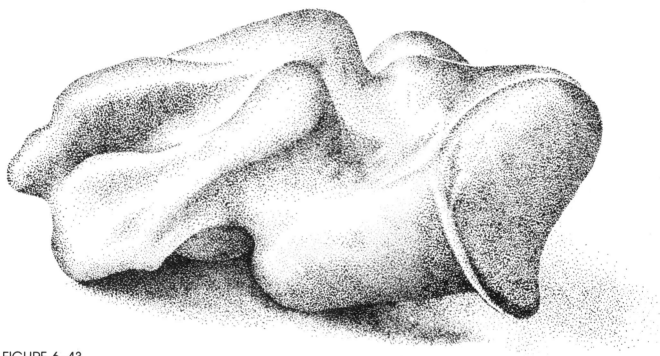

FIGURE 6–43
J. Walton. L. Moran, illustrator.

Evaluate the class' forms in a tactile manner with your eyes closed. Can you find a comfortable position for each form in your hands? Do all the forms fit your hands? Are the forms interesting? What did you discover? Could you determine how each form was intended to be held? How was the ice scraper in Figures 6–44 and 6–45 designed to be held? What are the advantages of this type of scraper over the common planar form? Was your form the most comfortable for you to hold? Could you pick yours out of all the others blindfolded? Could you do it with your fruit or vegetable in Chapter 4? Try it. We have a tendency to underestimate our senses. Is there a tactile/visual correlation?

When the tactile evaluation is completed, evaluate the forms visually. Is there a positive correlation between the tactile and visual evaluations? Were the best tactile solutions the best visual solutions? If so, what does this tell you?

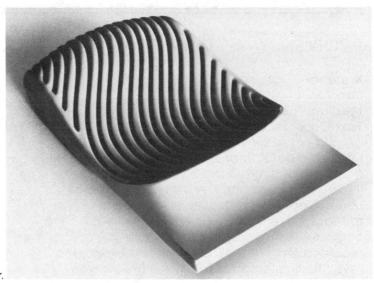

FIGURE 6–44
Robert DeBrey. Ice Scraper.

Top, finger pad **Rib Structure** **Bottom, thumb pad** **Composite Structure**

FIGURE 6–45
Robert DeBrey. Ice scraper structure drawings.

TOOLS AS EXTENSIONS OF HANDS

If you could add a tool to the hand, as an extension of the hand, you would be able to greatly increase the efficiency of the previously listed procedures and could add the cutting process to the list. A tool is generally defined as any device that is used for doing work. Early humans, more than two million years ago, were making and keeping their own tools instead of merely using and discarding natural objects as tools. Tools gave an advantage to the maker/user. Generally, the task could be done better and faster. Future problems will explore the uses of hand tools in relation to specific materials. How will a hand tool make a difference in the visual appearance of form? How will the use of hand tools relate to time and energy expended in creating form? But first you need to strengthen your understanding of what a truly three-dimensional object is, of how it functions in space. A truly three-dimensional object has an XYZ axis. The XYZ coordinate system is composed of three supposedly straight and continuous lines at 90-degree angles delineating height, width, and thickness (see Figure 6–46.

FIGURE 6–46
XYZ AXIS. S. Hammack, illustrator.

PROBLEM 6-4: Three-Dimensional Concept Formation

Materials: Optional
Size: Optional
Medium/Tools: Optional
Task/Considerations: Using a 3′ minimum length of solid or hollow stock (one-dimensional), cut it into five pieces. Reassemble, making the object *truly* a three-dimensional form. Note: You are limited to a linear form, however, the cross-sectional shape of the stock may vary greatly—e.g. round, square, triangular. Keep the pieces in the original (precut) order when the form is reassembled. Theoretically it should be able to revert to its original form; if it was hollow, you should still be able to pour water through the object after reassembly. Consider form/space relationships, proportional relationships, choice of materials, and the visual appearance of the object. Note: You may opt to segment a solid form instead of the suggested linear form. It is suggested that you construct several models from soda straws, pipe cleaners, dowel rods, or such before attempting a final composition. Be aware that a change in scale has a tendency to change the form from the model stage to the

FIGURE 6–47
Student unknown. L. Moran, illustrator.

finished object. Be prepared to adjust for the differences. (See Figure 6–47.)

Proportional relationships—the size as well as the size differences of each of the five pieces—are very important to this problem. Generally speaking, a composition of equal-sized pieces would tend to be monotonous. As you will remember from your two-dimensional studies, a composition is often made dynamic by creating a visual tension. This can be achieved by using pieces of unequal size to construct the form. The angles selected also affect the form-space relationship. If you choose to use compound angles rather than simple angles, you will find it easier to construct a truly three-dimensional form. How will your form compare to the XYZ axis mentioned earlier? In reality, many three-dimensional objects are conceptually and visually two-dimensional, as is the work in Figures 6–48 and 6–49, which is intended to be viewed frontally. This may be acceptable, depending on intent, for a professional visual artist. However, in this course of study your three-dimensional objects should displace space in three directions, that is, along the XYZ axis.

As in Problem 6–2 the choice of color is again an important consideration. Linear form requires a different approach to color usage, due to the minimal amount of mass. This may be dealt with by application of a contrasting color scheme in relation to the environ-

FIGURE 6–48
Dan Gorski. Home Sweet Home.

FIGURE 6–49
Jerry Leisure. Broom's Rule.

ment. Perhaps the construction of an environment for the form would be an appropriate solution. Consider detailing, such as pinstripping or sandblasting areas, to add visual interest to the form. Surface treatments such as wirebrushing, buffing, plating, or anodizing may also enhance the form. Be careful not to create *eye work*—unnecessary decoration—in the finishing of your form. As mentioned earlier, linear forms do not occupy much space and have a tendency to be overpowered by their environment. The visual impact and presentation are important considerations.

TWO-DIMENSIONAL/THREE-DIMENSIONAL INTERFACE

To work three-dimensionally visual artists often have to plan their objects two-dimensionally. They often must make presentation drawings for a client in order to receive a commission for a three-dimensional object, be it a sculpture or a can opener. The presentation may include the construction of a model or maquette. Figures 6–50, 6–51, 6–52, and 6–53 show presentation drawings and a model of a proposed dental patient chair. This experience is so valuable that I have developed the following problem in order to expose you to the process.

FIGURE 6–50
Hiroshi Fukushima. Dental patient chair.

FIGURE 6–51
Hiroshi Fukushima. Dental patient chair.

FIGURE 6–52
Hiroshi Fukushima. Dental patient chair.

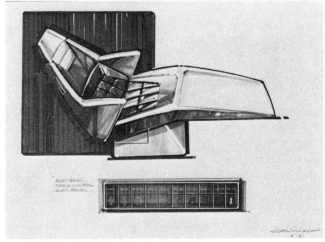

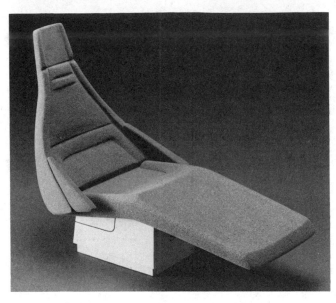

FIGURE 6–53
Hiroshi Fukushima. Dental patient chair.
Kinji Yanaba, photographer.

PROBLEM 6–5: Planar Development

PART 1: Pictorial

Materials: Illustration board

Size: 15″ × 20″, 3″ border, all sides

Medium/Tools: T-square, triangles, pencils, india ink, ruling pen, etc.

Task/Considerations: Develop, by means of thumbnail sketches, an interesting three-dimensional planar form. Select the most appropriate concept. A pictorial view should be presented by means of a perspective drawing. Refer to Chapter 5 to review drawing methods. Development of a complex form is suggested. The planes that constitute the form can be in various orientations to each other. Remember, a folded sheet of paper with simple angles is rather boring. You might compare this composition to a line drawing; make it more interesting by varying the line width and thickness and/or pattern. (See Figure 6–54.)

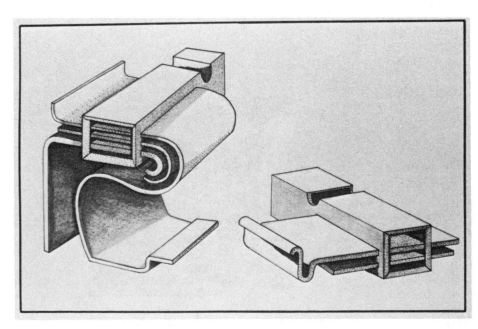

FIGURE 6–54
L. Weidner Maendler.
photographer.

PART 2: Orthographic Drawings

Materials: Illustration board
Size: 15" × 20"
Medium/Tools: Pencil, india ink, T-square, triangles, ruling pen, pencils, etc.
Task/Considerations: Using the rendering as a source, complete an orthographic drawing. Include adequate information to enable another member of the class to construct the planar form from your drawings. Include dimensions, tolerances, materials, processes, finish, plan of procedure, and any other pertinent information. Remember, it is better to have too much information than not enough. Refer to Chapter 5 to review the orthographic drawing process. (See Figure 6–55.)

PART 3: Construction

Materials: Optional planar forms
Size: 18" maximum in any direction
Medium/Tools: Optional
Task/Considerations: Using the orthographic drawings as a *blueprint,* construct the object from planar materials, for example, metal, plastic, fabric, glass, or wood. The object should be a truly three-dimensional, free-standing form. Finish in the appropriate manner. (See Figure 6–56.)

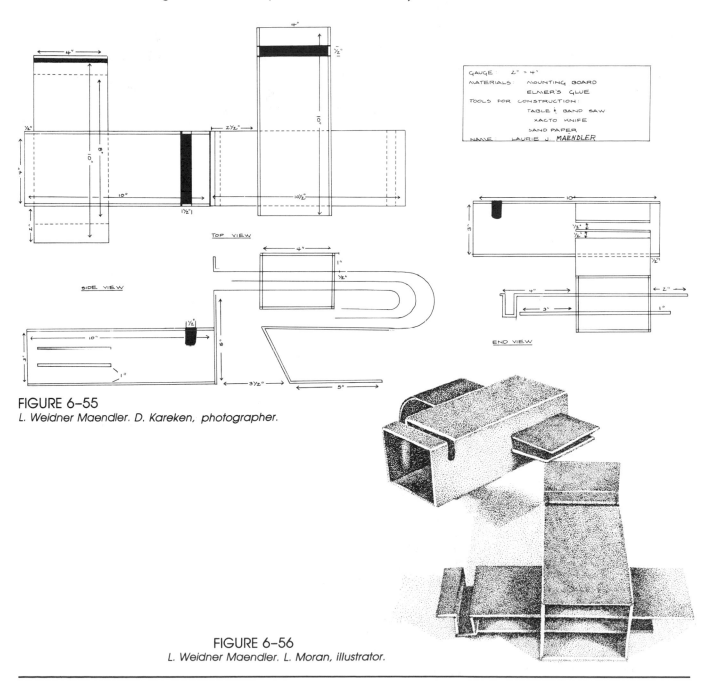

FIGURE 6–55
L. Weidner Maendler. D. Kareken, photographer.

FIGURE 6–56
L. Weidner Maendler. L. Moran, illustrator.

Does your object look like your perspective drawing? Was it difficult to make a planar form three-dimensional? Figure 6–57 shows another solution to Problem 6–5, in which the form is more organic.

The final project in this unit tends to tie the previous concepts and problems together. How does physical structure affect visual structure? Does the method used in construction affect the appearance of the object? Is the form altered when it is constructed of several different materials?

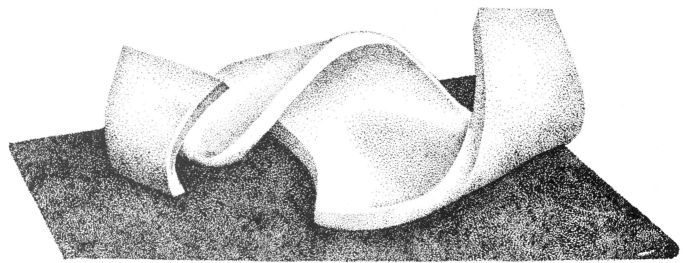

FIGURE 6–57
J. Davis. L. Moran, illustrator.

PROBLEM 6-6: Translation

Materials: Three different materials
Size: Optional
Medium/Tools: Optional
Task/Considerations: Select a solution to one of the previous three-dimensional problems that you consider to be worth developing further. It can be a linear, planar, or solid form. Translate the form to the two other modes of visual analy-

FIGURE 6–58
D. Allison-Hartley. L. Moran, illustrator.

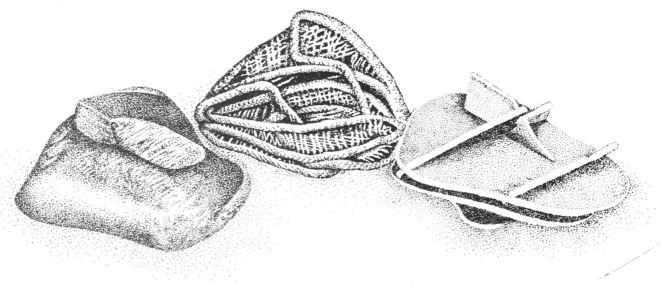

sis. For example, if you choose Problem 6–5, Part 3, a planar form, you now are asked to translate and fabricate it as a linear form and as a solid form. You must change the material each time; not just the form of the material. In other words, you may not use dowel rods for the linear form and plywood for the planar form because both are wood. Your best effort is required in form, craftsmanship, and presentation. All three parts should have the same exterior dimensions. (See Figures 6–58 and 6–59.)

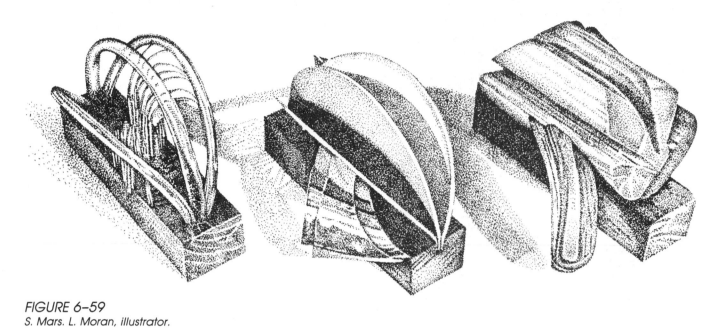

FIGURE 6–59
S. Mars. L. Moran, illustrator.

Consider the following suggestions. A linear form is easily developed from a contour style or an orthographic drawing. A planar form may be developed by simply extending a linear form in all directions. In developing a solid form, one method that I have found useful is to stretch a memory fabric, such as nylon, over a linear or planar form. This will give you a starting point in developing the form. In developing any of these forms you should consider the internal structure. For example, if a concave area exists in a solid form, what type of internal structure would be needed to support that area? More important, how would it appear in a linear or planar rendition?

What is a good three-dimensional composition? Use the evaluation method outlined in Chapter 2 to formulate your opinion. Examine Figures 6–60 and 6–61. Which of these three-dimensional compositions do you prefer? Why?

FIGURE 6–60
Kenneth G. Ryden. Harbinger of Goodwill.

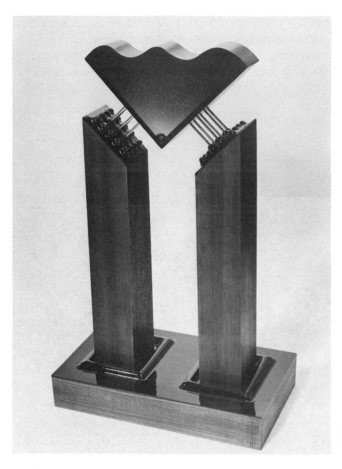

FIGURE 6–61
Robert Clore. Red Eye.

PROBLEM 6–7: Application

Formulate and carry out an application problem in which you attempt to relate three-dimensional studies to your area of interest. The concepts, materials, size, and other considerations are open.

SUGGESTED READINGS

KRANZ, STEWART, and ROBERT FISHER. *The Design Continuum.* New York: Van Nostrand Reinhold Company, 1966.

NELSON, JOHN A. *Handbook of Drafting Technology.* New York: Van Nostrand Reinhold Company, 1981.

THOMAS, RICHARD K. *Three-Dimensional Design: A Cellular Approach.* New York: Van Nostrand Reinhold Company, 1969.

WONG, WUCIUS. *Principles of Three-Dimensional Design.* New York: Van Nostrand Reinhold Company, 1977.

7 Physical Structure/ Manipulation

In the previous chapter we explored the visual structure of three-dimensional forms and the process of making conscious decisions that affected the appearance of the object. The constraints on physical structure were minimal.

The physical structure, however, can affect the visual structure of a form, as you discovered in Problem 6–6. In the last chapter we were primarily concerned with the aesthetic aspects of three-dimensional form—how a form looked and felt in relationship to space. In this chapter, the study of physical structure, we will be concerned with performance-orientated forms. I believe you will find that the solutions to the following problems generally have a high aesthetic rating, even though that is not our primary concern. After this unit of study, you will be prepared to construct three-dimensional forms that are strong and stable as well as aesthetically pleasing.

PERFORMANCE-ORIENTATED FORMS

Performance-orientated forms generally may be categorized as forms that hold weight, span space, obtain height, contain objects, or enclose areas. A working knowledge of physical structure is essential to students interested in the applied areas of exhibition design, package design, environmental design, sculpture, furniture design, general product design, and of course, architecture. The current body of knowledge about physical structure has primarily come from architectural design and engineering. I have attempted to translate that information to an area of general interest for visual arts students.

Perhaps the best approach to the study of structure is to realize that physical structure is a biological given. All plants and animals are dependent on structure. Their ability to survive hinges, among other things, on their ability to maintain a functional structural system. The commonly accepted biological definition of (physical) structure is the arrangement and functional unity of parts. Plants and animals have evolved efficient, highly adaptable structural systems. They are able to adjust to and/or move with an applied force. Inanimate objects generally do not have the ability to adapt; consequentially, structural consideration must be resolved at the planning stage. The choice of a proper structure at the planning stage is generally based on three aspects: comprehension of the function of the object, understanding of the forces and stresses the object will be exposed to, and knowledge of the physical properties of materials.

MATERIAL DETERMINATION

As visual artists we generally work with metals (steel, brass, copper, aluminum, etc.), woods (pine, mahogany, walnut, etc.), paper (corrugated cardboard, bristol board, index paper, etc.), plastics (vinyl, acrylic, butyrate, etc.), and fabrics (cotton, canvas, wool, and a host of synthetics). In addition, there are many composite materials such as particle board, bronze, and A.B.S., etc. How do you determine which material is correct for the function of the object you are developing? There are literally thousands of materials. Many vary only slightly in their physical characteristics. Again, how do you make the correct decision?

It is often helpful to be aware of basic distinctions within categories of material: hardwood versus softwood; ferrous metal versus nonferrous metal; thermosetting plastic versus thermoforming plastic, etc. Many technical books that explain these basic categories are available. Several are listed at the end of the chapter. Manufacturing firms publish technical information sheets, which are usually free upon request. The best method for learning about materials, how-

ever, is through personal experience and it doesn't come overnight. Eventually, you will be able to choose between polystyrene and butyrate, raw silk and woven polyester, or pine and padauk.

One of the purposes of this course of study is to introduce you to a wide variety of materials and their uses. You should be aware that the surface structure of a material can be altered, resulting in increased strength. Common processes that increase the strength or rigidity of materials include stitching. (Figure 7–1), corrugating (Figure 7–2), stamping (Figure 7–3), layering or laminating (Figure 7–4), molding detents (Figure 7–5), weaving (Figure 7–6), beading (Figure 7–7), folding or bending (Figure 7–8).

FIGURE 7–1
Boots. D. Kareken, photographer.

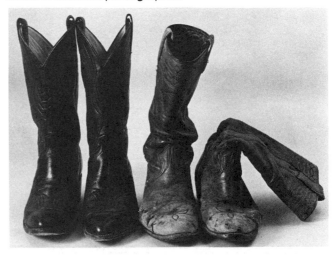

FIGURE 7–2
Corrugations. Courtesy Container Corporation of America.

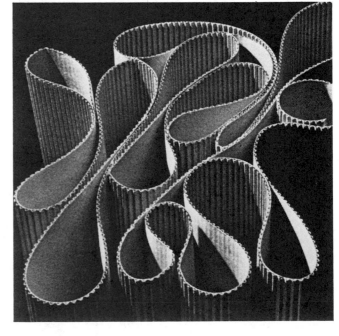

FIGURE 7-3
Auto body. F. Young, photographer.

FIGURE 7-4
Wasp nest. F. Young, photographer.

FIGURE 7-5
Paper automobile seat. Courtesy Container Corporation of America.

FIGURE 7-6
Lawn chair webbing. F. Young, photographer.

FIGURE 7-7
Double beaded 303 can. D. Kareken, photographer.

FIGURE 7-8
*Robert DeBrey Radio receiver components.
J. DeBrey*

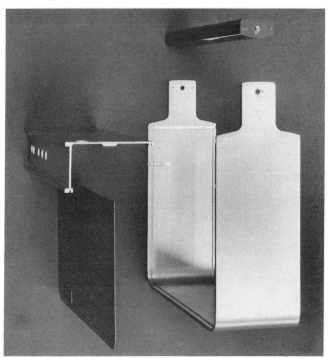

PROBLEM 7-1: Altered Planar Form

Materials: A flexible planar material, such as index paper

Size: 25½″ × 30″

Medium/Tools: A scoring tool

Task/Considerations: Select a planar material that will not remain rigid when supported at one end i.e., perpendicular to your body. Alter the structure of the material to enable it to support its own weight when held in this manner. This is an exercise in geometry. What forms give the greatest strength? Gradually add weight to the far end of the form. How much did yours hold before it started to bend?

STRUCTURAL PRINCIPLES

Physical structure is based upon the relationship between forces and stability. A force tends to exert tension or compression on a structure. Whenever a three-dimensional form is constructed it has to deal with two types of forces (loads) which create tension and compression. The first, and constant, is *dead load*. Dead load is the weight of the materials used to fabricate the form. *Live load*, however, may vary and be added to or removed from the form. In the case of a sofa, the live load would be calculated by the added weight of the people sitting on the sofa. An empty classroom has less live load than a classroom full of drawing tables, stools, and students. These live and dead loads are capable of producing a variety of stresses and forces within and upon a three-dimensional form.

Compression

The most basic principle is compression. Compression tends to cause materials to condense. If, for example, you were to stack twenty of these books on top of each other, the ones on the bottom would support more weight, i.e., resist a greater compressive force than the books on the top of the stack. If you were to hold a paper column, end to end, in your hands and press with all your strength, what would happen? The opposing forces would condense the column near the middle and it would eventually deform or buckle. A rule of thumb to remember in dealing with compression is the strength of a compression member is determined by the ratio of its diameter to its length. A short, thick (large diameter) form will support more weight than a tall, thin form.

Stress

Another closely related structural principle is stress. Crushing, or stress failure, is caused by a large weight over a small area. How often have you noticed a cylindrical column with a square base or footing larger than the diameter of the column (Figure 7–9) or a coaster under a table or chair leg? The purpose of this common practice is not to decorate or give lateral stability to the form, but to distribute the weight of the form evenly over a larger area. If you live in a northern climate, you are probably aware of what happens when you try to walk in deep snow in shoes or boots: You sink into the snow. However, when you wear snowshoes or skiis, the weight of your body is spread over a much greater area, and you are able to walk or glide on top of the snow.

Tension

Another basic force is tension. Tensile forces tend to stretch materials within a form. Common articles of clothing such as suspenders (braces) act under tension when in use (Figure 7–10). Forms under tension tend to be classified as linear. When materials are

FIGURE 7–9
Minneapolis Institute of Art. S. Hammack, photographer.

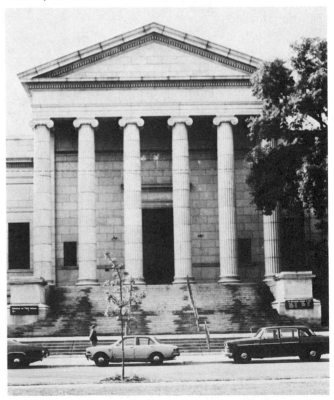

FIGURE 7–10
Suspenders (braces). M. Ward, photographer.

FIGURE 7–11
Roofer. F. Young, photographer.

under tensile stress, they tend to stretch and get thinner at the middle. Have you ever seen taffy being pulled? You can experiment with this concept yourself by stretching a rubber band to the breaking point. Tension also occurs in rigid materials; a rigid material under tension does not appear to *stretch,* although this is actually what is happening. The strength of a tension material is determined by its thickness or cross-sectional area. Differing from compression, length has no effect on strength if the cross-sectional area is identical. A piece of rope 6 feet long is just as strong as a piece of the same rope 30 feet long.

There are several other structural principles of which you should be aware; however, they are very simple concepts and as such are generally considered common knowledge.

Flexure

Flexure, or bending, has been experienced by many people when they have put a wooden plank on a scaffold (Figure 7–11), across a stream, or over some such impass and then proceeded to walk across the plank. Depending on the distance spanned, the size of the plank, and their weight, the plank generally flexes when they walk on it. The weight and consequent bending simultaneously induce tension and compression into the plank. The top of the plank bows in or compresses, and the bottom of the plank sags or stretches and is put under tensile stress. Common sense tells us if the person or object crossing the impass is large (heavy), a thicker plank is required. Forces are considerably less in a thick plank than in a thin plank. However, if the weight or force is too great, it will cause the plank to fracture or shear.

Moment

A type of structure that must resist fracturing forces, but from a different stress point, is a cantilevered

book-shelf (Figure 7–12). Logic tells us that a shelf 6 inches deep is going to apply less stress than a shelf 12 inches deep. The concept behind this reasoning is called moment. Moment is a force directly related to horizontal distance. This may be illustrated by another method. Pick up your supplies container and hold it at shoulder height. Now, extend your arm its full length. In what position did the container exert more force? In

FIGURE 7–12
Bookshelf. D. Kareken, photographer.

case you were unable to tell a difference, the container exerted approximately three times as much force (that is, it felt three times as heavy) when you extended your arm.

The one postulate to remember when dealing with physical structure is to use geometry instead of mass. If you were asked to develop a form, for a display system for sculpture you could hold more weight with less material (mass) by arranging a large percentage of the material at the periphery of the structure. In other words, hollow versus solid.

PROBLEM 7-2: Self-Supporting Form

Materials: Sheet of index paper
Size: 25½″ × 30″
Medium/Tools: Scoring tool, adhesives
Task/Considerations: Develop the tallest self-supporting three-dimensional form possible from the specified materials. Note: You may use adhesives only for joining purposes, not for the reinforcement of surfaces.

How do you make the form support itself and have lateral stability? A structure with a gradual decrease in width and depth in relation to height might be one method of solving the problem. Consider constructing the form using modules. Which method would give the greatest height? Are there other structural methods you could use? It is important to determine which construction method best solves the problem. (Figure 7-13.)

FIGURE 7-13
D. Langlais. L. Moran, illustrator.

Post and Beam

Basic architectural structural principles that are readily observable throughout your environment can easily be applied to other areas of the visual arts. The most common form is the column. It is generally used in conjunction with a horizontal unit. The combination is usually referred to as post and beam. The column resists compressive forces, while the beam resists flexure and fracturing. Post-and-beam constructions generally lack lateral stability and require some type of bracing, tying, or reinforcement. (See Figure 7-14.)

FIGURE 7-14
Metal pedestal table. Courtesy Thonet Industries, Inc.

Triangulation

Triangulation is perhaps the best method for establishing lateral stability, and it is used in a wide range of objects. It is well illustrated (see Figure 7-15) by the interior structure of the sculpture, Wichita Tripodal (6-14). It is suggested that you make use of triangulation in the linear problems to follow. A truss is a structural system that applies the concept of triangulation to resist tensile and compressive forces. A truss is generally fabricated of short linear pieces within a single plane. Trusses are often used in conjunction with columns or planar supports. (See Figure 7-16.)

FIGURE 7-15
James Rosate. Interior structure Wichita Tripodal. Courtesy Public Information Office, Wichita, Kansas.

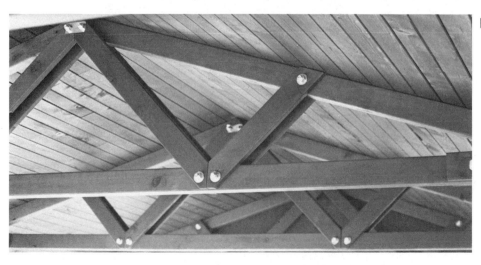

FIGURE 7-16
Truss. F. Young, photographer.

Slab

The slab structural system must be able to resist flexure and fracturing. The slab is a planar form that can distribute its loads in several directions, depending on how it is reinforced. The strength of a flat slab, unlike the basic postulate previously mentioned, is developed through mass. However, greater strength in a slab structure may be developed through geometry. An example would be the type and depth of a fold pattern, as you experienced in Problem 7–1. Applications of the slab structural system are uncommon outside of architecture. However, Figure 7–17 shows a play environment that makes use of vertical and horizontal slabs.

Suspension

I am sure you are aware of many uses of suspension as a structural system. The most popular examples in the United States are bridges such as the Golden Gate or Brooklyn (East River) bridges (Figure 7–18). A suspension structural system distributes loads through cables or membranes to (Figure 7–30). supports such as columns or post-and-beam constructions. Cables and membranes are only capable of resisting tension. Therefore, the material chosen for them must be very high in tensile strength.

At this time, it is appropriate to experience several classic physical structural problems, the first of which is to develop and construct forms that will support various amounts of weight.

FIGURE 7–17
Courtesy Gerry Allen Criteria Architects, Inc.

FIGURE 7–18
Lydia E. Pinkhams vegetable compound trade card. Collection of the author.

THE GREAT EAST RIVER SUSPENSION BRIDGE.
CONNECTING THE CITIES OF NEW YORK & BROOKLYN.
The Bridge crosses the river by a single span of 1595 ft suspended by four cables 15½ inches in diameter. The approach on the New York side is 2492 ft the approach on the Brooklyn side is 1901 ft Total length 5988 ft From high water to roadway 120 ft. From roadway to top 157 ft From high water to centre of span 135 ft. Width of bridge 85 ft. Total height of Towers, 277 ft.

PROBLEM 7-3: Vertical Planar Support Form

Materials: Index paper (any paper, but everyone must use the same kind and size of paper), white glue, Duco cement or double-faced tape.

Size: 15" × 22½" (recommended proportion is 1:1½, width to height).

Medium/Tools: A scoring tool

Task/Considerations: Develop and fabricate a vertical, planar, three-dimensional form, using no more than one sheet of paper, that will hold as much weight as possible. See Problem 7-2 for adhesive restriction. It is suggested that all folds be scored before folding, since a high level of craftsmanship is essential to prevent structural failure.

Analyze how other students solved the problem. Which types of structures held the most weight? How did your craftsmanship affect the structure? How did you achieve lateral stability? Did you make use of the information about the columns covered earlier? Note: In order to not influence your solution, I chose not to show examples because of the limited range of solutions to this problem.

PROBLEM 7-4: Vertical Linear Support Form

Materials: ⅛" diameter dowel rods
Size: 34" tall
Medium/Tools: Hot glue gun
Task/Considerations: Using the least possible material, develop and fabricate a tall, linear, three-dimensional form that will support 12 pounds. Note: The amount of material used will be determined by weighing the completed forms. The dowel rods may be affixed to each other in any manner; however, use of a hot glue gun is suggested. Do not overbuild the structure. Consider the differences between short columns and tall, thin columns discussed earlier in this chapter. (See Figure 7-19.)

FIGURE 7-19
A. Atwell. L. Moran, illustrator.

How do the resulting forms in Problem 7-3 and Problem 7-4 differ? What part does triangulation play in Problem 7-4's structure? How much weight do you think your form will hold? Add weight until it starts to buckle. Did you overbuild?

PROBLEM 7-5: Horizontal Planar Span/Support Form

Materials: Paper of your choice
Size: Optional, but see specific considerations
Medium/Tools: Optional
Task/Considerations: Develop and fabricate a planar, three-dimensional form of the least possible weight that will span a minimum of 24 inches and be capable of supporting a 6-pound weight, as its center, a minimum of 12 inches above the base. The span form must be free-standing and not be affixed or tied across the base. Remember, this is essentially a post-and-beam structure; consider tension and compression in horizontal structural members. Figure 7-20 shows a solution that deviates from the post-and-beam structural system but still solves the problem.

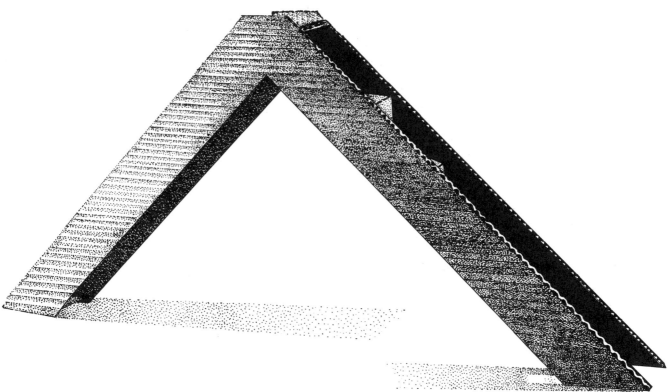

FIGURE 7-20
C. Irons. L. Moran, illustrator.

Analyze which structures were the most efficient. What additional considerations come into play when you add a horizontal member to the vertical supports?

Which type of paper is most effective? How did you deal with tension and compression?

PROBLEM 7-6: Horizontal Linear Span/Support Form

Materials: Optional
Size: Optional
Medium/Tools: Optional
Task/Considerations: Develop and fabricate a linear, three-dimensional form composed of the least possible number of identical units (mod-ules). The form should span a minimum of 24 inches and be able to support 24 pounds weight at its center, a minimum of 12 inches above the base. As in the last problem, the form must be free-standing and may not be attached to or tied across the base. (See Figure 7-21.)

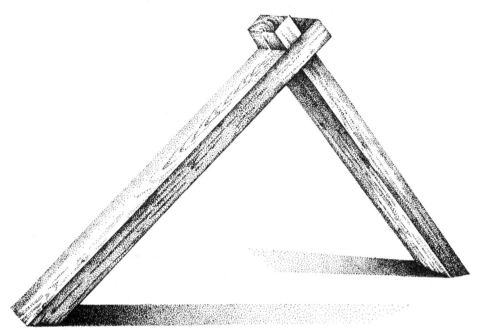

FIGURE 7-21
M. Pistillo. L. Moran, illustrator.

How did the emphasis on quantity affect your solution? What linear materials are available for your use? Did you, for example, consider rods, tubes, rounds, squares, triangles, wood, plastic, steel, brass? Be aware of the options!

It is important to try a structure problem on a different scale, one that you can relate to through your body size and weight.

PROBLEM 7-7: Tallest Form/Longest Form

Materials: Optional
Size: Optional, but your raw material is limited to 2″ x 6″ x 6′
Medium/Tools: Optional
Task/Considerations: Develop and fabricate one of the following options: (1) construct the tallest structural form you can safely climb or (2) con-struct the longest structural form you can safely walk across at a minimum height of 18 inches above the floor. Either option is to be fabricated from raw material or stock that is no larger than 2″ x 6″ x 6′ (864 cubic inches). You may use any kind and amount of hardware or any other method for joining the structural members (glu-ing, welding, etc.). (See Figure 7-22.)

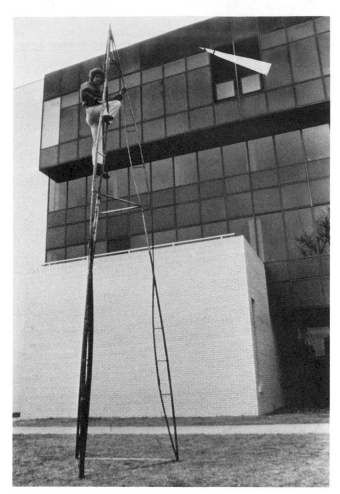

How can you maximize the amount of material? What is the best construction method? What is the best joining method? In the past, several students have developed costumes and performances to accompany their structural forms. Try it. Have some fun!

There are other basic structural principles that you should know before experiencing additional problems. The most common of these is the arch, as shown in Figure 7–23.

The Arch

As in the column, the forces within an arch are primarily compressive. The general form of an arch is curvilinear and held within a single plane. The natural arch in Figure 7–24 illustrates the structural principles very well. The material under the least stress has been removed over a long period of time by the eroding forces of wind and water. In order for the arch to support weight it must be tied across the base plane or supported by some other means, such as bracing. Therefore, an arch would have not been an acceptable solution to the two previous span problems.

A traditional architectural solution, especially in the construction of churches and barns, made use of a series of arches. This structural system is referred to as a *vault* (Figure 7–25).

FIGURE 7–22
S. Wagner. F. Young, photographer.

FIGURE 7–23
Railroad viaduct. F. Young, photographer.

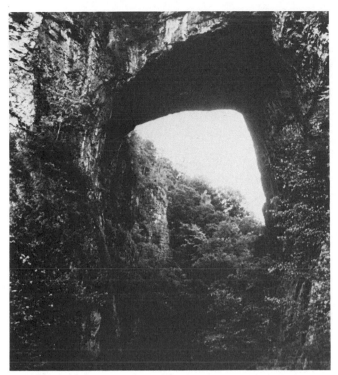

FIGURE 7-24
Natural Arch. F. Young, photographer.

FIGURE 7-25
Assumption Seminary Barn. F. Young, photographer.

The Dome

Another variation of the arch is the dome. The dome is a series of arches revolving around a vertical axis as illustrated in Figures 7-26 and 7-27. It should be noted

that the dome is an extremely stable form. A very common but structurally different type of dome is the *geodesic dome frame*, invented by R. Buckminister Fuller (Figure 7-28). The geodesic frame is a structural system based on adapting polyhedra, such as a

FIGURE 7-26
*Como Park Conservatory.
D. Kareken, photographer.*

FIGURE 7-27
Dome structure. Courtesy Container Corporation of America.

dodecahedron (a twenty-sided form), to a spherical plane. The geodesic frame is lightweight and easily constructed from prefabricated components, and it is the only form that gets stronger as it gets larger. Like all spheres it encloses the maximum amount of surface area. Geodesic frames are commonly used in exhibition design and architecture.

The Shell

Another structural system you are most likely familiar with is the shell. It is very difficult to break the shell of a chicken egg by squeezing the ends between your hands; however, it breaks readily when you apply a concentrated force, such as tapping it against the rim of a cast-iron skillet. The reason for the fracture is the shell's inability to resist bending forces. An example of a product making use of the shell structure is the type of helmet generally worn by motorcyclists (Figure 7-29).

Membranes

An aspect of the suspension structural system mentioned earlier, membranes, should be elaborated at this time. Membranes are commonly used in conjunction with a linear framework. They are generally flexi-

FIGURE 7-28
R. Buckminister. Fuller. Union Tank Car Co. geodesic dome. Courtesy Union Tank Car Co.

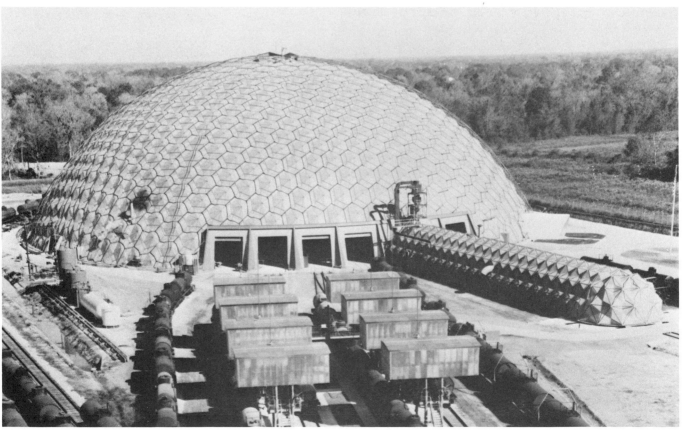

FIGURE 7-29
Helmet. Courtesy Bell Helmets, Inc.

FIGURE 7-30
Moss Tent. Benjamin Magro, photographer. Courtesy Moss Tent Works, Inc.

FIGURE 7-31
Chair. D. Kareken, photographer.

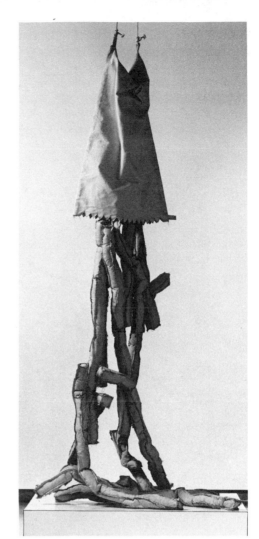

FIGURE 7-32
Claes Oldenburg. Falling Shoestring Potatoes. 1965. Collection Walker Art Center.

ble until put under stress. You have probably been made aware if you have ever set up a tent. (See Figure 7-30.)

Pneumatic Structures

If a membrane is constructed in such a manner as to not need the linear supports, that is, sealed and inflated, it becomes a pneumatic structure. This is common practice in furniture (Figure 7-31), toy, and recreational equipment design, as well as in sculpture and some forms of architecture.

Related to pneumatic forms are forms filled with substances other than air to help them maintain their form. Examples are stuffed items such as down jackets, foam-filled furniture, and beanbags, and this sculpture (Figure 7-32) which is stuffed with kapok. Other products are filled with liquids of various types to maintain their forms; they range from water beds to the Stretch Armstrong toy, which, I am told, is filled with molasses.

FIGURE 7-33
Tree. F. Young, photographer.

FIGURE 7-34
Marcel Breuer. Side chair. Courtesy Thonet Industries, Inc.

The Cantilever

The final type of structural system, the cantilever, is observed most readily in the environment in the form of a tree. A cantilevered structural system is composed of a projection that is supported at one end. Cantilevers may be classified as either horizontal or vertical. The limbs of a tree are examples of horizontal cantilevers. Examine the tree in Figure 7-33: You will notice the limbs are tapered (they are thickest near the trunk). This is where the greatest strength is needed. The trunk of the tree is a vertical cantilever. This is obvious when you realize the root system acts as a foundation or anchor. Notice the increased size of the cross section of the trunk near the ground. A cantilever must primarily resist flexure and fracturing and is generally attached to a stable form. A good example is a diving board. This structural concept is commonly applied to product design as shown in the chair in Figure 7-34 and computer display terminal in Figure 7-35. It may also be used in sculpture. The example in Figure 7-36 makes use of vertical and horizontal cantilevers.

FIGURE 7-35
Robert De Brey. Uniscope 100 display terminal.

The next problem calls for an understanding of the structural aspects of a natural shell form, the chicken egg. Did you know that if you were to drop an egg out of a third-story window and it were to land on a thick summer lawn, the chances are that it would survive the fall intact? Try the experiment. Why doesn't it break? How can you apply this information to the following problem?

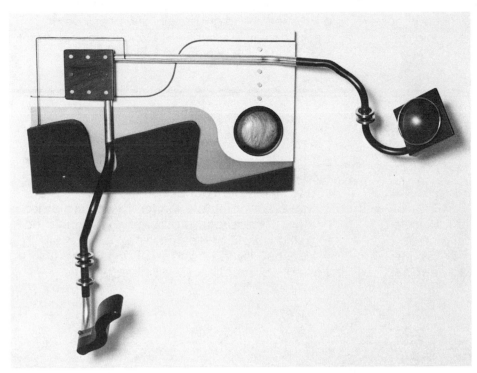

PROBLEM 7-8: Container

Materials: Optional
Size: Optional
Medium/Tools: Optional
Task/Considerations: Develop and fabricate a three-dimensional chicken egg container. The container should be able to endure a 15′ vertical drop without allowing the egg to break. The egg must be in a natural state when placed in the container; hard-boiled eggs are unacceptable. (See Figure 7–37.)

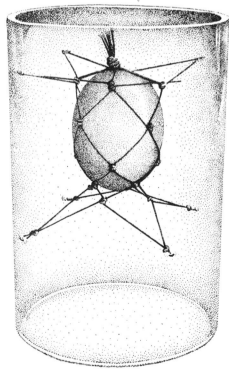

FIGURE 7–37
Mary Furuseth. L. Moran, illustrator.

What type of container (structure) gives the egg the most protection? Is the orientation of the egg a factor?

Of the successful solutions to the problem, which ones weighed the least?

In the following problem weight is an important consideration. When I first tried this problem I told my students to use eggs; however, at least one egg always seemed to get broken, and after several weeks in the mail broken eggs tend to be unpleasant, so I changed the contents to light bulbs.

PROBLEM 7-9: Mailer Container

Materials: Optional

Size: To conform with Postal Service regulations.

Medium/Tools: Optional

Task/Considerations: Develop and fabricate a lightweight, three-dimensional container for three 100-watt incandescent light bulbs. The container is to be mailed to a predetermined address at least 500 miles away. List your return address clearly; the container will be returned to you via the mail. Your goal is to have the pretested bulbs complete the trip in working order. Primary considerations should be given to structure, the weight of the container (this is easily established by the postage charge), and the ease of construction. (See Figure 7-38.)

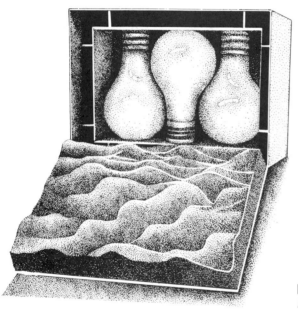

FIGURE 7-38
Dennis Langlais. L. Moran, illustrator.

Examine the container after its return. Were any of the bulbs inoperable or broken? Are any changes needed? What changes would you make?

Another and the final application of the study of physical structure is the development of space-enclosing three-dimensional forms.

PROBLEM 7-10: Space-Enclosing Form

Materials: Optional
Size: Optional. You may work in a ¼-scale model format if you so desire.
Medium/Tools: Optional
Task/Considerations: Develop and fabricate a space enclosure. The form should be able to be assembled, disassembled, transported to another location, and reassembled by another person or team. Submit a bill of materials and directions for assembly with the form. Consider how you communicate assembly instructions. See (Figures 7-39 and 7-40.)

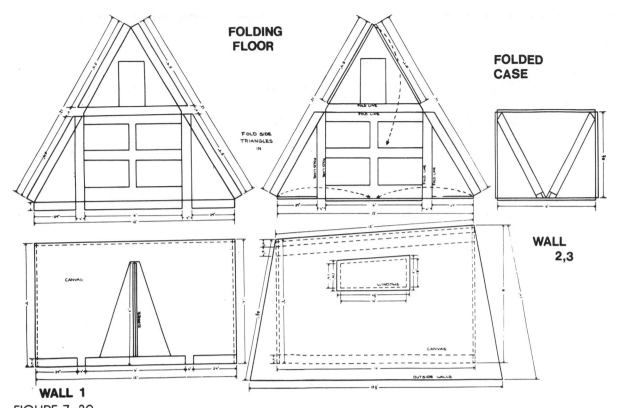

FIGURE 7-39
L. Owens. Ice Fishing House.

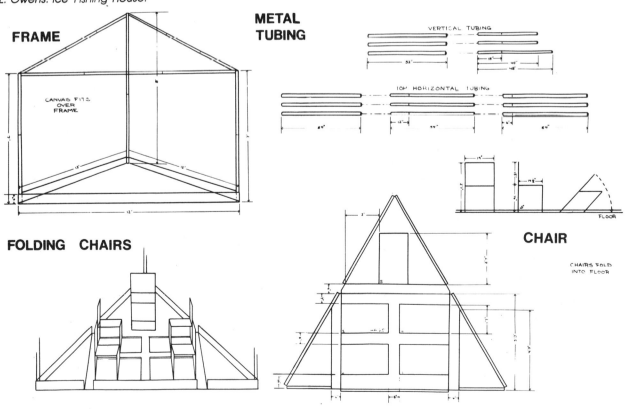

FIGURE 7-40
L. Owens. Ice Fishing House.

PROBLEM 7-11: Application Problem

Undertake a self-imposed application problem based on one or more of the concepts explored in Chapter 7. As usual, the concepts, size, materials, etc., are optional.

SUGGESTED READINGS

CRITCHLOW, KEITH. *Order in Space: A Design Source Book.* New York: Viking Press, 1970.

ENGEL, HEINRICH. *Structure Systems.* New York: Van Nostrand Reinhold Company, 1981.

FRASER, DONALD J. *Conceptual Designs and Preliminary Analysis of Structures.* Marshfield, Mass.: Pitman Publishing, 1981.

GREEN, PETER. *Design Education: Problem Solving and Visual Experience.* London: B.T. Batsford Limited, 1978.

KEPES, GYORGY, ed. *Structure in Art and in Science.* New York: George Braziller, 1965.

PEARCE, PETER, and SUSAN PEARCE. *Experiments in Form: A Foundation Course in Three-Dimensional Design.* New York: Van Nostrand Reinhold Company, 1980.

PUGH, ANTHONY. *An Introduction to Tensegrity.* Los Angeles: University of California Press, 1976.

THOMPSON, D'ARCY. *On Growth and Form.* Cambridge: Cambridge University Press, 1969.

VON FRISCH, KARL, and OTTO VON FRISCH. *Animal Architecture.* New York: Harcourt Brace Jovanovich, 1974.

WILLIAMS, CHRISTOPHER. *Origins of Form.* New York: Architectural Book Publishing Company, 1981.

8 Materials and Processes

THE WORKSHOP EXPERIENCE

This chapter will give you an opportunity to apply the three-dimensional concepts previously experienced. In essence, you will be exposed to a workshop situation. Included is a range of problems covering many concepts, materials, and processes common to working in a shop. The following assignments can be completed with the use of basic hand tools, power tools, or basic machinery available in most school workshops—band saw, circular or radial arm saw, drill press, abrasive finishing machine, sewing machine, and so on. It is important that you receive adequate instruction on the safe operation of the equipment at your disposal. This is to protect you and the equipment from misuse and abuse. Be safe. Get checked out on the equipment before using it. Remember, when you don't know what you are doing, there is no such thing as a dumb question. Ask questions! Be sure you know what you are doing before your proceed. Let's begin with a conceptual fantasy combined with a process experience.

PROBLEM 8-1: Ultimate Form

Materials: A casting material, a mold-making material, and a plastic material, such as clay
Size: Optional, but I suggest a maximum of 6″ in any direction.
Medium/Tools: Optional
Task/Considerations: If you were *mother nature,* how would you design the ultimate three-dimensional form? Be prepared to justify your position with a short presentation. Construct this form using an additive method and a plastic material, such as clay. Prepare the form for casting and cast it in one of the following materials: polyester resin, plaster, clay, body putty, lead, cement, hydrocal, bronze, or aluminum. It is suggested that you use an R.T.V. silicone mold-making material if you plan to cast the form in polyester resin. There are many types of R.T.V. silicone mold-making materials. Check with your local Dow-Corning or General Electric distributor for more information.

FIGURE 8-1
Constantin C. Brancusi. Golden Bird. *Courtesy The Minneapolis Institute of Arts.*

It may seem impossible for you to create the *ultimate form.* However, you should be striving to do so each time you approach a three-dimensional form problem. A good place to begin this problem is by defining *ultimate.* What are your standards? How and what do you consider the ultimate? Would you consider the forms in Figures 8-1, 8-2, 8-3, and 8-4 as *ultimate)?*

FIGURE 8-2
M. Van der Rohe. Barcelona chair. *1929. Courtesy Knoll.*

FIGURE 8-3
T. Evers. L. Moran, illustrator.

FIGURE 8-4
Student unknown. L. Moran, illustrator.

HAND TOOLS

I believe you should have a working knowledge of hand tools before using machines. Consequentially, I have included a classic *basic workshop* problem.

Although this problem will take time, you will find that it furthers your appreciation for the concept of craftsmanship.

PROBLEM 8-2: Hand Tool/Subtractive Method

Materials: Optional
Size: Optional
Medium/Tools: Optional
Task/Considerations: Develop a nonobjective form that is to be worked in a subtractive manner. Begin with a solid or implied solid material. Work this to its final form using only hand (nonpower) tools. Finish the form appropriately. Consider the method of presentation. The final form should demonstrate a high level of craftsmanship. (See Figures 6-34 and 8-5) Note: Technically experienced students may use power tools or a combination of power and hand tools in the completion of the project.

FIGURE 8-5
M. Miller. L. Moran, illustrator.

Does your form look like it was made with hand tools? Did the tools leave an identifiable mark? Are you able to tell how other objects were made by looking at the tool marks?

The following problem is a three-dimensional composition problem. I believe it is a further test of your compositional skills.

PROBLEM 8-3: Positive/Negative Cubic Form

PART 1: Format division

Materials: Optional
Size: 9" × 9"
Medium/Tools: Optional
Task/Considerations: Using shapes of your choice, develop a pleasing division within a 4½" square. Note: It may take several tries to arrive at a desirable solution. (See Figure 8–6.)

FIGURE 8–7
Flat layout of a cube. S. Hammack, illustrator.

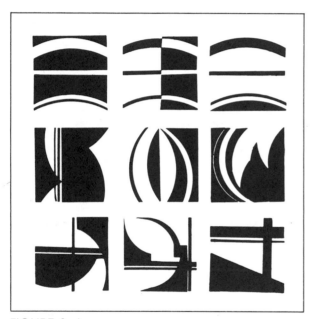

FIGURE 8–6
K. Drickey.

FIGURE 8–8
K. Drickey. L. Moran, illustrator.

PART 2: Spatial division

Materials: Drawing paper
Size: 18" × 24"
Medium/Tools: Ink, colored paper, T-square, triangle, X-acto knife, etc.
Task/Considerations: Draw a flat layout of a 4½" cubic form (see Figure 8–7). Consider the division in Part 1 as one of the faces of the cubic form. Project these forms into the interior space of the cube and record the position of each form on the other faces of the cube. This is simply a six-view orthographic projection. You may find it helpful to assign a different hue or value

to each form within the cube. This will aid you during the projection process. Note: Make the composition your best effort; strive to develop an interesting interior. Only you know the exact dimensions—that is, how far the forms project into the interior space, whether they contain negative, concave, convex areas, and so on. (See Figure 8–8.)

PART 3: Positive form

Materials: A thin planar material, a linear material

Size: 9″ × 9″ × 9″

Medium/Tools: Color application is limited to one hue.

Task/Considerations: The solution to Part 2 is considered a plan for a construction within a 9″ linear-frame cubic form. Construct the interior of the cubic form as volumetric or solid forms and attach them to the linear framework (see Figure 8–9). Note: A transparent planar framework may be substituted for the linear framework.

In order to test your compositional abilities, there is a final part to this problem. Assuming that the composition *works* in Part 3, then it should work in an opposite positive/negative spatial relationship.

PART 4: Negative form/Spatial reversal

Materials: A thin planar material
Size: 9″ × 9″ × 9″
Medium/Tools: Same restrictions as in Part 3
Task/Considerations: Construct a cubic form that is the exact spatial opposite of that made in Part 3: Make all negative areas positive and all positive areas negative (see Figures 8–10 and 8–11 to see how other students solved Part 3 and Part 4).

FIGURE 8–9
K. Drickey. L. Moran, illustrator.

FIGURE 8–10
K. Drickey. L. Moran, illustrator.

FIGURE 8–11
G. Yamron. L. Moran, illustrator.

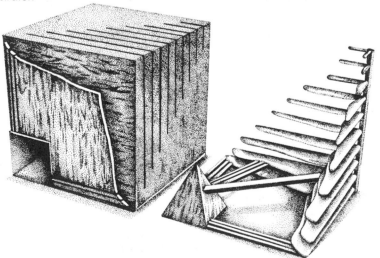

Do both compositions work? What changes would you make if you could? Is one part more successful than the other? Why? Does this problem prove anything to you about three-dimensional composition?

MACHINE TOOLS

The next problem is an introduction to machines, and as such, is a discipline problem. Its objective is to expose you to a variety of machines, to the sensitivity required in the juxtaposition of materials, and to joining and fastening devices. In addition, it should broaden your sense of aesthetics in relation to machine-made forms. Remember to make full use of your expanded compositional skills in solving this problem.

PROBLEM 8-4: Cubic Form Construction

Materials: Three different types
Size: 6″ × 6″ × 6″ (± 1/32″)
Medium/Tools: Optional
Task/Considerations: Construct a cubic form using a minimum of three different types of materials: three types of wood are not acceptable; wood, metal, and plastic are acceptable. The cubic form may be penetrated by using the appropriate shop equipment. Be conscious of proportional relationships—composition—within each side. Be sensitive to the interface from side to side to side. Consider material usage, surface quality, wood grain—anything that affects the completed work. A minimum of three fastening or joining devices (methods) must be incorporated in the cubic form. A high degree of control is expected. Finish the form appropriately. (See Figure 8-12.)

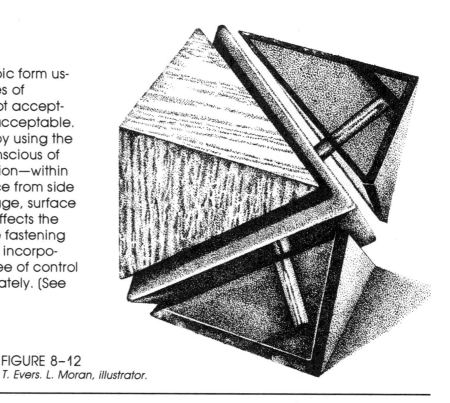

FIGURE 8-12
T. Evers. L. Moran, illustrator.

KINETIC ANALYSIS

The research project that follows will introduce you to an analysis of the kinetic aspects of a product—the range of motion incurred in the normal use of a product.

PROBLEM 8-5: Kinetic Resection

Materials: Optional
Size: Optional
Medium/Tools: Optional

Task/Considerations: Select a manufactured functional object that can be held in your hand. Note: You will be altering the form of this object;

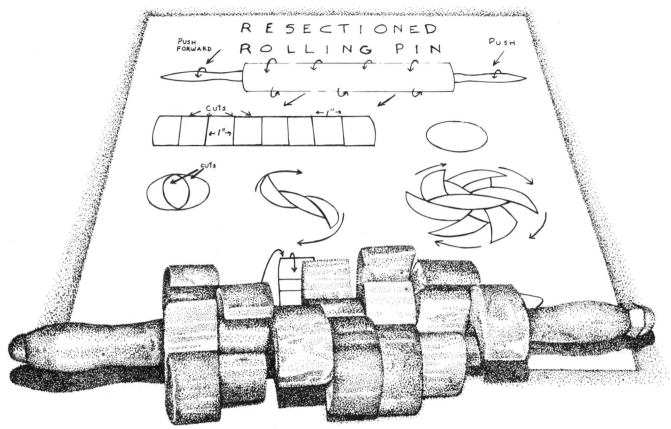

FIGURE 8-13
Student unknown. L. Moran, illustrator.

FIGURE 8-14
M. Kiriakos Ruse. L. Moran, illustrator.

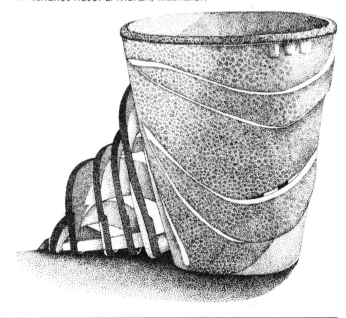

consider that when selecting the object. Are you able to use the object that you selected at the beginning of this course of study? Begin to gather information about the use of your object. How does it normally function? Use it yourself, and watch someone else use it. Record your observations, then analyze and diagram the range of motion. From this information, determine the appropriate divisions for segmenting the object. Keep in mind that your purpose is to identify the object's function visually through its segmentation and subsequent reassembly. It should look like what it does; that is, its form should be related to its function. Be very careful when segmenting the form. It is suggested that you number the pieces to make reassembly easier. Select the appropriate adhesive or assembly process for the material of your object and reassemble it. (See Figures 8-13 and 8-14.)

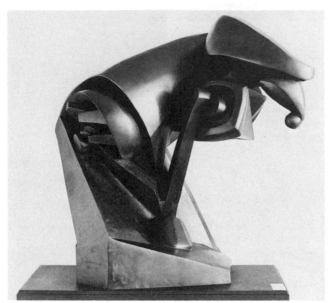

FIGURE 8–15
Raymond Duchamp-Villon. Le Grand Cheval. *1914. Collection Walker Art Center.*

Does it look like what it does? Is there a relationship between the appearance of form and the kinetic aspects of function? Was that relationship achieved in this sculpture of a horse? (Figure 8–15.) Traditionally, this has been true of product design. Refer to the visual reference chart for examples of streamlined products of the 1930s. Should there be such an apparent visual relationship in today's products?

COMPONENT CONSTRUCTION

The next problem introduces you to a method that is essential for the visual artist in a technological society. It grew out of my love for surplus stores and junk piles. You are again asked to work with industrially produced forms; however, this time you will use parts of objects or components. Many visual artists have used industrially produced component forms in their work. One of my favorites is Picasso's *Monkey and Her Baby,* even though the component usage is minimal (Figure 8–16). Another outlet for component assembly is the custom car field. The vehicle in Figure 8–17 was designed to emphasize a bank's extensive car loan program.

It is suggested that you research adhocism, eclecticism, recycling, and such before attempting this problem. Also, become acquainted with junkyards, surplus and salvage stores, antique shops, and second-hand shops in your area. You will discover objects and materials that are fantastic, reasonably priced, and just waiting for your use.

FIGURE 8–16
Pablo Picasso. Monkey and Her Baby. *1952. Courtesy The Minneapolis Institute of Arts.*

FIGURE 8–17
Gene Winfield. ForChevAMChrysVagen—1971. *Courtesy Gene Winfield Special Projects.*

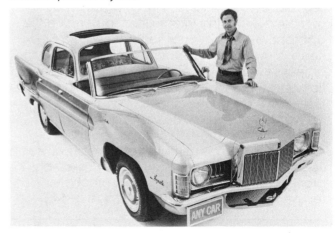

PROBLEM 8-6: Component Form

Materials: Optional
Size: Optional
Medium/Tools: Optional
Task/Considerations: Select a component or a series of industrially produced components. Take the components out of context and use them for a purpose other than that for which they were originally intended. Other materials may be added during the completion of the form. Strive to produce a serious, aesthetically pleasing whole, not chaos, clutter, or junk, as so often the case with first attempts at component form constructions.

Option 1: A functional object (see Figure 8–18).

Option 2: A decorative object (see Figure 8–19).

FIGURE 8–18
J. Throssel. L. Moran, illustrator.

FIGURE 8–19
M. Ward and C. McRae. L. Moran, illustrator.

The following problem provides an opportunity for developing competency with one machine. An additional objective is for you to develop a sense of personal proportion in relation to multiple forms.

PROBLEM 8-7: Related Forms

Materials: Optional

Size: Optional

Medium/Tools: Optional

Task/Considerations: Develop five forms that are related in proportion—height to width to thickness—using one of the shop machines (lathe, milling machine, sewing machine, circular saw, jointer, etc.). Each of these forms is to be an integral part of a progression: If you were to take one of the forms out of the sequence, you would destroy the visual continuity of the total form. These forms should show the capabilities of both the machine and the operator. Consider materials, process, finish, presentation, and so on. (See Figures 8–20 and 8–21.)

FIGURE 8-20
J. Courtney. L. Moran, illustrator.

FIGURE 8-21
M. Benyo. L. Moran, illustrator.

How will you solve the sequence aspect of the problem? Can you see the connection between designing sets, rows, collections of objects, and these nonobjective forms? (See Figures 8–22, 8–23, and 8–24.)

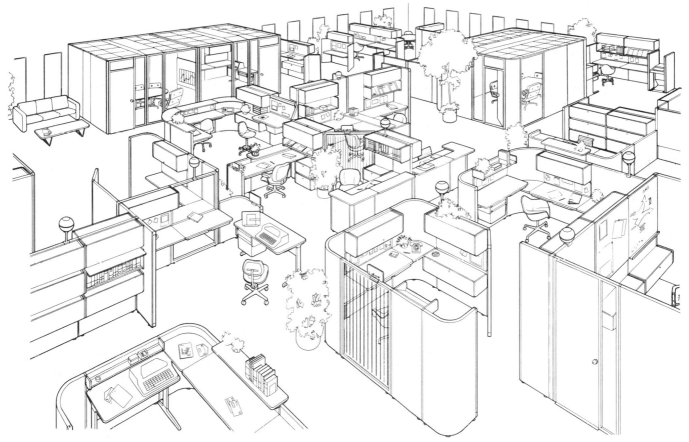

FIGURE 8–22
Action Office® System. Courtesy Herman Miller, Inc.

FIGURE 8–24
Marlene Knutson. Whale tub toy. Courtesy Tonka Corporation.
D. Kareken, photographer.

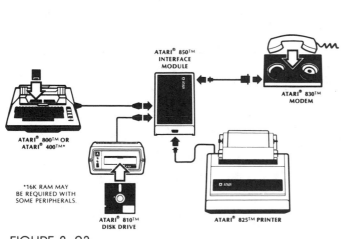

FIGURE 8–23
ATARI 400/800 Home Computers, ATARI 850 Interface Module,
ATARI 830 Modem, ATARI-825 Printer and ATARI 810 Disk Drive.
Permission of Atari, Inc.

The next problem requires the development and application of a logical proportion system. Refer to the bibliography at the end of this chapter for readings about proportion.

PROBLEM 8-8: Form/Space Relationship

Materials: Illustration board, black paper or pressure-sensitive film
Sizes: Square format: 11" x 11"
Circular format: 12" diameter
Rectonic format: 11" x 14"
Biomorphic format: A comparable area
Medium/Tools: India ink, ruling pen with compass attachment
Task/Considerations: Eight open circles of varying size are to be drawn in proportion to each other. The proportions must correspond to a logical principle and have visual impact.

PART 1: Layout

Using the eight circles, develop a composition that uses a logical (personal or formal) proportional system and is aesthetically satisfying. This should be considered as a holistic project. You must consider the total work area of the positive and negative space. The negative intervals between the circular shapes must also follow a prescribed proportional system. The circular shapes may be drawn in an open or closed manner.

PART 2: Fabrication

Materials: Optional: it is suggested that you use a material you are familiar with.
Size: Same as Part 1
Medium/Tools: Optional
Task/Considerations: The composition in Part 1 is to be regarded as the plan or top view of eight three-dimensional forms. You are to determine the front and side views of these forms, making them conform to a logical proportional system in all three dimensions. This project should show a high degree of competency with materials, tools, machines, processes, form, and presentation techniques. (See Figures 8-25, 8-26, 8-27, and 8-28.)

FIGURE 8-26
K. Drickey. L. Moran, illustrator.

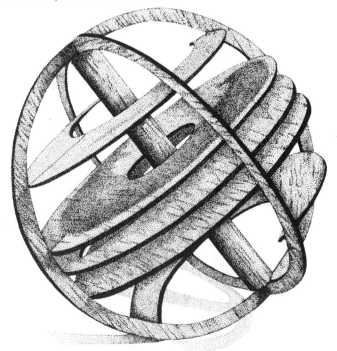

FIGURE 8-25
K. Drickey

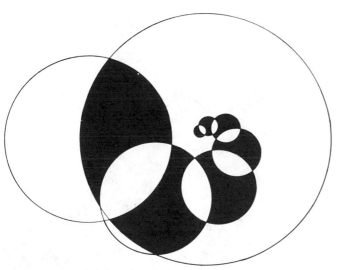

FIGURE 8–27
Student unknown.

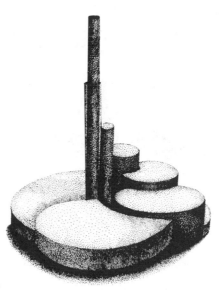

FIGURE 8–28
Student unknown. L. Moran, illustrator.

FORM FOR FORM'S SAKE

The final problem gives considerable freedom yet requires much discipline. It will encourage you to work with simple forms, often called pure form. This is espe-cially important since I am convinced that this will be the form of products of the future.

PROBLEM 8-9: Pure Form

Materials: Expanded polystyrene, fiberglass laminating resin, or plastic body filler
Size: 18″ minimum in any direction
Medium/Tools: Acrylic lacquer, spray gun
Task/Considerations: Develop a piece of ex-panded polystyrene (Styrofoam) by any method to result in a pure, simple form that will be en-hanced by a highly polished surface. Note: *Sim-ple* does not mean to imply the form should be dull and uninteresting. Consider the following ex-ample (Figures 8–29 and 8–30). This project re-quires a sensitivity to form and attention to de-tail. Your result should be near perfection. (See Figure 8–31.)

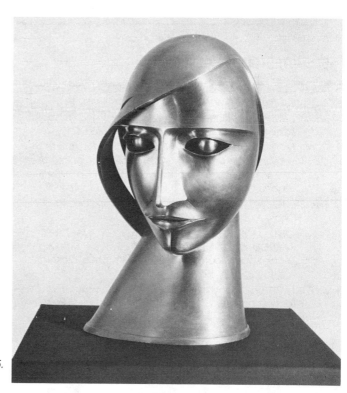

FIGURE 8–29
Rudolph Belling. Feminine Head *(formerly* Madonna*). 1925. Collection Walker Art Center.*

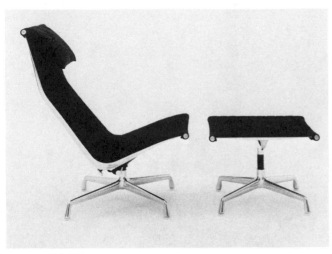

FIGURE 8-30
Charles Eames. Aluminum group furniture. 1958. Courtesy Herman Miller, Inc.

FIGURE 8-31
J. Van der Veen. L. Moran, illustrator.

SUGGESTED READINGS

BEAKLEY, GEORGE C., and ERNEST G. CHILTON. *Design Serving the Needs of Man.* New York: Macmillian, 1974.

BUDZIK, RICHARD S. *Sheet Metal Technology.* Indianapolis: Bobbs-Merrill Educational Publishing, 1981.

CORBUSIER, LE. *The Modulor: A Harmonious Measure to the Human Scale Universally Applicable to Architecture and Mechanics.* Cambridge; Massachusetts Institute of Technology, 1968.

FERRER, JOHN L. *Cabinetmaking and Millwork.* Peoria, Ill.: Chas. A. Bennett Co., 1970.

HAMMOND, JAMES J., EDWARD T. DONNELLY, WALTER F. HARROD, and NORMAN A. RAYNER. *Woodworking Technology.* Bloomington, Ill.: McKnight & McKnight Publishing Co., 1972.

JENCKS, CHARLES, and NATHAN SILVER. *Adhocism: The Case for Improvisation.* Garden City, N.Y.: Anchor Press, Doubleday, 1973.

KEPES, GYORGY, ed. *Module, Proportion, Symmetry, Rhythm.* New York: George Braziller, 1965.

KOWAL, DENNIS, and DONA Z. MEILACH. *Sculpture Casting Mold Techniques and Materials.* New York: Crown Publishers, 1972.

NEWMAN, THELMA R. *Plastics as an Art Form.* Philadelphia: Chilton Book Co., 1972.

NEWMAN, THELMA R. *Plastics as Design Form.* Philadelphia: Chilton Book Co., 1972.

MCCARTHY, WILLARD J., and ROBERT E. SMITH. *Machine Tool Technology.* Bloomington, Ill.: McKnight & McKnight Publishing Co., 1968.

RICHARDSON, TERRY. *Modern Industrial Plastics.* Indianapolis: Bobbs-Merrill Educational Publishing, 1981.

VERHELST, WILBERT. *Sculpture: Tools, Materials, and Techniques.* Englewood Cliffs, N.J.: Prentice-Hall, 1973.

9 Functional Aesthetics

As you approach the end of your first year of studio work, you should become more aware of what lies ahead and start making preparations to deal with it by the development of a personal philosophy. One aspect of this philosophical development is determining a criterion for aesthetic considerations and purchase decisions. It should be noted that I am using the term *aesthetics* not in the classical philosophical sense of beauty but rather to refer to the visual appearance of an object. Aesthetics, in this sense, is inherently linked to a product's function. Aesthetics addresses the physical and psychological relationship between utility and visual form and as such is called *functional aesthetics.*

My premise is a simple yet effective method of developing a visual awareness, a social consciousness, even a degree of visual literacy. After you read this chapter, I hope you will have two concerns: first, evaluating the objects you develop in the future as well as

the objects with which you have currently chosen to surround yourself (aesthetic considerations) and, second, evaluating the objects you will include in your future environmental situation (purchase decisions). Not surprisingly, there is a great deal of overlap for you as individuals in these two areas.

THE CONSUMER

Since the Industrial Revolution our society has learned to mass produce objects to satisfy our needs and cater to our wants and desires. Products have become the basis of our economy, our aspirations, and our way of life. Our society is founded on capitalism—the making, selling, possessing, and consuming of products. In essence, each of us plays the role of the *great American consumer.* A majority of consumer products are designed with the average American in mind. Our country is a land based on averages, one in which every conceivable statistic is compiled to give us a computer profile of the average American. The book *American Averages,* the source for many of the following statistics, tends to give credibility to the previous statement.

The average American is female, since females make up slightly over half of the population. She is Caucasian; she is Protestant; she has slightly more than twelve years of formal education and is twenty-four years old. She is 5'4" and weighs 142 pounds. She was married at the age of twenty-one-and-a-half to a man two-and-a-half years older. Chances are the couple received the most common wedding gift, a small electric appliance, usually purchased at a discount store that will not make exchanges. She has between two and three children, usually named after movie stars, sports heroes, popular songs, singers, biblical figures, presidents, or grandparents. She and her husband share the same religious faith. They own one car on which they owe slightly more than $1,500 in installment payments. Her husband holds a manual labor or service job and earns approximately $18,000 annually. They reside in a city with under 100,000 population. They have a five-room house valued at $45,000, two-thirds of which is mortgaged. The house contains a bathtub or a shower, a flush toilet, a vacuum cleaner, a refrigerator, a coffee maker, one telephone, one black-and-white television, and a washing machine. However, it has no clothes dryer, air conditioner, microwave oven, or separate food freezer. The average woman spends eight hours a day performing her household tasks; two plus hours are spent in the kitchen, in which she can enlist the aid of approximately 250 appliances designed for kitchen usage. How many do you think she really uses or needs?

Today's consumers at all levels of society are better educated and have access to a tremendous amount of visual information. Counting all forms of visual advertising (television, signs, newspapers, labels, etc.), the average American sees 1,800 commercial messages per day. Consequentially, you are literally saturated with visual forms; the selection of products has become a complex, if not confusing, process. Consumers who have no visual education are limited in their selective ability. They can play it by ear and hope for the best.

If you are able to obtain a degree of visual literacy, you should become more selective in your purchases. Your material possessions should become an extension of your own thinking, not what motivation research, market analysis, and sales have decided is good for you. In order to make informed purchase decisions, you need to be visually literate. The decisions you make will in turn influence the future objects you will design.

Factors in Aesthetic/Purchase Decisions

What factors within each of us influence our aesthetic considerations or purchase decisions? Subconsciously, the one factor that has the greatest influence on your objective decision making is your *frame of reference:* your age, sex, race, religion, social and economic status, environment, and most important, your past experiences. To cite an example of how frame of reference affects purchase decisions, my first experience in a bar was when I was seventeen on the senior trip to New Orleans. Since my family didn't *drink,* my only experience with bars was via television westerns such as "Gunsmoke." When approached by the bartender and asked what I wanted to drink, my natural response was, *Gimme a whiskey.* You can imagine the bartender's reaction! Family tradition and other influences can relate to frame of reference. If your father drove a Ford automobile and it was dependable and he liked it, the chances are great that you will purchase a Ford. The same holds true for a Maytag washing machine, or a Johnson reel.

The mass media generally dictates the *what, when, where, how, how much, and how often* with reference to purchase decisions. It is easy to identify advertisements for special interest groups in magazines, journals, newspapers, etc. How do the advertisements differ in *Playboy, Time, Seventeen,* and *Scientific American*?

The average American watches over twenty-seven hours of television a week. In the average household the television is on just over forty-five hours per week. Many of you watched an estimated 15,000 hours of television before graduating from high school. Ap-

FIGURE 9-1
Festal billboard. D. Kareken, photographer.

proximately ten minutes of each hour is devoted to commercials; you probably have watched an average of 150,000 commercials. How can you make an objective decision? As a child you were bombarded with appealing images of products (usually toys and junk foods) along with catchy, easy-to-learn little tunes to which you were attracted. Remember the Barry Manilow classic, *I'm Stuck on Bandaids...?* My oldest son, age thirteen, is constantly humming or singing tunes from commercials! I'm sure you're aware of differences in audience appeals, but if not, watch for the differences in advertising between prime time and morning cartoon time, or even the prime time ads shown in conjunction with child-oriented programs or holiday specials.

A good commercial conveys factual information. You need facts in order to make an objective decision to purchase a product. However, be advised that commercials hardly ever give you all the facts. Nonfactual commercials tend to use devices that link their product to fun, excitement, warmth, happiness, love, or sports and/or movie stars in hopes that you will identify with the event, emotion, or individual and purchase the product.

Average Americans, the individuals for whom the soap operas and Monday night football were developed, are also the individuals for whom supermarkets, discount stores, and such products as the Popiel Pocket Fisherman and Veg-a-matic were designed. Through television advertising, Mrs. Average is introduced to new products and promised success with her family through making a delicious cup of coffee

or made to feel inadequate because of *ring around the collar*. Mr. Average is told to change the brand of beer he drinks and when to buy a new car. Both are told what mouthwash to use and which toothpaste, snacks, and soft drinks are best for the children. In short, we are being commercially exploited by a segment of our own profession. As human beings we have certain physiological, spiritual, and psychological needs. Many are conscious tissue needs—food, shelter, clothing. The areas the commercials exploit most profitably are intellectual needs and to an even greater degree subconscious wants. Did you really need your last purchase? Or did you just want it? Many wants are inculcated by fad or fashion, by desires to *keep up with the Joneses*.

We tend to purchase fad items for the fun of it. The first fad item I remember having to have was a Hula-Hoop. How many of you purchased or were given a *pet rock* when they were popular? Remember when every automobile came equipped with a C.B.? Did you participate in the *urban cowboy* fashion fad? How many fads have come and gone since then? Is a fad item a valid product? What we often fail to realize is that a valid product should fulfill the practical needs of contemporary life.

A serious problem with the design of many products, and perhaps more often the manufacturing process, is that products are not made to last. Our society seems to be seeking stability, as witnessed by a strong nostalgic appeal in products, television programming, popular music, and advertising (see Figure 9-1). Between the end of World War II and the late

FIGURE 9–2
Watch catalog. Sears Catalog.

How many people do you think really needed the last new car they purchased? Or, were they influenced by the Detroit-sponsored ad campaign? Until recently, the average American traded cars every two-and-one-half years—to keep up with the changing styles, to add luxury items first introduced on the top-of-the-line models, or in some cases, simply out of habit. Have you ever heard of "new car fever"? I can remember my father coming down with a bad case of it about every three or four years. In 1975, during the so-called energy crisis, General Motors had an increase of 35 percent in full-size new car sales, while small car sales were down 28 percent. Were we returning to the days of the gas guzzlers? What attitude was to blame for the auto industry slump of 1980? The auto industry reportedly lost millions of dollars. Who was to blame? Was the Detroit product meeting the needs of the consumer? Does "Detroit" listen to the consumer? How many of you own a foreign car? If so, why did you choose it over a domestic vehicle? Compare the latest Detroit offerings to an alternative transportation solution: the *Freeway* (Figure 9–3), a one-passenger commuter vehicle with an estimated gas mileage rating of between 80 and 100 miles per gallon. Surprisingly, the drawings in Figure 9–4 were done as a class project in 1954. General Motors had a comparable vehicle on display in their exhibit at EPCOT Center when it opened in 1982. Do you think it will ever go into production?

1970s, many products were designed, manufactured, and purchased to satisfy short-term needs. This phenomenon was referred to as the *Kleenex culture* and was predicated on the concept of planned obsolescence. But consumer attitudes and the state of the economy have changed considerably. Consumers are taking longer to buy a product and are making fewer impulse and credit purchases. They are purchasing products of better quality and planning for longer usage. However, such products tend to cost more. Consumers seem willing to pay higher prices if they feel they are getting value, quality, and durability. Within recent years there has been a trend to purchase used or recycled products. Were past products better? At one time products were made to last the owner's lifetime and were advertised as such (see Figure 9–2). It was not uncommon for a product to last so long that it was passed from generation to generation. Today you are lucky if you get a five-year warranty. Radios and televisions used to have ten-year warranties; recent warranties average only ninety days, providing you keep the sales receipt, send in the warranty card, and comply with other conditions. Options do exist: You may wish to purchase the *buyer protection plan,* where in essence you bet the product will not last as long as the manufacturer says it will. Is this logical?

FIGURE 9–3
H. M. Vehicle/Freeway. Courtesy Dave Edmonton.

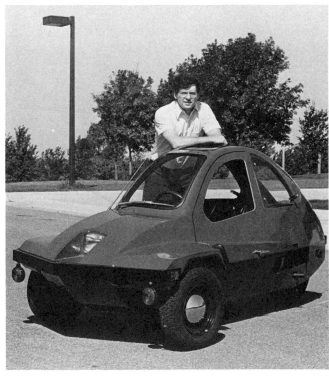

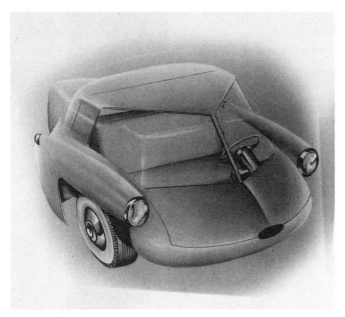

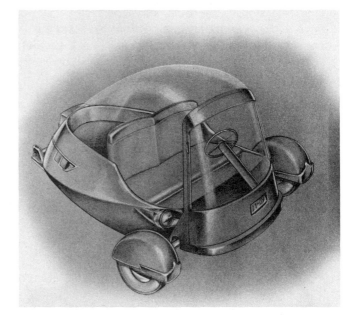

FIGURE 9-4
Auto concept illustrations 1954. Chester Freden, photographer. Courtesy Minneapolis College of Art and Design Archives.

PRODUCT EVALUATION CRITERIA

Apart from our frame of reference and our psychological, physiological, conscious, and subconscious needs and wants, several other very influential factors should be examined in developing a criterion for aesthetic considerations and purchase decisions. We can make these decisions intellectually, or intuitively, or most often, in combination. The *U.S.A theory* identifies three major factors in the evaluation of a product: utility, symbolism, and aesthetics. *Utility* is entirely objective and is measurable through performance—speed, durability, size, weight, efficiency, and so on. *Symbolic connotations*—masculine or feminine, beautiful or ugly, high class or low class, young or old, expensive or cheap—are primarily subjective criteria. Some are based on our personal likes and dislikes; others are determined by society. *Aesthetic considerations* are usually expressions of taste and vary from person to person.

This theory for evaluating a product was developed at the Institute of Design, Illinois Institute of Technology. The amount of each factor that goes into a decision can be determined and is useful in classifying and evaluating a product. For example, a commercial ice maker (Figure 9–5), and consumer products such as a ten-speed bicycle are *vernacular* products and are classified as primarily utilitarian. A vernacular product could also be referred to as a survival design: a product in which the life of the user depends on the performance of the product. Examples are military aircraft and scuba diving equipment. The Eames lounge chair

FIGURE 9-5
Commercial ice maker. Courtesy Frigidare.

(Figure 9-6) symbolizes social status and high cost; the Kenworth conventional tractor, (Figure 9-7) and the Sony Walkman (Figure 9-8) rank high in visual aesthetics. Too often the designers and the buyer of a given product concern themselves with its configuration (visual aesthetics) rather than its function and its intended user. This results in a poorly designed product, no matter how visually appealing the form. A good example is the doorknob design in the building where I teach (Figure 9-9). Doors are difficult enough to open under normal circumstances, but try to open one with your hands full of supplies or products. Impossible, but they sure look good! Can you think of a better solution for opening doors?

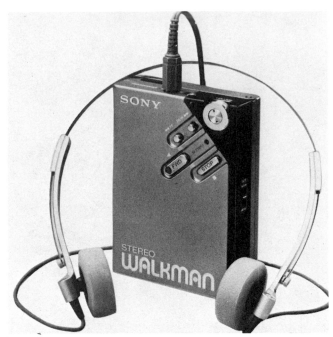

FIGURE 9-8
Sony Walkman WM-2. Walkman is a registered trademark of SONY corporation of America.

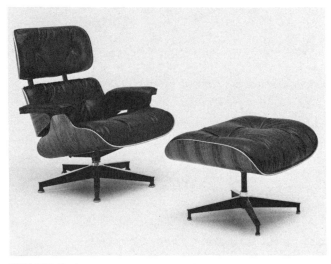

FIGURE 9-6
Charles Eames. Eames lounge chair and ottoman. Courtesy Herman Miller, Inc.

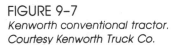

FIGURE 9-7
Kenworth conventional tractor.
Courtesy Kenworth Truck Co.

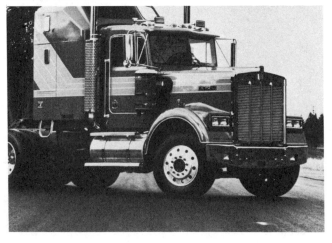

FIGURE 9-9
Door knob. D. Kareken, photographer.

KITSCH

Discussion of poorly designed products leads me to introduce a term that I'm sure is familiar to many of you: *kitsch.* It should be made clear that a kitsch item and a poorly designed item are not synonymous. However, many poorly designed products do fall into kitsch categories. A German word, *kitsch* is translated to describe objects that are in poor taste (see Figure 9-10). It is a term used in aesthetic classification. The essence of kitsch, though often in the form of the prod-

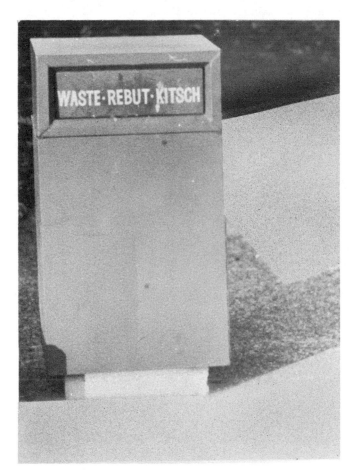

FIGURE 9-10
Kitsch. B. Annis Fladung, photographer.

FIGURE 9-11
Side of house, Kansas 1976. F. Young, photographer.

uct, is more often in its use or application as well as in its acceptance as a substitute for genuine objects. As a product it can take the form of cute, overdramatic, spectacular, or imitation.

Kitsch originated at the time of the Industrial Revolution. Until then, most people had very few things with which to decorate their homes. Early in this period manufactured products, everything from china ornaments to picture postcards, began to reach the homes of the lower and newly formed middle classes, who purchased them in an attempt to emulate the upper class. The desire to clutter the home with objects kept pace with the flood of cheap products produced at the factories. I have come to the conclusion that individuals have an innate desire to decorate or personalize their surroundings. However, the less visual education individuals have, the more likely they will prefer complexity to simplicity. This preference often leads to homes or businesses that are visually cluttered. Taken to extremes it might be considered *folk art,* as is this example from a small town in Kansas (Figure 9-11).

The average American today is still copying the upper class or rich. A person may desire social status that

FIGURE 9-12
VW / Rolls. V. Warren, photographer.

comes with owning a luxury automobile, but be unable to afford one. So compromises are made, and the result is kitsch: a Volkswagen with a customized Rolls Royce front grill and accessories (Figure 9-12). Considering the probable cost of such a custom vehicle, the owner could have possibly purchased a legitimate status vehicle. Kitsch appears in every segment

FIGURE 9–13
The executive bar glass set ad. D. Kareken, photographer.

of society, with upper-class kitsch differing from middle-class and lower-class kitsch only in price. You will also find that discussions of taste, within groups or with individuals, is very awkward in our society. We all think we have good taste; however, I would not recommend telling your friends or parents that their house is full of kitsch.

There will always be a demand for kitsch items and its eradication will be impossible. Kitsch, like the visual arts, can be good or bad, liked or disliked. It is possible for a individual to like kitsch just as it is possible for an individual to like a visual arts work that you consider bad. It is all a matter of taste. You must question the nature of kitsch. I suggest that a good use for kitsch is to collect it for what it is, analyze it, and learn from it. Our society embraces a diverse range of kitsch products. Movies and television are prime vehicles for the expression of kitsch, especially holiday specials.

Other kitsch categories include advertising (Figure 9–13), propaganda or patriotism (Figure 9–14), and politics, love and marriage, birth (Figure 9–15) and death (Figure 9–16), religion, sex (Figure 9–17), pornography (Figure 9–18), tourism, (Figures 9–19 and 9–20), architecture (Figure 9–21), product design (Figures 9–22 and 9–23), and fine art products (Figure 9–24).

It has been said that art challenges human ability to appreciate and understand. However, average consumers are faced with a dilemma—for the most part, they are visually illiterate. Tastemakers, in hopes of giving the public an appreciation of visual art, mass produced copies of masterpieces selected from the entire history of visual art. The most common reproductions are from the impressionist or other representational periods. How many people do you know who have a reproduction in their home? Is it Van Gogh's *Sunflowers,* by any chance? The problem with reproductions is that they are no longer genuine and generally have been transformed into something inferior. The photographers and printers tend to lose respect for faithfulness to scale, color, and the overall feeling of the image. In other words, reproductions have presented the public with facsimiles, but even worse, many individuals feel that reproductions are as attractive, as beautiful, and as effective as the original. Reproductions have their purpose; however, you should be aware of the original work and the differences between the two.

FIGURE 9-14
1942 calendar. D. Kareken, photographer.
Collection of the author.

FIGURE 9-15B
Birth announcement interior. D. Kareken, photographer. Collection of the author.

FIGURE 9-15A
Birth announcement for an artist. D. Kareken, photographer.
Collection of the author.

FIGURE 9-16
Memorial Park ad. Collection of the author.

Some forms of kitsch can be fun, amusing, or even dangerous. Such products may be classified as *gross-symbolism switches*. A gross-symbolism switch is a mass-produced object that connotes one function but performs another. These forms are quite common and readily available in most discount stores, gift shops (especially in tourist areas), and county fairs. Typical examples are the frying-pan wall clock for your kitchen wall, the light-bulb salt and pepper shakers (Figure 9–25), and bow-and-arrow squirt gun. A dangerous example of a gross-symbolism switch was reported several years ago in California. Apparently, a

FIGURE 9–17
You'll get a bang. . . . Collection of the author.

FIGURE 9–18
I'm a Latin from Manhattan post card. S. Hammack, photographer. Collection of the author.

FIGURE 9–19
Success in Minnesota. D. Kareken, photographer.

FIGURE 9–20
Souvenir—NY City—Snowball. MCAD Archives.

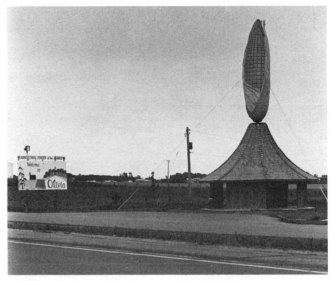

FIGURE 9–21
Welcome to Olivia. F. Young, photographer.

FIGURE 9–22
The rain goddess lamps. D. Kareken, photographer.
Collection of the author.

FIGURE 9–23
Deluxe designer phone. D. Kareken, photographer.
Collection of the author.

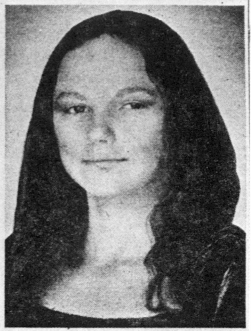

17-Year-Old Wins Our Mona Lisa Look-Alike Contest
...And a Free Trip To Paris for Two

Norma Pirkle really has something to smile about — she's the happy winner of our exciting Mona Lisa look-alike contest.

"Oh, no! I just can't believe it. I've never won anything before," exclaimed Norma in her Oxnard, Calif., home.

The 17-year-old high school student has won a fabulous all-expenses-paid vacation for two to Paris, France, for a fun-filled week of sight-seeing.

And, of course, she'll also visit the Louvre, the famed museum where the Leonardo da Vinci painting hangs. "I'm going to take my mother with me to Paris," said Norma.

"My friends are really going to be excited for me when they hear about this.

"I entered The ENQUIRER's contest after a friend told me I looked like Mona Lisa. So we took some pictures and sent them in.

"I didn't think about it much after that . . . I didn't want to get my hopes up too high. You can imagine how excited I am with the good news!

"And my mother is as excited as I am since we've never gone on many vacations. I'm not sure yet what we'll see while we're in Paris. I do know we'll see the real Mona Lisa. We'll probably leave during spring vacation so I don't miss any school."

MONA LISA **WINNER:** Teenager Norma Pirkle.

FIGURE 9–24
Mona Lisa look alike. D. Kareken, photographer.

FIGURE 9–25
Salt and pepper shakers. D. Kareken, photographer. Courtesy of P. Midthun.

FIGURE 9–26
Pistol lighter. D. Kareken, photographer. Collection of the author.

woman took a pistol from a drawer and went to investigate when she thought she heard a prowler during the night. Finding nothing, she put the pistol on the nightstand and went back to bed. The next morning she awoke, took out a cigarette, reached to the nightstand for the pistol-shaped lighter she keeps there, and shot herself in the left hand (Figure 9–26).

Another kitsch form to be aware of is classified as *shlock art.* It is considered original *art* work but is often not one of a kind. Shlock (the name is derived from the Yiddish word for wretched) is exemplified by the paintings and sculpture that you tend to see in art stores in suburban shopping centers. It is the landscape or cityscape decorating most motel rooms

FIGURE 9-27
Motel room. F. Young photographer.

(Figure 9-27) or the work hung in the waiting room of your dentist, doctor, or lawyer. European imports as well as the Camrose Art Corporation are responsible for many of the shlock works. Camrose is reported to employ 500 artists, whose work earns the corporation several million dollars each year. The real problem with shlock works is that they are not inexpensive. An individual may spend up to $150 on such works at a furniture store. How many pieces of excellent student work have you seen that could be purchased at that price? What would happen to the level of visual arts if the several million dollars per year were paid to non-shlock artists to promote their work?

ETHICAL AWARENESS

How may we approach a solution to this problem? I would suggest assimilation of certain values that will be explored in the following paragraphs. However, values or ethical awareness is not something that can be forced onto an individual. They are developed only through a long, gradual process of education. Each of you must shape your philosophy and discover your own *truths* in reference to aesthetic considerations and purchase decisions.

As a visual artist and consumer, you have an obligation to consider the ethics of form. Does the object visually express its purpose? Does the form suggest its function? In *Design for the Real World,* Viktor Papanek stated that some furniture, such as a dining table with legs constructed of stainless steel with a marble top, evokes the response to lie down and wait for the doctor to come and extract your appendix. Nothing about the table says, *Dine off me.* There is no connotation, or communication, between the form and the user. For several years I used an antique mortician's table, completely restored, as a dining table. I can truthfully say that most of my dinner guests were somewhat apprehensive at the thought of dining off such a table. It was, however, a beautiful form and functioned well once you got past the connotation.

Do you consider stylistic ethics? Is an object expressive of the culture in which it is to operate? The object should visually express the attitude of the times and the conditions under which it was designed and produced. Consider the products that have been designed to meet the demand for nostalgia or western lore. (Figure 9-28) Can you ethically own an *early American* style television ? Is this how a contemporary product should appear? (Figure 9-29.) What form should be given to products of the year 2025?

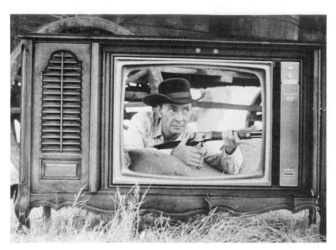

FIGURE 9–28
T.V. console. B. Tucker, photographer.

Environmental and Safety Concerns

The 1960s and 1970s made us aware of past and future environmental concerns. These should be considered when designing products or making purchases. Are the materials used in a product safe for human use or for the environment? Is the material used biodegradable? You might also consider the type of manufacturing process in relation to the amount of energy consumed. It is impossible to consider all the possible misuses of a product when designing it; however, you should be aware of the possible dangers. The misuse and abuse of products has led to the formulation of safety codes by some industries. You should be aware of these safety codes when making purchases. Safety codes are examples of manufacturers' ethics, whether initiated by the manufacturer or legislated by the government.

The Child Protection and Toy Safety Act became law in 1969. This law prohibits the sale of toys that could prove harmful to children. Any toy that presents an electrical, thermal, or mechanical hazard or that may endanger the child's safety through sharp or protruding edges, fragmentation, explosion, strangulation, asphyxiation, electrical shock, or fire is not to be sold.

The toy industry is acutely aware of its responsibility to design toys as safely as possible, as illustrated by the example of the construction of a stuffed animal toy (Figure 9–30).

Cost

The cost factor is also an ethical question. Granted, the manufacturer is in business to make a profit, but does the product serve as wide a public as possible after expense requirements are considered? Can production, marketing, and advertising costs be kept as

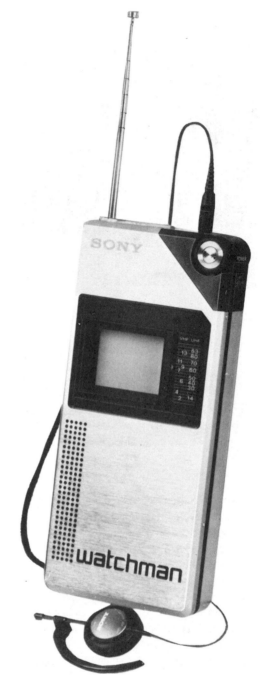

FIGURE 9–29
Watchman portable T.V. Watchman is a registered trademark of SONY Corporation of America.

low as possible and the product still be profitable for the manufacturer? Were $48 designer jeans an ethical product?

The next time you go to a fast-food restaurant, count the layers of packaging on a simple hamburger. Most products are overpackaged. It is not uncommon for the package to account for one-third of the direct

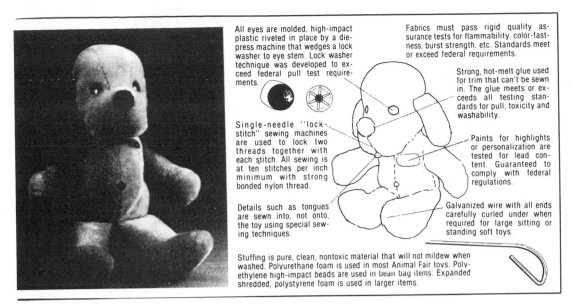

All eyes are molded, high-impact plastic riveted in place by a die-press machine that wedges a lock washer to eye stem. Lock washer technique was developed to exceed federal pull test requirements.

Single-needle "lock-stitch" sewing machines are used to lock two threads together with each stitch. All sewing is at ten stitches per inch minimum with strong bonded nylon thread.

Details such as tongues are sewn into, not onto, the toy using special sewing techniques.

Fabrics must pass rigid quality assurance tests for flammability, color-fastness, burst strength, etc. Standards meet or exceed federal requirements.

Strong, hot-melt glue used for trim that can't be sewn in. The glue meets or exceeds all testing standards for pull, toxicity and washability.

Paints for highlights or personalization are tested for lead content. Guaranteed to comply with federal regulations.

Galvanized wire with all ends carefully curled under when required for large sitting or standing soft toys.

Stuffing is pure, clean, nontoxic material that will not mildew when washed. Polyurethane foam is used in most Animal Fair toys. Polyethylene high-impact beads are used in bean bag items. Expanded shredded, polystyrene foam is used in larger items.

FIGURE 9–30
Stuffed animal construction diagram. Courtesy of Animal Fair.

cost of the product. You pay for the package and the advertising in each product you purchase.

Craftsmanship

Directly related to cost is labor and, more specifically, the quality of labor—the workmanship or craftsmanship. The average consumer, perhaps naively, expects a new $10,000 automobile to operate reasonably well and to have windows that don't leak, fenders that don't rust out, and interior parts that don't rattle (as they invariably do). Annoying as that one rattle that can't be pinpointed is, it's minor compared to the aggravation of fighting the bureaucratic system (the service department) to have your *rattle looked at.* In today's mass-produced society, do you have the option of demanding or even considering the quality of materials, method of construction, finish, attention to detail, and so on?

As consumers, we should ask these questions with each product we purchase. True, it takes a little thinking and may make the salesperson uncomfortable, but, you are the one who has to use the object. Ask the following questions about materials and structure: Has the integrity of the material been respected? Is the construction technique structurally sound? Will the material be easy to care for or will it take time and effort? Are you willing to make the trade-off? Has the worker taken pride in the construction of the object? Does the object express the methods used to make it, not disguising mass production as handicraft or the simulation of a process not used? How long will the material last or the product continue to function?

Similar questions could be asked of other areas of evaluation.

HUMAN FACTORS

Human factors are also an important consideration. They may be divided into five distinct groupings: anthropometrics, perceptual factors, performance factors, physiological factors, and sociopsychological considerations.

Anthropometrics deals with structural and functional measurements. As a consumer you need to consider whether the product fits your body and what you do with your body. We automatically consider fit when purchasing shoes or clothing; we should be equally aware of it when purchasing everything from a screwdriver to an automobile.

As a designer you should always consider the measurements of the user. There are several helpful books in this area; one of the most useful is the *Human Scale Set.* However, there will be times when you will have to develop your own information due to the limitations of the charts.

A good example of *perceptual considerations* might be the legibility of type on a road sign or the correct color choice for a hospital operating room. Perceptual considerations also include auditory and tactile stimulations. Unnecessary noise is a major concern of mine when I am designing a toy. The sound should be pleasing, even stimulating, to the child but not an irritant to an adult.

Performance factors such as strength, endurance, speed, safety, stress, and boredom must also be considered when designing or purchasing a product. This is exemplified by the selection process commonly used to purchase sports equipment.

Physiological factors generally relate to a task or work situation—the work environment. For example, you probably considered a physiological human factor if you decided to purchase a lamp to enable you to do your studio work at night. What were your considerations? Were some more important than others?

The final group of human factors, *sociopsychological considerations,* are primarily subjective and are somewhat difficult to measure. This group includes things like the amount of personal space needed for you to feel comfortable. Have you ever noticed how people space themselves when they have to stand in line? Pay attention the next time you register for classes or go to a movie. Sociopsychological considerations include modesty, peer pressure, and group identity. You should be aware of all of the above when designing or purchasing products.

AESTHETIC CONCERNS/DECORATION

Aesthetically we are concerned with the organization of the sensual elements. Does the product consider the visual and tactile elements? Are the olfactory, gustatory, auditory, and kinesthetic factors, if applicable, related to the concepts of size, shape, color, line, form, structure, and space? When evaluating the visual organization of a product, we are often confronted with graphic application or surface decoration. The first question to ask ourselves about graphic application is, is it necessary? Is it analogous to the surface space on which it is placed? Does the graphic application reinforce or contribute to the structure? Remember the stitching on the cowboy boots? Decorative though it may be, it is also serving a useful function. Is it harmonious with the form of the object? Will the decoration be appealing throughout the life of the object? Have the graphics been applied for ethical reasons? Or is the graphic application nothing but *eye work?* How do you react to the decoration on the products in Figures 9–31, 9–32, 9–33, and 9–34?

You will often find that a common, hand-operated object will function better and often costs much less than a newer technologically advanced product. Compare the cost of a manual potato masher and the Braun kitchen machine (Figure 9–35), which, incidentally, has difficulty in mashing potatoes. However, because the kitchen machine is a multipurpose machine, perhaps a trade-off was made with other functions. We have been conditioned to believe that if a product costs more, it is better. This is not the case.

FIGURE 9–31
Lamp. D. Kareken, photographer. Courtesy L. J. Young.

FIGURE 9–32
Vase. D. Kareken, photographer. Courtesy C. Marcheski.

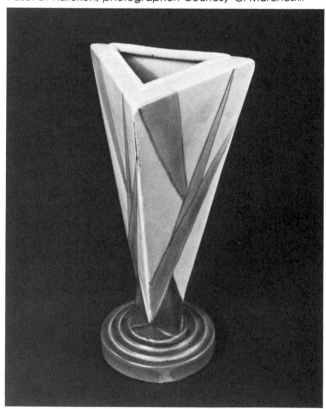

FIGURE 9–33
Van. F. Young, photographer.

FIGURE 9–34
Dixie cup—floral collection. Courtesy James River, Dixie Northern, Inc.

FIGURE 9–35
Braun KM–3 kitchen machine. Courtesy Braun A. G.

Each product must be considered individually and its merit weighed. Each object should blend utility, materials, and process into a visually satisfying, ethical form. It is a misconception that taste and appropriate design are luxuries beyond the means of the average American.

Since the Watergate political scandal there seems to be a trend in this country to place an importance on values and ethics. The consumer has begun to recognize many deceptive practices of manufacture and marketing. As a consumer you must be informed about the products you purchase to enable you to develop a criterion for making valid purchase decisions. This heightened awareness as a consumer will also sharpen your awareness as a designer. As a consumer you have the power to replace poor products in the market by the simple act of selective purchasing. This in turn will increase the demand for appropriately designed products. Consequentially, you evaluate your environment each time you add to it. Remember, only you can change it.

PROBLEM 9-1: Criteria Development

Task/Considerations: Develop criteria for making a purchase decision.

How does it differ from criteria developed for design considerations? From criteria developed for making aesthetic decisions? How do your criteria differ from those of your classmates? What do they have in common? Compare your frames of reference. How does that affect your criteria?

PROBLEM 9-2: Purchase Decisions

Task/Considerations: Have a consumer contest. As a class, determine the type of object you want to purchase—appropriately designed, kitsch, vernacular. Determine the amount of money each of you wishes to spend for this assignment. Each of you should begin with an equal amount; from one to five dollars is recommended. Determine the amount of time needed to purchase the objects—two hours, by next class period, tomorrow. Purchase the objects. Return to class and discuss the objects and the sources of purchase. Count the excess money each class member has. The individual who purchased the object considered to be the best example of its type at the lowest cost could be declared the winner. Set up an exhibition to share your information with other students.

SUGGESTED READINGS

BENNET, CORWIN. *Spaces For People: Human Factors in Design.* Englewood Cliffs, N.J.: Prentice-Hall, Inc., 1977.

BROWN, CURTIS F. *Star Spangled Kitsch.* New York: Universe Books, 1975

CAPLAN, RALPH. *By Design.* New York: St. Martins Press, 1982.

CRONEY, JOHN. *Anthropometry For Designers.* New York: Van Nostrand Reinhold Company, 1981.

DE LUCIO-MEYER, J. J. *Visual Aesthetics.* New York: Harper & Row, 1973.

DIFFRIENT, NIELS, ALVIN R. TILLEY, and JOAN BARDAZJY. *Human Scale 1/2/3.* Cambridge: MIT Press, 1980.

DIFFRIENT, NIELS, ALVIN R. TILLEY, and DAVID HARMON. *Human Scale 4/5/6.* Cambridge: MIT Press, 1981.

DIFFRIENT, NIELS, ALVIN R. TILLEY, and DAVID HARMON. *Human Scale 7/8/9.* Cambridge: MIT Press, 1981.

DORFLES, GILLO. Kitsch: *The World of Bad Taste.* New York: Universe Books, 1969.

EVANS, HELEN MARIE. *Man the Designer.* New York: Macmillan, 1973.

FEINSILBER, MIKE, and WILLIAM B. MEAD. *American Averages.* New York: Doubleday & Co., 1980.

JEROME, JOHN. *The Death of the Automobile.* New York: W. W. Norton and Co., 1972.

KEPES, GYORGY, Editor. *The Man-made Object.* New York: George Braziller, 1965.

NELSON, GEORGE. *How To See.* Boston: Little, Brown & Co., 1977.

PAPANEK, VICTOR. *Design For Human Scale.* New York: Van Nostrand Reinhold Co., 1983.

PAPANEK, VICTOR. *Design For the Real World.* New York: Pantheon Books, 1971.

PAPANEK, VICTOR, and JAMES HENNESSEY. *How Things Don't Work.* New York: Pantheon Books, 1977.

PULOS, ARTHUR J. *American Design Ethic.* Cambridge: MIT Press, 1982.

SOMMER, ROBERT. *Design Awareness.* San Francisco: Reinhart Press, 1972.

Conclusion: Attributes and Attitudes of the Visual Artist

Recently, I was asked to speak at a conference on careers in art. My first thought was the obvious—what does a product designer do? Not being satisfied with the obvious, I ultimately chose to approach the topic from the point of view of what attributes and attitudes have I been able to identify in successful individuals from all facets of the visual arts. I feel it is a fitting conclusion for this text.

What are the attributes or more specifically the attitudes of the successful visual artist? The following attributes and attitudes are not necessarily given in order of importance nor do they apply in all cases. Moreover, the listing may well be incomplete. However, it should help you begin to clarify your thinking about your development as a professional visual artist.

AESTHETICS

Develop a highly refined sense of aesthetics. Feel comfortable making aesthetic decisions. Apply these

decisions to your daily life. Your personal environment, as well as your work, should be a reflection of your beliefs.

TECHNICAL SKILLS

Develop technical proficiency. Establish technical standards for yourself. Constantly strive to improve. Make use of current developments in technological information. Become familiar with new materials, processes, and equipment within and outside of your discipline. Consider learning a trade that directly relates to your discipline. Many excellent ideas are lost forever because the individual could not technically produce what he or she had envisioned.

COMMUNICATION

Develop your communicative skills: visual, verbal, numerical, and so on. Perhaps even more ideas are lost due to failure to communicate. Generally you will find yourself having to communicate visual concepts by verbal means to individuals who are not visually orientated. Sharpen your awareness of connotation and symbolism and learn to use them to your advantage. Communication skills are essential in the reseach process. You often need information from individuals in fields other than the visual arts. How well can you communicate with a physicist, an actor, a medical researcher, a farmer, or an airplane pilot?

RESEARCH

Be able to conduct and interpret research. Research is asking questions, making observations, gathering information or data, visual documentation, and so on. We are living in an age of information. Learn to use computers. Stay abreast of current developments. You can not afford the time and effort required to reinvent the wheel with each new problem.

PROBLEM SOLVING

Develop a sensitivity to problems. Be able to recognize and identify problems. Develop a problem-solving methodology. Approach problems from the point of view of the user and the task to be completed. Go beyond the norm; be a boundary pusher. Be able to organize and synthesize diverse bodies of information. Strive to see relationships between seemingly unrelated facts or bodies of information. Be thorough. Be prepared to work on several problems simultaneously.

CRITICISM

Be prepared to give constructive criticism. Learn to be diplomatic. Be self-critical. Most important, be able to accept and objectively evaluate—even severe criticism—of your work. Remember, if a person criticizes your work, he or she is not necessarily criticizing you as a person. Be able to separate your personal worth from your work.

COMPROMISE

Be able and willing to make compromises in your work, but not in your standards. Experience working in groups. Be open to other points of view and be willing to recognize that others may have an appropriate or better solution to a specific problem. Be willing to combine your ideas with the ideas of others if doing so will result in a better solution. Be adaptable. Be flexible.

FUTURE ORIENTATION

Be oriented toward the future. Think ahead, but develop an ability to make use of past experiences,

FIGURE 10–1
Employment wanted ad. Collection of the author.

successes, or failures in solving problems. Be willing to share ideas and to teach others.

EXPERIENCES

Be receptive to new experiences. Take calculated risks. You will never know what is to be gained from an experience without trying. We learn best from personal experience. Be entrepreneurial. Develop an idea and make it pay.

STANDARDS

Develop and/or adopt philosophical, moral, and ethical standards by which to operate. Consider the ramifications of your work on individuals, the society, the environment. Be dedicated to your profession and to furthering the goals of that profession. Have a legitimate reason to work.

WORK

Enjoy your work. You will work approximately 80,000 hours in your lifetime. Be enthusiastic about your work. Consider it a challenge, not a job. Be prepared to work long and hard.

SELF-IMAGE

Believe in yourself and your abilities. Be patient.

Credit lines for Visual Reference Chart*

PRODUCTS

1850, Thonet; 1851, First Singer sewing machine, The Singer Co.; 1851, bloomers, Library of Congress; 1850, side chair, MCAD; 1867, Zeotrope, collection of author; 1869, home washing machine and wringer, Library of Congress; 1874, child clothing and hoop toy, Library of Congress; 1876, night lamp, Montgomery Ward and Co.; 1887, Seth Thomas alarm clock, D. Kareken; 1880, Star safety razor, D. Kareken; 1887, Acorn stove, collection of author; 1884, Yale lock, collection of author; 1890, Hires root beer ad, collection of author; 1890, double breasted square cut sack suit, Montgomery Ward & Co.; 1893, Duryea gasoline buggy, G. Cassaday; 1895, Morris chair, collection of author; 1897, kitchen tin wear, Courtesy National Houseware Manufacturing Assoc.; 1900, Brownie camera, Eastman Kodak Co.; 1902, Aluminum cooking utensils, collection of author; 1902, Teddy bear, D. Kareken, by permission of Linda Young; 1902, united craftsmen room, MCAD; 1903, director's chair, Gold Medal, Inc.; 1902, Franklin runabout, G. Cassaday; 1910, regulator wall clock, collection of author; 1910, play blocks, collection of author; 1910, Vortex vacuum sweeper, collection of author; 1912, Chevrolet, Courtesy Chevrolet Division, General Motors; 1913, Mission style furniture, D. Kareken; 1914, men's fashion, MCAD Archives; 1915, John Deere tractor, Deere & Co.; 1915–55, Coca-Cola bottle and fountain glass, The Coca-Cola Co.; 1916, Pyrex ad, collection of author; 1915, women's clothing, M. Wahlquist; 1917 Chevrolet, Courtesy Chevrolet Division, General Motors Corp; 1918, stained glass lamps, D. Kareken; 1920, cast iron construction toy, D. Kareken; 1920 Chevrolet, Courtesy Chevrolet Division, General Motors Corp; 1920 telephone, collection of author; 1920, Glenwood range, D. Kareken; 1922, furniture and clothing examples, D. Kareken; 1924 Chevrolet, Courtesy Chevrolet Division, General Motors Corp; 1925–26, low armchair and floor lamp, MCAD Archives; 1925, Westinghouse fan, collection of author; 1927 Chevrolet, Courtesy Chevrolet Division, General Motors Corp.; 1928, toaster, collection of author; 1928 Breuer chair, Thonet, Inc.; 1929 Pictorial Review, D. Kareken; 1930 Chevrolet, Courtesy Chevrolet Division, General Motors Corp.; 1932, Zippo lighter, Courtesy Zippo Manufacturing; 1933, sanforized ad, collection of author; 1934, Chrysler airflow, G. Cassaday; 1935, boy's clothing, Courtesy Montgomery Ward & Co.; 1935, furniture, D. Kareken; 1935, furniture collection of author; 1935, kitchen stove, collection of author; 1936 Chevrolet, Courtesy Chevrolet Division, General Motors Corp.; 1936–37, Fiesta ware, D. Kareken; 1937, Electrolux vacuum cleaner, Electrolux Corp; 1937, John Deere Model G., Courtesy Deere & Co.; 1939, Parker 51 pen, Parker Pen Co; 1936 Chevrolet, Courtesy Chevrolet Division, General Motors Corp; 1940, bedroom furniture, D. Kareken; 1941, jeep, G. Cassaday; 1942 Chevrolet, Courtesy Chevrolet Division, General Motors Corp.; 1940, bicycles, collection of author; 1946, Schick electric razors, D. Kareken; 1947 Chevrolet, Courtesy Chevrolet Division, General Motors Corp; 1947, Eames chair, Herman Miller, Inc.; 1948, clothing, collection of author; 1949, telephone, H. Dreyfuss & Assoc., D. Kareken; 1949 blender, Courtesy Oster Co.; 1951 Chevrolet, Courtesy Chevrolet Division, General Motors Corp.; 1953, dinette set, collection of author; 1953 living room furniture, collection of author; 1954 Eames chair, Herman Miller, Inc.; 1954 Chevrolet, Courtesy Chevrolet Division, General Motors Corp; 1955, Frigidaire refrigerator, White Consolidated Industries, Inc.; 1950s, Knoll ad, Knoll; 1955 Chevrolet, Courtesy Chevrolet Division, General Motors Corp; 1955, portable television receiver, General Electric Corp; 1956, girl's dress pattern, D. Kareken; 1956 Chevrolet, Courtesy Chevrolet Division, General Motors Corp; 1957 Chevrolet, Courtesy Chevrolet Division, General Motors Corp; 1957, first transistor, Sony Corp. of America; 1957, Eames chair, Herman Miller; 1957, Saarinen chair, Knoll International, Inc.; 1958, Edsel automobile, G. Cassaday; 1958 Chevrolet, Courtesy Chevrolet Divi-

sion, General Motors Corp; 1959 Chevrolet, Courtesy Chevrolet Division, General Motors Corp; 1960, storage wall, G. Nelson & Associates, Inc.; 1961 Chevrolet, Courtesy Chevrolet Division, General Motors Corp; 1962 Pentel sign pen, Pentel of America; 1962, ball chair, Stendig International, Inc.; 1964, Ford Mustang, G. Cassaday; 1964, camera, Eastman Kodak Co.; 1964, mighty dump, Tonka Corp; 1964 Chevrolet, Courtesy Chevrolet Division, General Motors Corp; 1965; Chevrolet, Courtesy Chevrolet Division, General Motors Corp; 1969, mini skirt clothing, collection of author; 1969 Chevrolet, Courtesy Chevrolet Division, General Motors Corp; 1973, modular storage, collection of author; 1973 Chevrolet, Courtesy Chevrolet Division, General Motors Corp; 1976 Chevrolet, Courtesy Chevrolet Division, General Motors Corp; 1977, tennis racquet, D. Kareken; 1977, storage system, Rebots Milano; 1978, food processor, Courtesy North American Phillips Corp; 1979, double oven microwave range, Litton Industries; 1979, clock radio, Dream machine is a registered trademark of SONY Corp. of America; 1979 chair, Thonet; 1981, western clothing, D. Kareken, Sheplers, Inc.; 1981 Chevrolet, Courtesy Chevrolet Division, General Motors Corp., G. Cassaday; 1982, sewing machine, The Singer Co.; 1982, Magic wand speaking reader, Courtesy Texas Instruments; 1980, glassware, Courtesy Libbey Glass Division, Owens-Illinois, Inc.; 1982, Kodak disc camera system, Eastman Kodak; 1983, Ford T-Bird Turbo Coupe, Courtesy Ford Motor Co.

VISUAL COMMUNICATION

1850, ad, Library of Congress; 1960, ad, Library of Congress; 1870, ad, Library of Congress; 1880, ad, Levi Strauss & Co.; 1889, ad, Milton Bradley, collection of author; 1889, Bell logo, reproduced with permission of American Telephone & Telegraph Co.; 1894, Upjohn logo, The Upjohn Co.; 1895, W. Bradley, courtesy of The Society of Typographic Arts; 1900, Bell logo, reproduced with permission of American Telephone & Telegraph Co.; 1903, Crayola, courtesy Binney & Smith; 1903, l'Art de la Mode, D. Kareken; 1905, Stuart's tablets, D. Kareken; 1910, *Collier's*, M. Wahlquist; 1910–46, eye salve, D. Kareken; 1914–33, champion lamp, D. Kareken; 1914, movie ad, Library of Congress; 1913, ad, collection of author; 1920, Morton's salt, D. Kareken; 1920, In Concert, collection of author; 1920, Crane Quality, L. Young, D. Kareken; 1921, Bell logo, reproduced with permission of American Telephone & Telegraph Co.; 1923 TIME cover, D. Kareken, collection of author; 1926, tablets, D. Kareken; 1928, ad, D. Kareken, collection of author; 1928, logo, courtesy Container Corp. of America; 1930, Mak. Yur. Own, D. Kareken; 1930, cigar, D. Kareken; 1930 Lucky Strike ad, D. Kareken; 1933, Albodon, D. Kareken; 1934, Steak & Shake, Inc.; 1934, coffee, D. Kareken; 1935, Rid-a-Pain, D. Kareken; 1939, ad, D. Kareken; 1938, ad, D. Kareken; 1939, Bell logo, reproduced with permission of American Telephone & Telegraph Co.; 1940, coffee, collection of author; 1942, Ameri-

ca's Answer, Jean Carlu; 1940s, logos, courtesy Montgomery Ward; 1942, TIME cover, D. Kareken; 1942, Lucky Strike pack, D. Kareken; 1944, label, D. Kareken; 1946, Mobilgas special, D. Kareken; 1946, logos, D. Kareken; 1946, 48 States . . . courtesy Container Corp. of America; 1948, ad, collection of author; 1945, ad, Knoll; 1953, Dostoevsky, courtesy Container Corp. of America; 1955, MCAD catalog, MCAD Archives, D. Kareken; 1954, Alvin Lustig; 1955, CBS logo, W. Golden, CBS; 1954, Squirt logo, courtesy Squirt & Co.; 1957, Soundblast, D. Kareken; 1957, IBM logo, courtesy IBM; 1960, logo, courtesy Container Corp. of America; 1962, Westinghouse logo, Paul Rand, courtesy Westinghouse Electric Corp.; 1964, Bell logo, courtesy American Telephone & Telegraph Co.; 1965, Mobil logo, I. Chermayeff/Geismar Associates; 1965, ad, copyright Volkswagen of America, Inc. Volkswagen, Beetle and Rabbit are registered trademarks of Volkswagen, AG; 1966, Art in America, D. Kareken; 1966, Victor Moscoso, *Junior Wells and His Chicago Blues Band*, Collection, The Museum of Modern Art; 1968, ad, collection of author; 1969, Bell logo, reproduced with permission of American Telephone & Telegraph Co.; 1970, assorted logos, Margulies; 1970, ad, Volkswagen of America; 1972, ad, Ziebart; 1977, TIME cover, copyright 1977 TIME Inc., all rights reserved; 1979, Art Expo poster, Chermayeff & Geismar Associates; 1981, ad, Volkswagen of America; 1981, Apple Computer System, D. Kareken; 1981, *Fetish* magazine, D. Kareken, courtesy Rik Sferra; 1982, courtesy Hask Toiletries, Inc.; 1982, ad, courtesy Maxwell Corp. of America; 1983, Bell logo, reproduced with permission of American Telephone & Telegraph Co.

ENVIRONMENT

1845–75, Italianate, Spencer Museum of Art, University of Kansas; 1854, parlor view, Library of Congress; 1860, Early Victorian, courtesy *The Old House Journal*; 1880, Victorian Baroque, Spencer Museum of Art, University of Kansas; 1885, parlor, courtesy *The Old House Journal*; 1890, Queen Anne, collection of author; 1910, builder's home, cottage style, collection of author; 1913, silent flow, collection of author; 1910 Georgian revival, 1920 Georgian colonial, 1928 American 4-square, 1930 Vernacular Wright, 1946 Cape Cod cottage, 1947 kitchen, 1949 prefab house, 1961 split level, 1968 subdivision house, 1970 town house, all from THE AMERICAN HOUSE by Mary Mix Foley, drawings by Madelaine Thatcher, copyright © 1980 by Mary Mix Foley, reprinted by permission of Harper & Row, Publishers, Inc.; 1920, kitchen, D. Kareken; 1928 bungalow, G. Cassaday; 1939, living room, modern style, collection of author; 1939, prefab house, G. Cassaday; 1943, living room, collection of author; 1955, ranch house, collection of author; 1953, dining furniture, collection of author; 1965, kitchen, General Electric; 1975, Panton chair, courtesy Herman Miller Inc.; 1980, earth sheltered home, courtesy Gerry Allen, Criteria Architects, Inc.

*Note that in the credits above Kareken and Wahlquist photographed and Cassaday illustrated specific figures. All illustrations in Visual Reference Chart are part of the collection of the author with the following exceptions: Products (1949 telephone and 1981 Sheplers Catalog), Visual Communication (1955 MCAD Catalog and 1981 Apple Computer System).

INDEX

Boldface numbers refer to illustrations; 'fig.' means colorplate

Ability, artistic, degrees of, 5
Abstraction, 36, 95
Academic curriculum, 8
 modified approach, 10
Accordion fold, 72
Additive mixture, 53–54
Additive work processes, 114–15
Advertising:
 and purchase decisions, 164–65
 successful, 32
Aerial perspective, 83
Aesthetics:
 functional, 163–81
 of product design, 167, 178–80
 of three-dimensional form, 107, 129
Aesthetic sense, developing, 182–83
Aguet, H., 28, 29, 40
Ahey, R., 51 (fig.), 52 (fig.), 53 (fig.)
Albers, Josef, 35, 49 (fig.), 55, 58
Albright, Ivan, 95
Allen, Gerry, 86, 136
Allison, D., 126
Alston, Rebecca, 71 (fig.)
Alternative solutions, developing, 3
Alviani, Getullio, 75
Ambiguity, in figure/ground, 27
America, artistic training in, 9–11
Amplified perspective, 85–86
Angular perspective, 85, 91
Anthropometrics, 177
Appearance:
 structure and, 129
 work process and, 121–23
Architectural structures (arch, dome etc.), 134–44
Architecture, 12, 130
Arch structure, 140
Art. See also Visual art
 as a career, 182–84
 "creative," 2, 9

Articulation of space, 107–8
Artifacts, of popular culture, 12–13
Artist. See Visual artist
Artistic ability, degrees of, 5
Artistic training, throughout history, 8–11
Arts history, teaching of, 12–13
Assembly. See Construction
Assignments, course, structured vs. unstructured, 2
Attraction, in a composition, 32
Atwell, A., 137
Automobiles, design of, 166

Bagnall, Jim, 6
Balance, visual, 30–32
 vs. asymmetry, 31
Bardazjy, Joan, 181
Basic Workshop approach (Bauhaus curriculum), 9
Batista, K., 61
Bauhaus curriculum, 8–11
 critique of, 9
 modified approach, 10
Bayley, Stephen, 23
Beakley, George C., 102, 162
Beck, Jacob, 58
Belling, Rudolph, 161
Belliston, Larry, 102
Bending, 115
Bennet, Corwin, 181
Benyo, M., 158
Bethke, T., 101
Bezold, Wilhelm von, 56
Biederman, Charles, 76, 105
Biological structure, 130
Bionics, 10
Birren, Faber, 57, 58
Blanc, Charles, 57
Blumensen, John G., 23

Boccioni, Umberto, 116
Boundary pushing, in course projects, 3–5
Bowen, E., 27, 42, 66
Bradley, Milton, Company, 10
Brancusi, Constantin, 150
Bravick, D. J., 50 (fig.)
Breuer, Marcel, 111, 144
Bro, Lu, 102
Broom, Joy, 82, 96
Brown, Curtis F., 181
Brown, Ezra, 23
Brown, M., 54 (fig.)
Budzik, Richard S., 162
Burlini, Joseph A., 106
Burpee, James, 80, 81
"busy," 40
Butterworth, D., 67 (fig.)
Byers, D., 43, 50 (fig.), 94
Byrne, Kevin, 60

CAD (computer-aided design), 88
Camouflage, visual deception in, 44
Camrose Art Corporation, 175
Cantilever structure, 144
Capitalism, 164
Caplan, Ralph, 181
Careers in art, 182–84
Carlson, S., 54 (fig.)
Carraher, Ronald G., 48
Cast drawing, 8
Castle, Wendell, 105, 107, 109, 112
Cezanne, 3
"chaotic," 40
Character (typographic), 34–35
Chevreul, M. E., 56
Chilton, Ernest G., 162
Chromatic colors, 51
Clore, Robert, 113, 128
Closure, in a composition, 40–41

Clutter, visual, 169
"cold," 40
Coleman, J., **69**
Color, 49–58
 contrast of, 50
 equalization of, 55
 and figure/ground perception, 27
 and illusion of space, 83
 industrial systems of, 51–52
 mix and match exercise, 56
 mixture of, 51–56, 70–71
 perception of, cultural differences in, 49–50
 primary and secondary, 51–52
 qualities of, 50–51, 83
 theory of, 49–58
 of three-dimensional form, 122–23
 trends in, 119
 uses of, 118–19
Column, 134
Communication:
 in a composition, 32
 through connotative structure, 67
Communication skills, developing, 183
Complementary hue, 51
Complexity:
 and closure, 41
 of a composition, 39–40
Components, industrial, 156–57
Composition, 29–48
 amount of information in, 39–46
 components of a successful, 30–44
 deception in, 44–46
 evaluating, 29–34
 figure/ground in, 29–32, 34–35
 grouping in, 35–39
 intuition in, 62
 like/dislike of, 32
 visual components of, 59
 when to stop working on, 39–40
Compression, 132
Compromise:
 artistic, often necessary, 5
 learning to, 183
Computer-aided drawing, 88
Computer skills, developing, 183
Connotative structure, communication by, 67
Consistency, in composition, 32
Constraints:
 construction within, 117–20
 in problem-solving, 3
Construction. *See also* Structure
 within constraints, 117–20
 from industrial components, 156–57
Construction (assembly), 114
Consumer society, 164–81
Container building projects, 145–46
Contrast, simultaneous, of color, 50
Convergence, and illusion of space, 84
Coppola, R., **86**
Cost, as problem-solving constraint, 3
Course design (this book), 2–3, 46, 103
Courtney, J., **158**
Craft guilds, 8
Craftsmanship:
 of consumer products, 177
 and successful composition, 32
Creativity, in art studies, 2, 9
Critchlow, Keith, 148
Criticism, constructive, learning to accept, 183
Croney, John, 181

Cube, drawing, in parallel perspective, 90
Cutting, 115

Davidoff, Jules B., 48
Davis, J., **29, 47, 126**
Debrey, Robert, **115, 121, 131, 144**
Deception, visual, in composition, 44–46
Decoration:
 aesthetic concerns in, 178
 two-dimensional space in, 24, 80
Decorative space, 80
De La Groiv, Horst, 23
De Lucio-Meyer, J., 181
Depth illusion, 79–87
Design. *See* Product design
Detailing, 123
Diffrient, Niels, 181
Dimension:
 drawing methods for achieving, 79–91
 exaggerated, 107–8
 two- and three-, 76–77
Directional grid, 65
Disaster project, 95–97
Discursive drawing, 88–89
Displacement, linear, 71–72
Dissection drawing, 92
Distribution, visual, 38–39
Dobbe, Doug, **42**
Doblin, Jay, 23, 102
Dome structure, 141–42
Dondis, Donis A., 48
Donnelly, Edward T., 162
Dorfles, Gillo, 181
Dot:
 as center of interest, 68
 fusion of dots, 69–71
 as visual component, 62, 67–71
Dow, Arthur Wesley, 10
Drawing, 79–102
 in artistic training, 10
 cast, 8
 for problem solving, 92–102
 for spatial representation, 79–91
 technical systems of, 87–88
Dreisbach, G., **119** (fig.)
Dreyfuss, Henry, **112**
Drickey, K., **152, 153, 160, 161**
Drop grid, 65
Duchamp-Villon, Raymond, **156**
Dunser, J., **50** (fig.)

Eames, Charles, 3, **4, 107. 162, 168**
Eames, Ray, 3
Ecole de Beaux Art, 8
Edmonton, Dave, **166**
Element-and-principles approach to artistic training, 9–10
Encyclopedia of Collectibles, 23
Engel, Heinrich, 148
Engel, J., **50** (fig.), **54** (fig.), **76**
Enlarging, 93–95
Environmental analysis, 92–93
Environmental concerns, of product design, 176
Equivocal space, 82
Escher, M. C., **74**
Essence analysis, 93
Evaluation, aesthetic, 107, 163–64
Evans, Helen Marie, 181
Evers, T., **151, 154**
Excitement. *See* Visual interest

Expansion grid, 65
Experiences, new, being receptive to, 184
Eye-level line, 84
Eye work, 123

Fad, 165
Failure under stress, 132
Feinsilber, Mike, 181
Ferebee, Ann, 23
Ferrer, John L., 162
Figure/ground, 25–35
 and closure, 41
 strong, weak and ambiguous, 27
 in a successful composition, 29–32
Filled structure, 143
Finishes, for three-dimensional form, 118
Fisher, Robert, 128
Fledurg, B. Annis, **169**
Flexure, 133
Folding, 115
Folk art, 169
Force (load), 132
Form, 158–61
 and function, 175
 hand as, 116–17
 implied, 110
 overlapping, 82
 progression of, 158
 pure, 161
 in space, 104, 159
 vs. structure, 77–78
Foundation studies, 1–11
 Bauhaus influence on, 9–11
 course design, 2–3, 103
 goals of, 1, 5–6
 history of, 7–11
 meaning of "foundation," 7–8
Four-color printing, 52, 70
Fraser, Donald J., 148
Freden, Chester, **167**
Freehand drawing, 88–89
French Academy, 3
Fukushima, Hiroshi, **85, 86, 88, 114, 123, 124**
Fuller, R. Buckminster, 141, **142**
Function, form and, 175
Functional aesthetics, 163–81
Functional color, 119
Furuseth, Mary, 145
Fusion, of dots, 69–71
Future orientation, developing, 183

Garrett, Lillian, 78
Gaston, Johannes, **61, 87**
Geodesic dome, 141–42
Germany, artistic training in, 9
Gestalt theory, 25, 81
Giedion, Sigfried, 23
Goethe, 56
Gold, S., **77, 78, 116**
Gombrich, E. H., 48
Goodman, Sue, 102
Goodry, S., **54** (fig.)
Gorski, Dan, **82, 122**
Gradation, and illusion of space, 84
Graves, D., **31, 75, 96**
Greek art, 85
Green, Peter, 148
Greene, Herb, **80**
Greenstreet, Bob, 102
Gregory, R. L., 48
Grey, chromatic and achromatic, 51

Grid, 59–66
 and surface pattern, 62–66
 types and characteristics of, 63–65
Gropius, Walter, 8
Gross-symbolism switch, 171–74
Ground. *See* Figure/ground
Grouping, 35–39
 of dots, 70–71
Guilds, and artistic training, 8

Halftone, 63, 70
Hammack, S., **40, 47, 53, 62, 106, 121, 132, 152, 172**
Hammond, James J., 162
Hand:
 as form, 116–17
 as tool, 116–20
 tools as extension of, 121
Handcrafting, 116
Hand tools, 116, 121, 151–54
Hanks, Kurt, 102
Harlan, Calvin, 78
Harmon, David, 181
Harmon-Miller, Jean E., **30**
Harris, Mark, **119** (fig.)
Harrod, Walter F., 162
Hartmann, Robert R., 102
Hastie, Reid, 102
Hennessey, James, 181
Henning, J., **100**
Hepworth, Barbara, **114**
Hering, Ewald, **57**
Hofmann, Armin, 78
Holme, Bryan, 23
Horizon line, 81, 84
Howze, James D., **86**
Hue, 51–54
 complementary, 51
Human factors, in product design, 177–78
Hypothesis drawing, 92

ID approach, 10–11
Illusion of space, 79–87
Image:
 incomplete, closure of, 40–41
 visual components of, 59
Imagery:
 and symbolic association, 5
 types of (abstract, representational, nonobjective), 95
Images, popular, identifying when they were made, 12–13
Imitation, vs. innovation, 2, 5
Implied form, 110
Industrial components, 156–57
Industrial Revolution, 164, 169
Infinite space, 80
Information, visual:
 in a composition, amount needed, 39–43
 and visual deception, 44–46
Innovation, vs. imitation, 2, 5
Institute of Design, Illinois Institute of Technology, 167
Institute of Design (ID) approach to artistic training, 10–11
Intensity, 51
 color mixing and, 55
Interest, visual, 30–32, 122
Intuition:
 in composition, 62
 vs. objectivity, 119
Intuitive space, 81

Irons, C., **138**
Isometric drawing, 88
Itten, Johannes, 58

Jacob, Michel, 57
Jacobson, C., 72, 73
Janas, J., 99
Janson, H. W., 23
Jencks, Charles, 162
Jerome, John, 181
Jones, J. Christopher, 6
Jones, Tom Douglas, 58
Jung, Carl G., 48
Junk yards, components from, 156

Kane, Joseph Nathan, 23
Kareken, D., **26, 31, 33, 35, 36, 37, 38, 63, 64, 65, 66, 71** (fig.)**, 89, 130, 133, 141, 143, 165, 168, 170, 171, 172, 173, 174, 178**
Kepes, Gyorgy, 23, 48, 78, 148, 162, 181
Kinetic analysis, 154–56
Kirkland, L. P., **119** (fig.)
Kitsch, 168–75
Kleenex culture, 166
"knock-offs," 5
Knutson, Marlene, **119, 159**
Koberg, Don, 6
Koenig, Leonard, **29, 31, 96**
Konder, C., **56** (fig.)
Kowal, Dennis, 162
Kranz, Stewart, 128
Kron, Joan, 23

Lahti, R., **101**
Langlais, D., **134, 146**
Laux, M., **46** (fig.)
Le Corbusier, 162
Leisure, Jerry, **123**
Lent, S., **53** (fig.)
Lewitt, Sol, **108**
Light, and color, 53–54
Light source, position of, and shading, 83
Like/don't like attitude, 3, 32
Limited space, 80–81
Line:
 qualities of, and illusion of space, 83
 as visual component, 62, 71–72
Linear form, 107–8
Linear perspective:
 and illusion of space, 86–87
 principles and types of, 84–86
Linear-planar form, 111
Linear-planar-solid form, 113
Linear-solid form, 112
Line of vision, 84
Load, dead and live, 132
Lucas, James G., 48
Lucker, D., **90, 91, 92, 97, 98, 100**

Machine tools, 116, 154
Maendler, L., **124, 125**
Magritte, René, **45**
Magro, Benjamin, 143
Maquette, 123
Marcheski, Cork, **111** (fig.)
Marketable color, 119
Mars, S., **43, 118, 127**
Mason, John, **108**
Mass media, advertising in, 164–65
Materials:
 choice of, 3, 130

properties of, 114, 130
 for three-dimensional forms, 149–62
 translation of (from one to another), 126–27
McCarthy, Willard J., 162
McCoy, Kathryn, **81**
McCoy, Michael, **81**
McKim, Robert H., 6
McRae, C., **36, 46, 157**
Mead, William B., 181
Medium, choice of, 32
Meilach, Dona Z., 162
Mellor, George, 113
Membrane, in a structure, 142–43
Meurer, D., **50** (fig.)
Middle ages, artistic training in, 8
Miller, Judy, **45**
Miller, M., **151**
Milton Bradley Company, 10
Mix-Foley, Mary, 23
Mixture of color, 51–56
 additive, 53–54
 optical, 70–71
 subtractive, 51–53
Model, 122
 scale, 123
Modeling, plaster, 117–20
Modular structure, 76–78
Moment, 133–34
Monolith, 110
Moran, L., **38** (fig.)**, 39, 47, 93, 122, 151, 155, 161**
Motion, implied, 76
Motion analysis, 154–56
Muller-Brockmann, J., 78
Munsell, Albert H., **57**
Munsell system, 51–52
Munzner, Aribert, **83** (fig.)

Naeve, Milo M., 23
Nature approach to artistic training, 10
Negative form, 110, 116
Negative shape, 28–29
Nelson, B., **67**
Nelson, George, 181
Nelson, John A., 128
Neo impressionism, 68
Nesting form, 117–18
Newman, Thelma R., 162
Nonobjective imagery, 36, 95

Object:
 function of, 163–64
 location of, and illusion of space, 81
Object investigation exercise, 92–93
Objective drawing, 92
Objectivity, vs. intuition, 119
Observation, 92–93, 104–7
Oldenburg, Claes, **143**
One-dimensional object (nonexistent), 107
One-point perspective, 85, 89–91
Open-mindedness, in problem-solving, 3
Order, visual. *See* Grouping
Organization, spatial. *See* Composition
Originality. *See* Innovation
Orthographic projection, 82, 87–88
Ostwald, Wilhelm, **57**
Ostwald system, 52
Ott, Jerry, **30**
Overlapping forms, and illusion of space, 82
"overworked," 40
Owen, Charles, **74**

Owens, L., **147**
Owner's manual project, 93

Packaging of consumer products, 176–77
Padgham, C. A., 58
Papanek, Victor, 175, 181
Parallel lines, convergence of, 84
Parallel perspective, 85, 89–91
Parative mixture, 70–71
Pattern, 62–66
 applications of (wallpaper, etc.), 63
 grid and, 62–66
 repetition in, 63
Peak, E. J., **85**
Pearce, Peter, 148
Pearce, Susan, 148
Perception, 24–48
 closure and, 40–41
 control of, by distribution, 39
 grouping and, 35–39
 of space, 24–25
 study of, 2
 visual deception and, 44–46
Performance, structure and, 129–48
Periodic structure, 63
Perspective. See Aerial perspective;
 Linear perspective
Perspective drawing, 85
Photographs:
 color in, 52
 enlarging, 93–95
Physical structure. See Structure
Picasso, Pablo 3, **4**, 111, **156**
Picture plane, 81, 84
Pigment, mixing of, 51–53
Pistillo, M., **139**
Plagiarism, 5
Planar form, 108
Planar shape, as visual component,
 62, 73–76
Planar-solid form, 112
Plaster modeling, 117–20
Plastic materials, 114
Pneumatic structure, 143
Pointillism, 68
Popular culture. See also Consumer so-
 ciety
 artifacts of, 12–13
Porter, Tom, 102
Positive attitude, needed for
 problem-solving, 2
Positive/negative shape, 28–29
Post and beam structure, 134
Practical training, vs. theoretical stud-
 ies, 2
Prang Company, 10
Prang system, 51
Presentation drawing, 123
Primary and secondary colors, 51–52
Printing, color in, 52, 70
Printz, Bonnie, **84**
Problem-solving, 1–3
 drawing methods for, 92–102
 methodology of, 2–3
 positive attitude needed in, 2
 skills, developing, 183
Product design, 12–13, 119, 130, 165–68, 175–80
 aesthetic concerns in, 178–80
 as a career, 182–84
 ethical concerns in, 175–77
 human factors in, 177–78
Products, consumer, 164–81
 cost of, 176–77

decoration of, 178
durability of, 165–66
ethical concerns regarding, 175–77
evaluation of, 167–81
performance of, 178
in poor taste, 168–75
purchase decisions, 164–70, 180
Progression:
 of forms, 158
 linear, 72
 of planar shapes, 74–76
Projects, course, 2–5
 boundary-pushing approach to, 3–5
 problem-solving approach to, 2–3
 "right" solutions to, 2
Proportion, of forms, 160
Proximity:
 and closure, 41
 in composition, 35–36
Pugh, Anthony, 148
Pulos, Arthur J., 23, 181
Purchase decisions, 164–68, 180
 status-seeking and, 169–70

Quadruped mammal project, 98–99

Raferty, Gerry, **81**
Rauschenberg, Robert, **33**
Rayner, Norman A., 162
Rectangular grid, 65
Recycling, 166
Refinement of a solution, 3
Relief form, 76–77, 104
Renaissance, 85
Repetition, in surface pattern, 63
Representation imagery, 95
Reproductions of art masterpieces, 170
Research skills, developing, 183
Rettew, Steve, **113**
Richardson, Terry, 162
Rifkin, Carole, 23
River, James, **179**
Roman art, 85
Rood, Ogden, **57**
Roode, Judy, **60**, **84**
Rosate, James, **111**, **135**
Round, in the (form), 104
Rowland, Kurt, 23
Ryden, Kenneth G., **127**
Rynkiewicz, P., **34**

Safety:
 of consumer products, 176
 in using tools, 149
Sahl, M., **28**, **55** (fig.)
Samsa, G., **51** (fig.), **52** (fig.), **53** (fig.)
Saunders, J. E., 58
Scale, change in, 122
Scale model, 123
Schlock art, 174–75
Schmidt, Christian, 102
Schoenfeld, Susan, 78
Seale, William, 23
Segmenting, 115
Self-expression. See Innovation
Self-image, developing, 184
Self-image project, 99–101
Seurat, Georges, **68** (fig.)
Shade of color, 51
Shading:
 drawing methods for, 91
 and illusion of space, 83
Shape, 25–29
 and figure/ground perception, 25,
 28–29
 positive/negative, 28–29

Sheeler, Charles, **82**
Shell structure, 142, 144
Shift grid, 65
Signac, Paul, **68**
Silver, Nathan, 162
Similarity:
 and closure, 41
 in composition, 38
Simmons, Seymour, 102
Simple grid, 63–65
Simultaneous contrast of color, 50
Simultaneous perspective, 85–86
Size contrast, and illusion of space, 81
Slab structure, 136
Slesin, Suzanne, 23
Smith, David, **109**
Smith, Robert E., 162
Social consciousness, and aesthetic
 evaluation, 163
Solid form, 110. See also Three-dimen-
 sional form
 as visual component, 62
Solutions:
 alternative, 3
 visual, 120
Sommer, Robert, 181
Space:
 articulation of, 107–8
 concepts of (decorative, infinite, lim-
 ited, intuitive), 80–81
 drawing methods for representing,
 79–91
 equivocal, 82
 form in, 104, 160
 illusion of, 79–87
 perception of, 24–25
 two- and three-dimensional, 24
Space-enclosure project, 146
Spray gun, 119
Standards:
 developing, 184
 setting, 5
Station point, 84
Steffen, D., **56** (fig.)
Stella, Frank, **31**
"sterile," 40
Still, Clyfford, **31**
Stress, 132
Structural drawing, 92
Structure, compositional, 59–78
 connotative, 67
 visible, 59
Structure, physical, 129–48
 and appearance, 129
 vs. form, 77–78
 and performance, 129–48
 principles of, 132–34
 types of (architectural systems), 134–
 44
Structured vs. unstructured assign-
 ments, 2
Studio programs. See Foundation stud-
 ies
Stuffing, 143
Stylistic ethics, 175
Subtractive mixture, 51–53
Subtractive work processes, 114–15
Sum-of-the-parts exercise, 42–43
Surface:
 pattern, 62–66
 shading of, 91
 three-dimensional, treatment of,
 123
Surplus stores, components from, 156
Survival design, 167

Suspension structure, 136
Symbols:
 in abstract art, 36
 conceptualizing closure with, 41
 consensual, 41
 gross-symbolism switch, 171–74
 objectivity clouded by, 5
 in product design, 167
Symmetry, 31

Tactile sense:
 and visual sense, 120
 in working with three-dimensional
 form, 104, 119
Tallier, L., **74**
Tansey, Richard G., 23
Taste, poor, 168–75
Taylor, Joshua C., 23
Teacher, role of, in artistic training, 9
Technical drawing systems, 87–88
Technical skills:
 developing, 183
 for problem-solving, 3
Television watching, 164–65
Tension, 132–33
Theoretical studies, vs. practical train-
 ing, 2
Thiel, Philip, 48
Thomas, Richard K., 128
Thompson, D'Arcy, 148
Thonet, **13**
Three-dimensional form, 76–78, 103–
 62. *See also* Solid form
 aesthetic judgment of, 107
 analysis, classification and descrip-
 tion of, 104–13
 appearance of, 121–23, 129
 coloring of, 118–19, 122–23
 constructing, 77–78, 114–28, 149
 developing and planning, 122–26,
 130
 finishes for, 118
 materials used in, 113, 126–27, 130,
 149–62
 observation of, 104–7
 performance-oriented, 129–48
 problems in studying, 104
 reasons for studying, 103
 self-supporting, 134
 structure of, 129–48
 tactile sense used for, 119
 tooling of, 115–16, 121
 work processes in constructing, 113–
 16, 121–23, 149–62
Three-dimensional space, 24, 104
Three-point perspective, 85–86
Throssel, J., **157**

Thurston, Jacqueline B., 48
Tilley, Alvin R., 181
Time constraints, for problem-solving, 3
Tinney, Robert, **44**
Tint, 51
Tobias, Robert, **32, 105, 114, 117**
Tone, 51
Tool(s), 115–21
 hand as, 116–20
 hand-held, 116, 121, 151–54
 machine, 116, 154
 safe use of, 149
Trade-offs. *See* Compromise
Transformation. *See* Progression
Translation, 93–95
 of materials, one to another, 126–27
 of three-dimensional form to two-
 dimensional form, 103
Transparency, and illusion of space, 82
Tresut, B., **68**
Triangular grid, 65
Triangulation structure, 135
Trova, Ernest, **112**
Truss, 135
Tucker, B., **176**
Two-dimensional form, 76–77, 103. *See
 also* Planar form; Shape
Two-dimensional space, in decoration,
 24, 80
Two-point perspective, 85, 91
Type style, 34–35

Ultimate form project, 150
Unstructured approach to artistic train-
 ing, 11
Unstructured assignments, 2
Upitis, Alvis, **83**
U.S.A. theory of product evaluation,
 167–68
Utility, of products, 167

Value, 51
 color mixing and, 54
 contrast of, 83
Van der Rohe, Mies, **150**
Van der Veen, J., **162**
Van der Weg, Phil, **109**
Vanishing point, 84
Vasarely, Viktor, 58
Vaull, **140**
Verhelst, Wilbert, 162
Verily, Enid, 58
Vernacular products, 167
Visual artist:
 attributes of, 182–84
 ethical concerns of, 175–77
 skills needed by, 89

term defined, 2
 training of, 8–11
Visual arts:
 standards setting in, 5
 study of, 1–6
 theory in, 24–25
 training in, 8–11
Visual awareness, 163–64, 169–71
 and purchase decisions, 164, 169–70
Visual components:
 analysis of, 62
 structural arrangement of, 59–78
Visual image. *See* Image
Visual information, flood of, 164–65
Visual interest, 30–32, 122
Visual literacy, *See* Visual awareness
Visual perception. *See* Perception
Visual reference chart, 5, 12–22
Visual sense, and tactile sense, 120
Volumetric form. *See* Solid form
Von Frisch, Karl, 148
Von Frisch, Otto, 148

Wade, David, 48
Wagner, S., **140**
Wahlquist, M., **33**
Walton, J., **115, 120**
Ward, M., **133, 157**
Warhol, Andy, **32**
Warren, V., **169**
Weber-Fechner law, 54
Williams, Christopher, 148
Winer, Marc S. A., 102
Winfield, Gene, **156**
Wingler, Hans M., 23
Wong, Wucius, 78, 128
Wood, Grant, **101**
Work, enjoying, 184
Work processes for three-dimensional
 form:
 additive and subtractive, 114–15
 and appearance, 123
 tools used, 115–16
Workshop experience, 149–62
Worrell. W. Robert, **113**
Wright, R., **47**

XYZ coordinate system, 121–22

Yamron, G., **153**
Young, F., **5, 26, 55** (fig.), **67, 97, 99, 110,
 112, 119** (fig.), **131, 133, 135, 140,
 141, 144, 145, 169, 173, 175, 179**
Young, F., Sr., **13**

Zaccai, Gianfranco, **110**
Zakia, Richard, 41